CUP OF COFFEE

A PHOTOGRAPHIC
TRIBUTE TO LESSER KNOWN
TORONTO
MAPLE LEAFS

=== 1978-99 ===

Graig Abel *and* Lance Hornby
foreword by Wendel Clark

Published by ECW Press
665 Gerrard Street East
Toronto, ON M4M 1Y2
416-694-3348 / info@ecwpress.com

Editor for the press: Michael Holmes
Author and cover photo: © Dave Abel
All photographs © Graig Abel

LIBRARY AND ARCHIVES CANADA
CATALOGUING IN PUBLICATION

Abel, Graig, author

Cup of coffee : a photographic tribute to lesser known
Toronto Maple Leafs, 1978–99 / Graig Abel and Lance
Hornby; foreword by Wendel Clark.

ISBN 978-1-77041-272-9
also issued as: 978-1-77090-903-8 (pdf)
978-1-77090-902-1 (epub)

1. Toronto Maple Leafs (Hockey team)—Pictorial works.
2. Hockey players—Ontario—Toronto—Pictorial works.
3. Toronto Maple Leafs (Hockey team)—History—
Pictorial works.
1. Hornby, Lance, author II. Clark, Wendel, 1966–, writer
of foreword III. Title. IV. Title: Photographic tribute to
lesser known Toronto Maple Leafs, 1978–99.

GV848.T6A24 2016 796.962'6409713541
C2016-902391-5 C2016-902392-3

The publication of *Cup of Coffee* has been generously supported by the Government of Canada through
the Canada Book Fund. *Ce livre est financé en partie par le gouvernement du Canada*. We also acknowledge
the contribution of the Government of Ontario through the Ontario Book Publishing Tax Credit and
the Ontario Media Development Corporation.

Ontario
Ontario Media Development
Corporation

Canada

PRINTED AND BOUND IN CANADA PRINTING: MARQUIS 5 4 3 2 1

MIX
Paper from
responsible sources
FSC® C103567
www.fsc.org

To my wife, Jane, who once again saw me spend hours at the
computer scanning and researching player images for the book.
— G.A.

To brother Mike, who took to me to my first Leafs game,
and to all the *Cup of Coffee* players who let me tell their
stories for the *Toronto Sun.*
— L.H.

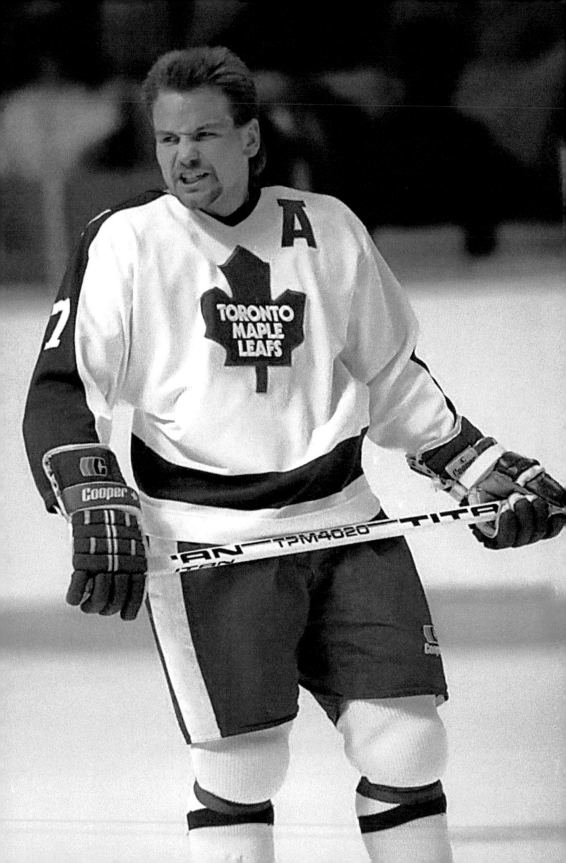

FOREWORD

Thirty-one years ago, I put on my Maple Leafs sweater for the first time.

It was a huge honour — and it came on the home team stage. The National Hockey League Draft was held in Toronto in 1985, and the Leafs had the No. 1 pick. The scene was a little different than I'd imagined: Maple Leaf Gardens was being renovated, so they held the draft at the Metro Toronto Convention Centre.

I knew the Leafs were a very famous team. Many of their greatest players had come from my home province, Saskatchewan, and from elsewhere in western Canada. My dad was a fan and would've listened to Foster Hewitt on the radio and later watched *Hockey Night in Canada* every Saturday evening.

But I remember so many of our fans came out with cameras and autograph books to be among the crowd. I'll never forget the cheering when my name was announced first. The Leafs had not done very well the year before, but the fans were still excited about a new start and my being chosen first.

I walked up to the podium where our general manager, Gerry McNamara, was waiting for me, and where the Stellick brothers, Gord and Bob, had my sweater. When I put it on for the first time, there was even more cheering and I thought, "Wow, this is going to be fun."

My first game in Boston was a bit of a blur, but I do recall seeing my #17 hanging in the stall. I had worn #22 as a junior, but Rick Vaive had that when I arrived and I wasn't about to argue. Our old trainer, Guy Kinnear, picked out 17 and reminded me that the great Dick Duff had worn that number. Fine with me — I was just happy to be in the NHL.

Bill Derlago was my centre that first night and set me up for a couple of good chances. I didn't score, but they traded Billy the very next day to the Bruins for Tom Fergus. I still bug Bill about that when we play old-timer hockey. Maybe if I'd scored one or two that night, they might have kept him! That did teach me how lucky I was to be able to stay with Toronto for so long — almost 10 years — when so many others were traded to and from the team or came and went on waivers. You just never know.

During my time in Toronto, I saw a lot of guys play their first game and always got a kick out of seeing them in the dressing room for the first time, wearing the sweater, looking around the Gardens. It always seemed to mean the most to the Ontario kids who had grown up with the Leafs. I especially remember Mike Johnson's first game in 1996–97. He was a Toronto kid who really embraced the chance to play in his own city, and he went into TV after he finished playing.

I'm fortunate for having been able to make an impact for the Leafs, score some goals, be physical and, yes, get involved in a fight or two. I was proud to be captain for three years between 1991 and 1994 when we had some of our best years, going to the conference final in consecutive springs.

You'd like to play for the same team forever, but it doesn't usually happen that way. Later in the 1990s, I experienced what it's like to be traded and then to come back. When I returned from the New York Islanders in 1996 and watched the equipment guy scrape the New York logo on my helmet off and put a Leaf back on, I joked with the media that I'd never gotten Toronto out of my system. I was older, had less hair, but I was going to play the same way I did before.

During the time I was away — with Quebec, the Islanders, and later with Tampa Bay, Detroit and Chicago when I was a free agent — hockey felt more like a job to me. Nothing against those teams, but in Toronto there was always something going on and it was usually about the Leafs. People like to knock Toronto for that, but it was, and is, a great place to play.

I was very emotional the day I announced my retirement in 2001, so fortunate to start and end my career there. You hear all about hockey being an institution in Toronto and that is true no matter how long you spend as a Leaf.

WENDEL CLARK
January 2015 | Toronto, ON

INTRODUCTION

As I complete nearly 40 seasons as the Toronto Maple Leafs' team photographer, I think of the many players who have sat for their training camp headshots.

Camp is where wide-eyed young draft picks come for the first time, where traded players meet new teammates, and where farmhands and walk-ons show up eager to impress Toronto management.

Some of these guys stick around and sign a long-term contract, enjoying all of the fame that comes with it. You can name dozens and dozens of players who've made their name in the Toronto market through the years. You don't even need their last names. Darryl, Dougie, Wendel, Felix, Tie, Mats, Cujo and Eddie the Eagle: All household names because they're Maple Leafs.

Then there are Dallas, Darwin, Drake, Frank "The Animal," Trees and Motor City Smitty, names you may not remember as well but that certainly ring a bell. They were only recalled or brought in for a game or two, perhaps moving between the Leafs and the farm like a yo-yo. Or, as they say in pro hockey, "Here for a cuppa coffee."

Along with photographing the action at the Gardens from 1977 to its closing in 1999, I also shot the Newmarket Saints during their time as the

5

Leafs' affiliate, playing just north of Toronto. I would travel up Highway 400 on Friday nights to see the players trying hard to get a break with the Leafs.

The Saints operated from 1986 until 1991. At first I'd travel to Newmarket on my own, but when my son, David, picked up my camera and wanted to be just like Dad, it turned into a family event. My wife, Jane, daughter, Katie, Dave and I would go up to the rink at the Ray Twinney Complex, a fun Friday for all. I made a few bucks, Dave learned about the art of taking a sharp image in a fast-moving sport, while Jane and Katie just watched the game and enjoyed the hot dogs and popcorn. It was always entertaining hockey because the players weren't holding back in their goal to make the Leafs and the National Hockey League.

There were players who eventually got that chance through hard work, an injury or just plain luck. And many that never did. I watched players like Marty Dallman, Jack Capuano (now coach of the New York Islanders), Jim Ralph (now with Leafs TV and radio broadcasts) and pluggers such as Val James try their best.

It wasn't a long trip from Newmarket to the Gardens, and a replacement could be called up at 5:00 p.m. and be there for that night's game. It's like that today with the Toronto Marlies, who are just a few minutes down the road from the Air Canada Centre at Ricoh Coliseum.

In the franchise's 100-year history, more than 950 players have put on a Toronto sweater. About a third of those did so during my first two decades on the job, 1978 to 1999, when the Leafs moved more players in and out than at any time, before or since. I had exclusive copyright to all the images I'm now sharing with you — 256 players, to be exact. My photo position in the Gardens was one row away from the glass in the south-end golds, and I couldn't get any closer without buying an expensive rail seat. Some years the Leafs did very well and went deep into the playoffs, in others they were out of the race by January.

In a not-so-good-year the Leafs would start calling up players to see if they could help, such as 2015–16. A lot of these guys I'd seen quite a bit, and I often wondered why another player did not get the call. Near the end of a bad season, I focused on the new guys and shot more of them than the regulars. I always thought that the newer guy might stick and that I would need plenty of photos before the season ended. In some cases it would work out; they'd get a

couple of shifts near the end of game. But there was also the chance they'd be gone after that game, never to be in the NHL again.

I talked to one of these "cup of coffee" players and he joked that the Greyhound bus depot must be at the Gardens since every week a new player came in while another seemed to board the bus out of town.

During the late '90s, Dave came to work for me full time after graduating from Loyalist College in Belleville with a degree in photojournalism. Some afternoons he'd go through my old print files of Leafs. The big names were there, but once in a while he'd find photos of a player he'd never heard of. I'd tell him where the player came from and how long he lasted.

Through the years, some of these players would contact me when they found out I had photos of them. They thought that there was no evidence that they'd actually played a game for the Leafs. It meant a great deal for them to show their kids and grandkids that they actually did suit up, even if it was for one of their exhibition games wearing a random number.

I didn't realize how much it meant to the players to have an NHL photo until my nephew Brandon Elliott got a shot with the Tampa Bay Lightning. Drafted in 2004, in the fifth round, 158th overall, he only made it into one pre-season game in Montreal. I was able to get an action photo of him that night from the Montreal team photographer, and we even found his game sweater online, which we purchased. It meant so much to him and the family to have these mementos.

It's nice to watch new Leafs make their first appearance, whether they stick for just one night or enjoy a 10-year career. You always pull for the new guy, hoping he will be the one to help us get the Stanley Cup back.

When I'm taking pictures, I often think what I'd give for that chance to be on the ice as a Leaf. As a junior player in Streetsville, I thought maybe one day even I could make it with *my* Leafs.

So you have to give a lot of credit to the guys who did make it. Even if it was only for a cup of coffee.

GRAIG ABEL
April 2016 | Toronto, ON

The 239 players in this book played between one and 200 games in Toronto. They became Leafs through

- more than 300 trades,
- almost 100 draft picks,
- more than 20 free agent contracts,
- ten waiver claims or compensation awards.

C **RUSS** #16
ADAM
(1982-83)

BORN: May 5, 1961, Windsor, Ontario
DRAFTED: 1980, 7th round, 137th overall
LEAF LINE: 8 GP 1 G 2 A 3 PTS 11 PIM

A graduate of the Kitchener Rangers' '81 Memorial Cup squad, he finished fourth in scoring his final year behind two future NHLers, Brian Bellows and Jeff Larmer. But Adam's string of 20- and 30-goal seasons in junior quickly ebbed as a pro, with 11 goals in his first full year in New Brunswick. He made the Leafs to start the 1982–83 season, but the club's terrible start — with coach Mike Nykoluk griping about fans and reporters putting too much pressure on his youngsters — saw him demoted in November.

Adam's minor-league career, with stops in the IHL and Europe, took him to the Newfoundland senior league where he met future wife, Paula, and was assistant coach of the Leafs' farm team in the early 2000s. His son Luke was born in St. John's and spent time as a forward with the Buffalo Sabres.

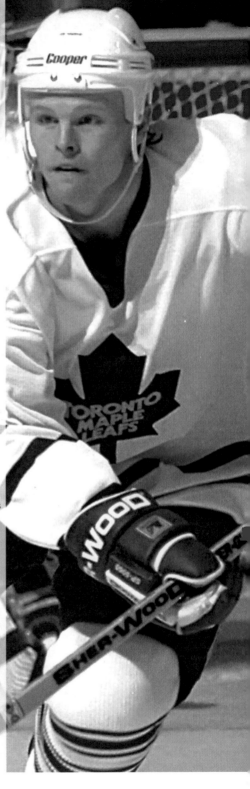

C **KEVYN** #42
ADAMS
(1997–2000)

BORN: October 8, 1974, Washington, D.C.
SIGNED: August 7, 1997, as a free agent
LEAF LINE: 58 GP 5 G 8 A 13 PTS 46 PIM

A well-regarded centre with a knack on the draw, Adams came through Miami University (Ohio), the 23rd overall pick of Boston. He was the second NCAA player chosen after Paul Kariya went 4th to the Ducks. Dedication on the farm led to strong play in 1999–2000, and Adams appeared in all 12 playoff games. But that led to Columbus claiming him in the expansion draft. He played for five other NHL teams and was assistant coach in Buffalo until 2013. His latest job is with Harborcenter Hockey Academy, a training complex next to the Sabres arena.

Adams was raised in Clarence, NY, near Buffalo. So many people came to see him play when the Leafs visited that the clan needed a family friend to donate a private box to defray tickets.

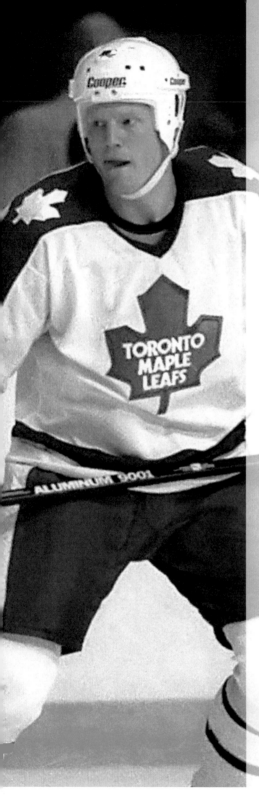

LW **MIKE** #8
ALLISON
(1986–88)

BORN: March 28, 1961, Fort Frances, Ontario
ACQUIRED: August 18, 1986, from the New York
Rangers for Walt Poddubny
LEAF LINE: 86 GP 7 G 19 A 26 PTS 76 PIM

Allison made an impression on the Leafs as a
Ranger rookie, getting a hat-trick against them
in the 1980–81 season opener while playing
with Swedish studs Anders Hedberg and Ulf
Nilsson. That was after the redhead scored on his
first NHL shot, part of a 64-point rookie year.
Slowed by knee injuries, Allison never repeated
his 26-goal campaign that season, but was a solid
two-way toiler as a Leaf.

Between 1975 and 1987, the Leafs lost seven
straight playoff overtimes at the Gardens. The
streak was broken by Allison against the Red
Wings in a post-season game at home — the first
against Detroit since George Armstrong in 1961
and the biggest at home since Bob Pulford in the
'67 final against Montreal.

Allison eventually returned to Fort Frances,
where he taught and worked for Canada Customs.

D **GREG** #25 **ANDRUSAK**
(1999–2000)

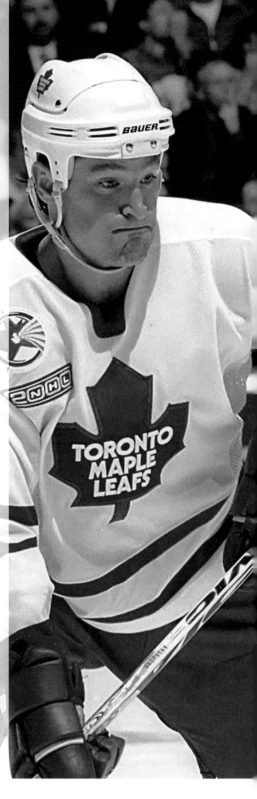

BORN: November 14, 1969, Cranbrook, British Columbia

SIGNED: August 14, 2000, as a free agent

LEAF LINE: 9 GP 0 G 1 A 1 PTS 4 PIM

A promising freshman season at the University of Minnesota-Duluth led to his selection by Pittsburgh, 88th overall in 1988. Andrusak's break with the Leafs came at camp in '99 when both Bryan Berard and Dmitri Yushkevich held out. The Leafs remembered him from the previous spring's playoff series against the Pens. General manager and coach Pat Quinn had plenty of respect for Andrusak, but after Cory Cross was added and the holdouts returned, Andrusak was loaned to the Chicago Wolves (IHL). His only point was during emergency recall, during which he also appeared in three playoff games.

The more noteworthy 1988 draft choice, behind Andrusak at 89th, was Buffalo's flyer on Russian Alexander Mogilny. He'd become an NHL star and wear #89 for the Leafs from 2001–04.

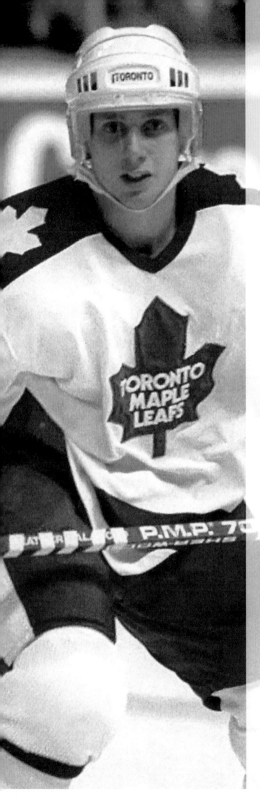

C **TIM** #8
ARMSTRONG
(1988–89)

BORN: May 12, 1967, Toronto, Ontario
DRAFTED: 1985, 11th round, 211th overall
LEAF LINE: 11 GP 1 G 0 A 1 PTS 6 PIM

Armstrong scored more than 60 goals for the Marlies after the Leafs gambled on him late in the draft. He made the most of his unexpected trip to the NHL in a chaotic 1988–89 season for the team before a separated shoulder intervened. His only goal was also his only post-game bow, third star in a 6–1 New Year's Eve win over the Nordiques in 1988. He had 25 goals for the Newmarket Saints the next year, but by then the Leafs had gone in another direction.

Armstrong spent much of his time as a Marlie and a Leaf explaining to folks he was no relation of the great Leaf and junior coach George Armstrong. Tim did have a T.O. hat-trick of sorts, playing for the Leafs and the Marlies and being drafted in his hometown the same day Wendel Clark went 1st overall.

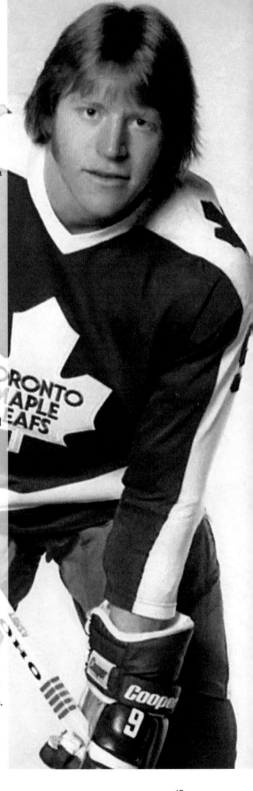

C **DON** #8, #9, #20
ASHBY

(1975–79)

BORN: March 8, 1955, Kamloops, British Columbia
DRAFTED: 1975, 1st round, 6th overall
LEAF LINE: 141 GP 26 G 40 A 66 PTS 34 PIM

Ashby found himself with a great opportunity early in his career. Norm Ullman and Dave Keon departed, leaving some holes at centre behind Darryl Sittler. Within two years, Ashby was knocking on the door of a 20-goal season, but would appear in just 15 games under new coach Roger Neilson. The latter wanted his third-line centre to be a solid checker, and that meant Jimmy Jones ahead of Ashby. Traded with Trevor Johansen to Colorado for Paul Gardner, he played 47 games with the Rockies and the Edmonton Oilers and was consigned to the Central Hockey League's Wichita Wind. A few days after the Wind lost a seventh game final in the '81 league championship, Ashby and wife, Terry, were driving home through the Okanagan Valley, BC, and were struck head-on by a pickup truck. Don died a few hours later at a Kelowna hospital.

In the Oilers' second ever visit to Toronto on March 29, 1980, Edmonton won 8–5, and Ashby took full advantage of playing wing with a fired up Wayne Gretzky, getting a hat-trick and three assists. The late Ashby had an "unsung hero" trophy named in his honour before the CHL folded.

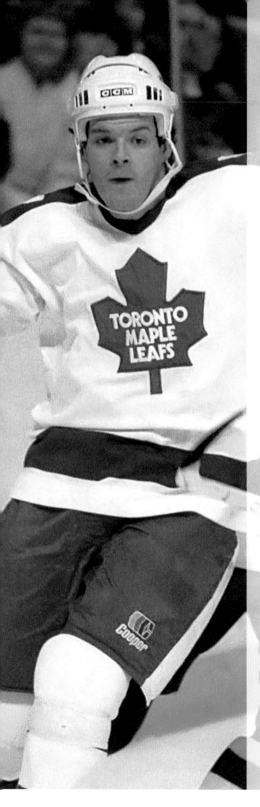

C **NORMAND AUBIN** #24, #35

(1981–83)

BORN: July 26, 1960, St. Leonard, Quebec
DRAFTED: 1979, 3rd round, 51st overall
LEAF LINE: 69 GP 18 G 13 A 31 PTS 30 PIM

Aubin had a very happy new year in 1982, with the Leafs calling him from the Cincinnati Tigers of the ECHL for his first NHL game. He went on to get 14 goals in a half-season. With 288 goals in four years in the Quebec Major Junior Hockey League (regular season and playoffs), including an 8-goal, 11-point game with Verdun, many thought the Leafs were developing their own Beliveau. But speed was always a concern and he was down to four goals in 26 games the next year. He never made it through one calendar year as a Leaf.

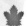

While in the minors with St. Catharines, injuries to both farm team goalies one night led to Aubin volunteering in net. He allowed five goals in 47 minutes. When the Saints lost in seven games to Rochester in the '84 Calder Cup playoffs, Aubin, Bruce Boudreau and Mike Kaszycki were the top line.

RW **PATRIK** #24 **AUGUSTA**
(1993–94)

BORN: November 13, 1969, Jihlava, Czechoslovakia
DRAFTED: 1992, 7th round, 149th overall
LEAF LINE: 2 GP 0 G 0 A 0 PTS 0 PIM

Augusta came to his first camp in 1992, given a slightly better chance of making the team than another Eastern European, the diminutive Nikolai Borschevsky. But coach Pat Burns had a log jam at right wing and Augusta, son of former world championship star Josef Augusta, was only given a two-game trial at New Year's. Augusta eventually went to the west coast with the independent Los Angeles Ice Dogs, then home for a long career as player and manager.

In 1993–94 when Dave Andreychuk became the last Leaf to reach 50 goals, Augusta fired 53 for the St. John's Maple Leafs.

D **REID** #4, #33
BAILEY

(1982–83)

BORN: May 28, 1956, Toronto, Ontario
ACQUIRED: January 15, 1983, from
Edmonton for F Serge Boisvert
LEAF LINE: 1 GP 0 G 0 A 0 PTS 2 PIM

The undrafted Bailey had endeared
himself in the Flyers organization,
thanks to his physical role in a Calder
Cup for the Maine Mariners in 1979–80.
That earned him 27 games between
1980 and '82, but the imminent breakup
of the Broad Street Bullies led him to
the Leafs. He had the distinction of
playing two playoff games that year
to one regular season at a time when
Toronto rarely made post-season
appearances.

Bailey's arrival was quiet compared to
Boisvert's departure as he went public
in tearing a strip off Toronto players
and coaches for the poor results. Bailey
later worked for the Ice Capades for
many years handling their bookings and
promotion.

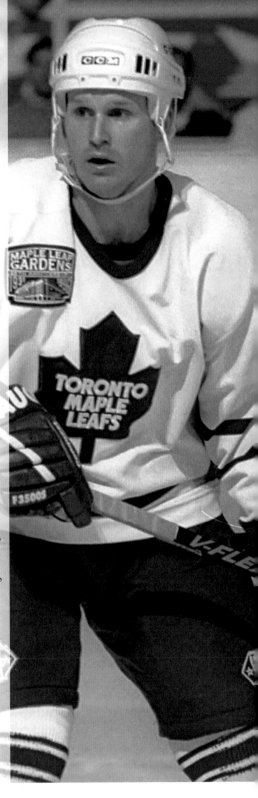

C **JAMIE** #16
BAKER

(1996–98)

BORN: August 31, 1966, Nepean, Ontario
ACQUIRED: June 14, 1996, from San Jose for
D Todd Gill and 5th-round pick C Peter Cava
LEAF LINE: 71 GP 8 G 13 A 21 PTS 38 PIM

Baker replaced the popular Gill in the room but
a slide in team fortunes didn't help his transition,
either. The checker had 16 points in 58 games in
his first season but was cut the next year at camp,
while Gill became captain of the Sharks. With
centres such as Alyn McCauley rising through
the ranks, the Leafs used Baker only sparingly in
1997–98.

Baker continues to work as a colour
commentator for the Sharks and hopes to get
into coaching and hockey school instruction.

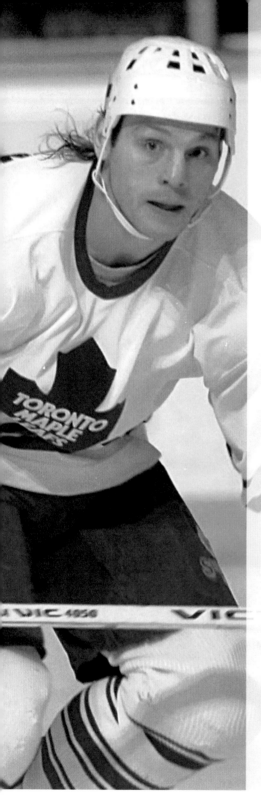

LW **KEN** #8, #22
BAUMGARTNER
(1991–96)

BORN: March 11, 1966, Flin Flon, Manitoba
ACQUIRED: March 10, 1992, from the New York
Islanders with C Dave McLlwain for C Claude
Loiselle and RW Daniel Marois
LEAF LINE: 200 GP 7 G 7 A 14 PTS 520 PIM

Quick fists and a lightning wit summed up The
Bomber, who gave the Leafs plenty of backbone
in the Pat Burns era. He made the jump from
defenceman to forward in the NHL as the 245th
pick overall (Buffalo) in 1985. He enthusiastically
took part in fights, shouting, "Daddy's home!"

A dedicated vice president of the Players'
Association during the first lockout, he suffered
a shoulder injury at the start of the half season
in 1994–95. Baumgartner took business courses
in his playing days and has worked in wealth
management since retiring as an assistant coach
with Boston in the early 2000s.

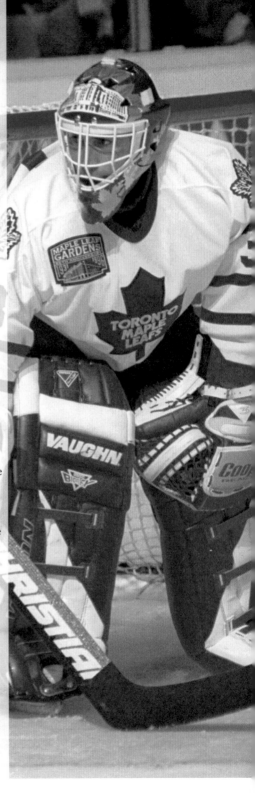

G **DON** #33
BEAUPRE
(1995–97)

BORN: September 19, 1961, Kitchener, Ontario

ACQUIRED: January 23, 1996, from Ottawa with
C Kirk Muller. It was a part of a three-way trade
with Damian Rhodes going to the Sens, and LW
Ken Belanger to the Isles, with Ottawa moving
D Bryan Berard and C Martin Straka to the
Island, and New York sending D Wade Redden
to Ottawa

LEAF LINE: 11 GP O W 8 L O T 4.84 GAA

This would be a tough ending to a great NHL
career as Beaupre joined a Leaf team with its
play in tatters. Beaupre had been a Leaf killer
with Minnesota and Washington, both excellent
defensive teams, and he also had the Senators'
first ever shutout before the trade to Toronto. He
was already looking forward to retirement and
family life back in Minnesota. When demoting
him, GM Cliff Fletcher let him go to Utah of the
IHL rather than St. John's so Beaupre could be a
little closer to his children.

Beaupre was the first Leaf goalie to appear
in at least 10 games and not win any, though
Jonathan Bernier had an 10-game losing streak
in the shootout era in 2014–15. Beaupre was the
first netminder selected in the 1980 draft at 37th,
playing 667 games. Right behind him, the Kings
picked Kelly Hrudey, who played 677.

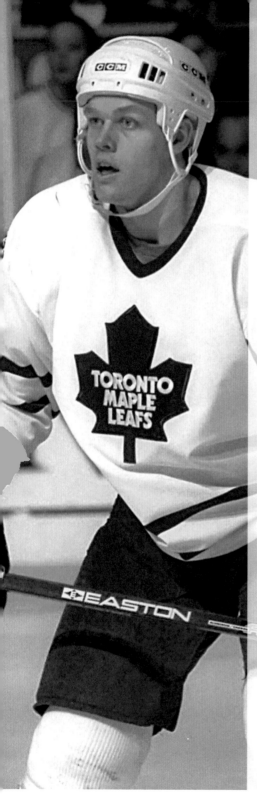

LW **KEN** #43
BELANGER
(1994–95)

BORN: May 14, 1974, Sault Ste. Marie, Ontario
ACQUIRED: March 18, 1994, from Hartford for
9th-round choice RW Matt Ball
LEAF LINE: 3 GP 0 G 0 A 0 PTS 9 PIM

Four scrappy members of the St. John's Leafs
would clear 200 penalty minutes in 1994–95,
but only one would get the call to Toronto in
the shortened NHL season. While Belanger
had a chance after Ken Baumgartner separated
his shoulder, Belanger had his own shoulder
problem at the time and wasn't summoned
until March. By then the Leafs were filling
Baumgartner's role by committee.

Belanger went on to coach youth hockey and is a
member of the Soo's Hall of Fame.

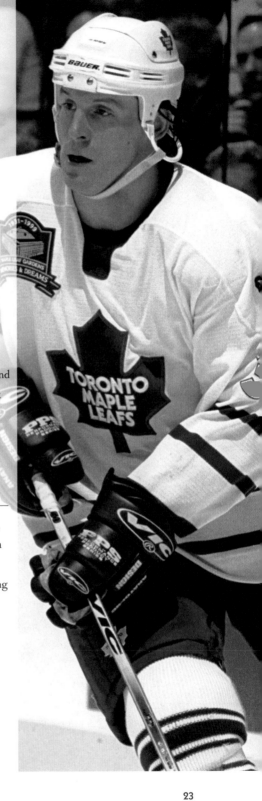

D **BRYAN** #34
BERARD
(1998–2000)

BORN: March 5, 1977, Woonsocket, Rhode Island
ACQUIRED: January 9, 1999, from the New York
Islanders with a 6th-round pick (Jan Sochor),
for G Felix Potvin and a 6th-round pick (traded
to Tampa, who selected Fedor Fedorov)
LEAF LINE: 102 GP 8 G 41 A 49 PTS 64 PIM

One of the most talented — and star-crossed —
of Leafs, he was an absolute express train. But,
when the stick blade of Ottawa's Marian Hossa
detached Berard's right eye in a freak accident
on March 11, 2000, his days as a premier rushing
defender ended.

Though many urged him to quit, Berard
underwent several surgeries to maintain the
minimum required eyesight and stayed in pro
hockey until 2009. He also appeared in CBC's
Battle of the Blades ice dancing competition.

<small>D</small> DRAKE #24, #29, #55
BEREHOWSKY

(1990–95, 2003–04)

BORN: January 3, 1972, Toronto, Ontario

DRAFTED: 1990, 1st round, 10th overall

TRADED: April 7, 1995, to Pittsburgh for D Grant Jennings

RE-ACQUIRED: February 11, 2004, from Pittsburgh for D Ric Jackman

LEAF LINE: GP 133 G 7 A 28 PTS 35 81 PIM

The Leafs finally ceased rushing their first rounders into action when the 1990s rolled around. But Berehowsky wouldn't likely have cracked the blue line of the back-to-back conference finalists between '92 and '94. His best years came late in his career with Edmonton and Nashville and a strong nine-game return to the Leafs some 14 years after being drafted, with 3 points and a plus-5.

In the spirited final regular season game at Chicago Stadium, a game that meant little with the two clubs meeting in the playoffs, Berehowsky had put too much stress on his wonky knee and sat out.

Berehowsky, whose father was a Toronto high school football coach, went behind the bench himself with the ECHL's Orlando Solar Bears and the WHL's Lethbridge Hurricanes, and he is currently associate coach of the OHL's Sudbury Wolves.

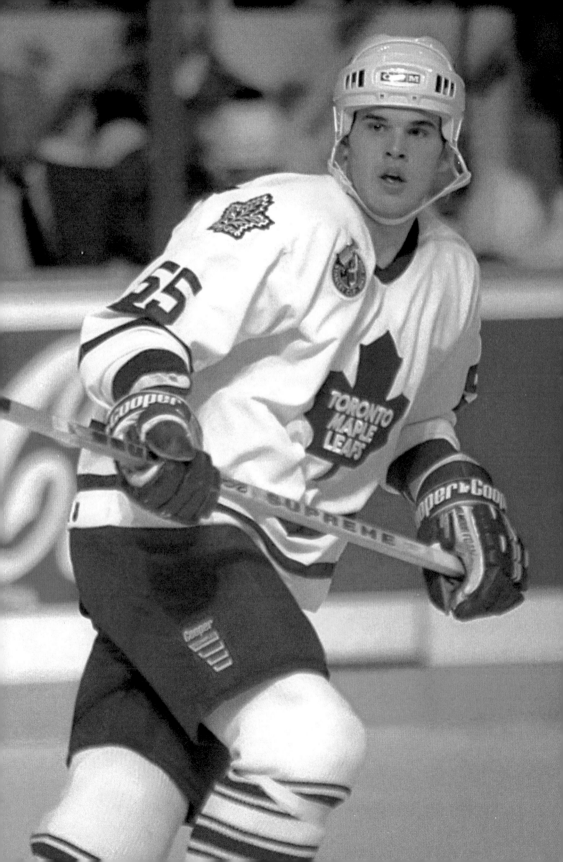

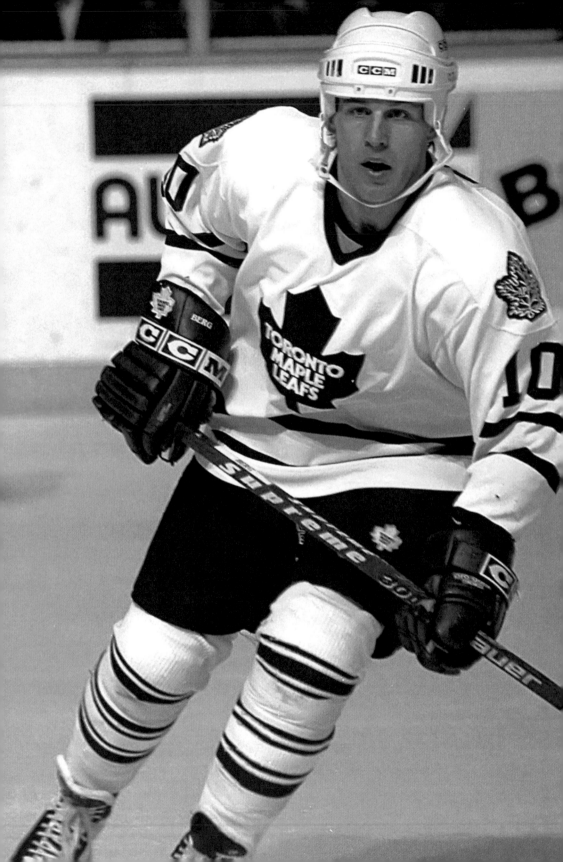

C/W **BILL** #10
BERG

(1992–96)

BORN: October 21, 1967, St. Catharines, Ontario
ACQUIRED: Claimed on waivers from the New York Islanders,
December 3, 1992
LEAF LINE: 196 GP 21 G 21 A 42 PTS 206 PIM

Pat Burns probably regretted saying "I wouldn't know Bill Berg
if I ran over him with my truck." It was his knee-jerk response to
boss Cliff Fletcher's impulsive pick-up of the little-known checking
specialist. But Berg used the quote as motivation as he, Peter Zezel
and Mark Osborne formed one of the most effective lines in recent
Leaf playoff history. Proud to wear George Armstrong's #10, Berg
infuriated opponents with his zeal to finish hits, though he was often
injured in his final two seasons.

Berg parlayed his playing career into work as a TSN analyst.
During his first TV gig, asked to represent the Leafs at the Global
Network's fall launch — the station carried Toronto games — Berg
was nervous at the podium and blurted, "This year we'll go all the
way to the Stanley Cup." A then-unknown star of another new show
noticed Berg's line was a hit and used it a few times himself to get
laughs while promoting his series debut. Berg figured the guy's show
would likely fizzle after a few episodes; but the actor in question was
Matthew Perry, and *Friends* was very successful indeed.

Berg also tried scouting for the Minnesota Wild and coaching
youth hockey in Beamsville, Ontario.

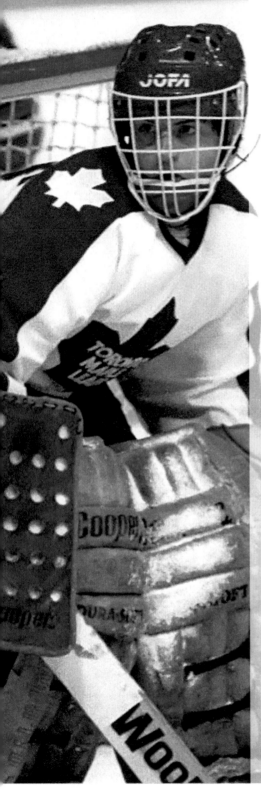

G **TIM** #1
BERNHARDT
(1984–87)

BORN: January 17, 1958, Sarnia, Ontario
SIGNED: December 5, 1984, as a free agent
LEAF LINE: 61 GP 17 W 31 L 7 T 4.26 GAA

The 1985–86 Leafs gave up 386 goals in 80 games, so you know he had it rough. But there were a few rewarding moments for the under-appreciated one-time QMJHL All-Star. Bernhardt was about the fifth goalie in Calgary's system, not likely to get playing time behind Dan Bouchard and Reggie Lemelin. So he signed with Toronto and worked diligently on the farm (almost 200 games with St. Catharines and Newmarket), as well as made the Leaf numbers look a little better in a last-place season. That experience prepared him for a rewarding career in scouting with Dallas, Phoenix and the NHL's Central Bureau.

Asked about life with the Leafs for a *Toronto Sun* article in 2009, Bernhardt said, "We didn't have a great team, but I loved the buzz of a Saturday morning skate with all the *Hockey Night in Canada* people at the Gardens. What I learned [for his later scouting jobs] was not to rush players, not to slight anyone and be careful who you trade. [. . .] I have to thank Jim Gregory and Frank Bonello (architects of great Leafs and Marlies teams) for my start at NHL Central Scouting. I'm sure they had a soft spot for me because I was a Leaf."

LW **CRAIG** #16 **BERUBE**

(1991–92)

BORN: December 17, 1965, Calahoo, Alberta

ACQUIRED: September 19, 1991, with G Grant Fuhr and RW Glenn Anderson from Edmonton for C Vince Damphousse, LW Scott Thornton, D Luke Richardson and G Peter Ing

LEAF LINE: 40 GP 5 G 7 A 12 PTS 109 PIM

In his first big move to reshape the Leafs, Cliff Fletcher needed some muscle to ease pressure on Wendel Clark and to complement both Anderson's offence and Fuhr's clutch netminding.

Berube did prove handy with his dukes and opened up some room for young linemates, such as Rob Pearson. But his good efforts made him part of an even bigger Fletcher blockbuster four months later, going back to his home province in the 10-player swap for Doug Gilmour.

Berube went over the 1,000 NHL penalty-minute mark as a Leaf. "I took a lot of beatings in junior hockey. That's how I learned to fight." Fittingly, he wound up as coach of the Flyers for a while, which was his first NHL team. Berube is one of the first NHL coaches of First Nations heritage.

LW **FRANK** #36 **BIALOWAS**
(1993–94)

BORN: September 25, 1970, Winnipeg, Manitoba
SIGNED: March 20, 1994, as a free agent
LEAF LINE: 3 GP 0 G 0 A 0 PTS 12 PIM

What can you say about The Animal?
Discovered by St. John's farm team coach Marc
Crawford as he pounded his way through the
East Coast League, he became an instant fan
favourite on The Rock. When Ken Baumgartner
hurt his thumb and the Leafs were roughed
up and on a three-game winless streak, he was
called up on the promise he wouldn't become a
sideshow. With his Tasmanian Devil tattoo, and
his title as runner-up in the Mr. Manitoba body
building contest, Bialowas did throw a scare into
opponents. The Leafs had a record of 2–0–1 in
his three games.

Bialowas had thrown out his hockey equipment
at one point before reviving his career in St.
John's. After the Leafs released him in '95, he
went on to become even more popular with the
AHL's Philadelphia Phantoms, whom he helped
to a Calder Cup in '98.

RW **MIKE** #22
BLAISDELL
(1987–89)

BORN: January 18, 1960, Moose Jaw,
Saskatchewan
SIGNED: July 10, 1987, as a free agent
LEAF LINE: 27 GP 4 G 2 A 6 PTS 6 PIM

In 1986, Blaisdell had been a 15-goal and plus-
15 player in Pittsburgh, so there were high
hopes he could boost Toronto's offence. But a
combination of injuries and better play from
home-grown Leafs kept Blaisdell near the farm,
where he did snipe 40 goals for Newmarket in
two seasons. More scoring exploits would follow
for the Canadian national team, and in the British
League where he eventually coached.

Blaisdell credited his excellent minor league
tutelage to the Adirondack Red Wings — a 1981
Calder Cup winning team with Peter Mahovlich,
Greg Joly and Denis Polonich. He was linked to
a very unpopular trade by Leaf GM Jim Gregory
back in 1978. When Toronto gave up skilled
winger Errol Thompson and a package of high
drafts for tough winger Dan Maloney, one was a
1980 first rounder, which became Blaisdell.

RW **LONNY** #16
BOHONOS

(1997–99)

BORN: May 20, 1973, Winnipeg, Manitoba
ACQUIRED: March 7, 1998, from
Vancouver for C Brandon Convery
LEAF LINE: 13 GP 6 G 3 A 9 PTS 8 PIM

Bohonos had 10 points in six games after the Leafs and Canucks exchange, earning a call-up at a time Toronto lacked offensive punch. Bohonos did have a productive period as well as defensive lapses. Associate GM Mike Smith was not as sold on Bohonos as some fans and media and cut him on the eve of the 1998–99 season. Bohonos kept lighting it up on the farm to earn another shot, getting 9 points in as many playoff games in the club's long run that spring.

Despite 41 points in 61 NHL games with the Leafs and Canucks, Bohonos never played another NHL game after the '99 playoffs. He went on to five more 20-goal seasons in the Swiss League and the AHL.

D **FRED** #11
BOIMISTRUCK
(1981–83)

BORN: November 4, 1962, Sudbury, Ontario

DRAFTED: 1980, 3rd round, 43rd overall

LEAF LINE: 83 GP 4 G 14 A 18 PTS 45 PIM

He's long been considered the poster boy for the Leafs rushing young players, especially defencemen, into a poor team dynamic in the early '80s. What's often not written about is his solid first season, a plus-nine in 57 games with a weak team. But he was decked in a one-punch fight, which seemed to rattle his confidence, and was sidelined for the season by a hard hit in a game against Montreal in March.

Boimistruck looked back on the experience this way in discussion with the *Toronto Sun*:

Like any other junior, I realized a dream of playing in the NHL in my first year. But I found myself on a losing club and my confidence level went down with it. I found the game changed for me and the fun got sucked out of it. That I was given such an opportunity was unbelievable, yet there is some bitterness that goes with the way things turned out.

Boimistruck was out of the game by age 23 in the mid-80s, but helped coach the Belleville Bulls in the '90s. He pursued a love of trains and is now a VIA Rail engineer working routes around Ontario.

RW **SERGE** #12, #33
BOISVERT
(1982–83)

BORN: June 1, 1959, Drummondville, Quebec
SIGNED: October 9, 1980, as a free agent
LEAF LINE: 17 GP 0 G 2 A 2 PTS 4 PIM

The first Leaf to see time in the Japanese league (49 points in 30 games for Sapporo in 1981–82), he made it into opening night of the 1982–83 NHL season. Roughed up in Chicago that evening he was a minus-10 in his Leaf career and lashed out at coach Mike Nykoluk upon being demoted. He was eventually packed off to Edmonton for Reid Bailey, but that was not the end for Boisvert, who hooked up with his home province Habs and put his name on the '86 Stanley Cup.

Titles seemed to follow Boisvert everywhere but Toronto. Before winning the Stanley Cup he played in the minors for Sherbrooke, which captured the Calder Cup in '85. Turning to coaching in Norway, he won the 2005 league championship with Frisk. He's now part of the Canadiens' amateur scouting staff.

RW **NIKOLAI** #16
BORSCHEVSKY
(1992–95)

BORN: January 12, 1965, Tomsk, USSR
DRAFTED: 1992, 4th round, 77th overall
LEAF LINE: 142 GP 48 G 65 A 113 PTS 38 PIM

Nik the Stick got enough of his banana blade on a Bob Rouse shot to send Leafs Nation into playoff ecstasy on May 1, 1993. The overtime goal against Detroit ended 15 years of playoff frustration in Toronto, but it was not his only shining moment. The plucky Siberian was popular with teammates and fans alike. He came back from a ruptured spleen, and, though the Leafs traded him to Calgary, Borschevsky ultimately returned to the GTA to operate a hockey school.

While many pet owners in Toronto named their critters Killer and Cujo in homage to Leafs Doug Gilmour and Curtis Joseph, Canadian actor and passionate Leaf fan Mike Myers christened his dog Borschevsky.

LAURIE #12
BOSCHMAN
(1979–82)

BORN: June 4, 1960, Major, Saskatchewan
DRAFTED: 1979, 1st round, 9th overall
LEAF LINE: 187 GP 39 G 70 A 109 PTS 409 PIM

As his penalty total suggests — especially in his rookie year of 1979–80, when he was one of team's off-ice hellraisers — Boschman was no shrinking violet. But he was profoundly disturbed by Harold Ballard publicly mocking his born-again Christian beliefs.

Boschman was being counted on to help the Leafs take the next step after the '78 Cup semifinal, but by the '82 trade deadline he was moved to Edmonton for forwards Walt Poddubny and Marlie junior Phil Drouillard. Boschman was appreciated more elsewhere, as part of a strong Winnipeg Jets team and later as the first captain of the expansion Ottawa Senators.

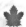

Fred Boimistruck recalled being on a Leaf charter flight that developed an engine fire during landing and seeing Boschman quietly clutching his bible as the plane came down between fire trucks on each side of the runway. Boschman continues to promote the role of Christianity in hockey.

C BRUCE #11, #12, #17, #19, #28, #35
BOUDREAU

(1976–82)

BORN: January 9, 1955, Toronto, Ontario

DRAFTED: 1975, 3rd round, 42nd overall

LEAF LINE: 134 GP 27 G 42 A 69 PTS 44 PIM

It amazes folks that Bruce "Gabby" Boudreau has not re-joined the Leafs in some capacity, given that he is from Toronto and spent 12 years around the Gardens scene as a Marlie, Leaf and farmhand. He lost count of how many times he moved back and forth from the Leafs, but one assignment was in the '77 playoffs when coach Red Kelly used an undersized trio of Boudreau, Paul Evans and Bob Warner as an energy line against the Broad Street Bullies. Small yet talented, he filled a variety of roles after getting 165 points for the last Marlie squad to win the Memorial Cup. He remained coach George Armstrong's favourite junior pupil.

To date, his successful coaching career has been with other clubs, most recently the Minnesota Wild.

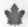

In six seasons in the NHL, he never played the full schedule, though in 1977–78 he had 29 points in 40 games. As Leaf property, he was a teammate of Randy Carlyle and Ron Wilson. The three coaches can now joke about Boudreau bumping Carlyle in Anaheim and Carlyle coming full circle to replace Boudreau with the Ducks.

C **BRIAN** #44
BRADLEY

(1990—92)

BORN: January 21, 1965, Kitchener, Ontario
ACQUIRED: January 12, 1991, from Vancouver for
D Tom Kurvers
LEAF LINE: 85 GP 10 G 32 A 42 PTS 68 PIM

Bradley had some early success with two
100-point seasons in the OHL (London), a
world junior title with Canada in 1985 and some
success with Trevor Linden in Vancouver. So
expectations were high when Toronto unloaded
the unpopular Tom Kurvers for some offensive
help. But Bradley seemed uncomfortable in the
spotlight and never seemed to mesh with coach
Tom Watt. It was in Tampa Bay that he'd later
excel as a scorer, with a 42-goal year.

The Leafs lost two unprotected players to the
Lightning in the '92 expansion draft, Bradley and
forward Keith Osborne. Not long after leaving
the Leafs, he was in the NHL All-Star Game and
named an assistant captain.

LW **AARON BROTEN** #21

(1990–91)

BORN: November 14, 1960, Roseau, Minnesota

ACQUIRED: November 17, 1990, with
D Michel Petit and LW Lucien DeBlois from
Quebec for LW Scott Pearson and two 2nd-
round draft picks. One was traded to Washington
by Quebec, with the Caps choosing D Eric
Lavigne, while Quebec took Finnish defender
Tuomas Gronman in '92

LEAF LINE: 27 GP 6 G 4 A 10 PTS 32 PIM

A strange swap in which Leafs gave up youth in
Pearson and draft picks but did little to improve
themselves with the mucker Broten. Aaron was
one of three NHL brothers with Neal, the star,
and Paul, who was closer to Aaron's level. Two
of Aaron's Leafs goals were in a big road win in
New York soon after the deal.

Angry at being cut at camp in '91, Broten refused
to report to the Leafs' new farm team in St.
John's. His contract was bought out, but he was
able to work his way briefly back to the NHL
with Winnipeg. The brothers Broten reunited in
'99 to play for an inexperienced U.S. side at the
World Championship to help their country avoid
relegation.

D JEFF #33
BROWN
(1997–98)

BORN: April 30, 1966, Ottawa, Ontario
ACQUIRED: January 2, 1998, from Carolina
for a 4th-round pick (Evgeny Pavlov)
LEAF LINE: 19 GP 1 G 8 A 9 PTS 10 PIM

When the Leaf power play went 0-for-58 in December of 1997,
associate GM Mike Smith made his first trade since taking office
almost five months earlier. Brown, a special teams expert who'd hurt
Toronto in the '94 conference final with Vancouver, came aboard.
He missed time with a freak leg infection from lace bite, and Smith
dithered about re-signing him (which would have pushed Carolina's
draft pick a round higher). Eventually, Smith made Brown a deadline
trade for Caps' defenceman Sylvain Côté.

Brown had warned the Leafs to make some positive changes or he would
not re-sign in 1998–99. "Ultimately, I want to win the Cup," he said.
"If it's not going to happen in Toronto, I would love the opportunity to
go some place else. It has nothing to do with Toronto, the city, the people.
I want to be on a winner. I've played 13 years and made the finals once.
I'd love that opportunity again."

The Leafs had a shot at Brown in the 1984 draft, but took another
Ottawa area product, Todd Gill, 11 picks earlier at 25th. Jeff's son
Logan, a 6-foot-6 centre, was a first-round pick of Ottawa in 2016.

LW **JEFF** #23
BRUBAKER

(1984–86)

BORN: February 24, 1958, Hagerstown, Maryland
ACQUIRED: December 5, 1985, on waivers from
Edmonton
LEAF LINE: 89 GP 8 G 4 A 12 PTS 276 PIM

By the time Brew made it to the Leafs, he'd
played high school, junior, NCAA, WHA, AHL
and Central League Hockey, as well as two
NHL stops. He managed 12 points his first year
when not roughing up opponents to the tune of
209 penalty minutes in 68 games. But when he
produced zilch in 21 starts in 1985–86, he was
re-claimed by the Oil.

While a coach of the ECHL Greensboro team,
Brubaker's Monarchs engaged in a memorable
1994 brawl with ex-Leaf John Brophy's Norfolk
Admirals. Angry that Brophy questioned his
club's toughness in a newspaper article, Brubaker
pinned the story up before a return road game
nine days later. Just two seconds into the game,
almost 300 penalty minutes resulted.

c MIKE #22 BULLARD

(1991–92)

BORN: March 10, 1961, Ottawa, Ontario
ACQUIRED: July 29, 1991, from
Philadelphia for a 3rd-round pick
(Václav Prospal)
LEAF LINE: 65 GP 14 G 14 A 28 PTS 42 PIM

New GM Cliff Fletcher had Bullard for
two years in Calgary, one of them a 48-
goal campaign, and hoped the 30-year-
old still had a spark. He managed 14
goals but had clearly lost a step. When
the Sens and Lightning didn't bite in the
expansion draft, he went to Germany
and played another decade.

While in Calgary, Bullard was part of a
seven-player Fletcher deal that brought
Doug Gilmour to the Flames and sent
Bullard to the Blues.

D**DAVE** #26
BURROWS
(1978–81)

BORN: January 11, 1949, Toronto, Ontario
ACQUIRED: June 14, 1978, from Pittsburgh for D Randy Carlyle
and C George Ferguson
LEAF LINE: 151 GP 5 G 27 A 32 PTS 72 PIM

Had the Leafs gone one step further in the playoffs after securing
Burrows, perhaps this trade wouldn't have been so harshly judged
by fans. But GM Jim Gregory and Roger Neilson heard it for years
that they gave up on young future Norris Trophy–winner Carlyle.
Burrows, more defensive-minded than Carlyle, gave it his best shot
but was homesick for the Pens after a couple of years.

He was returned in a deal with Paul Gardner for Paul Marshall
and Kim Davis, all forwards. The trade was made by Gregory's
replacement, Punch Imlach, who really just wanted two one-way
contracts off the books. With no real idea who he wanted in return,
Imlach asked Pittsburgh counterpart Baz Bastien, who gave him a
list of five names. The "pro scouting" on this deal turned out to
be Imlach taking home the Pittsburgh media guide and choosing
Marshall and Davis.

As a kid growing up in Toronto, Burrows worshipped Tim Horton.
Upon joining Pittsburgh the first time, he was partnered with the
40-something Horton on the blue line.

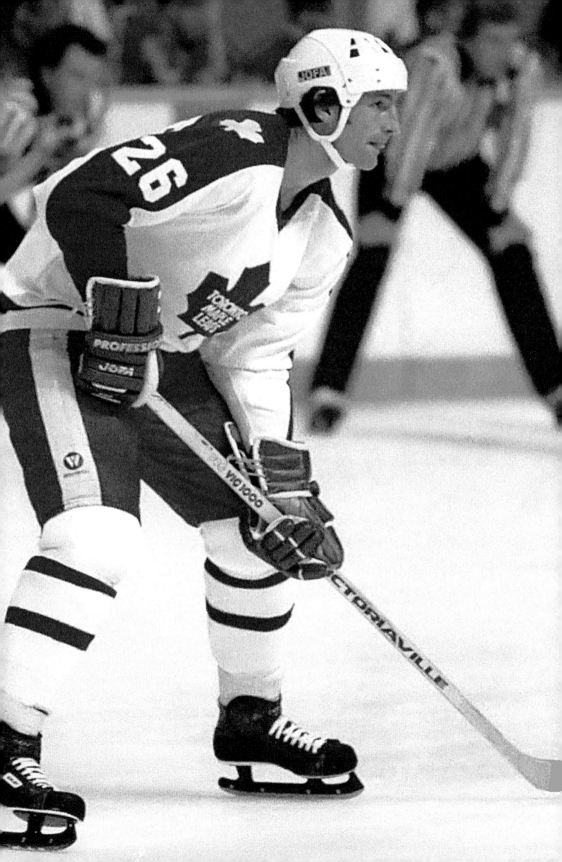

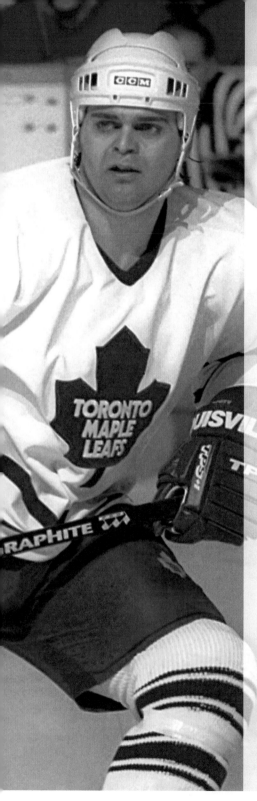

D **GARTH** #2
BUTCHER
(1994–95)

BORN: January 8, 1963, Regina, Saskatchewan

ACQUIRED: June 28, 1994, from Quebec with
C Mats Sundin, RW Todd Warriner and a 1st-
round pick (transferred to Washington, which
selected D Nolan Baumgartner) for D Sylvain
Lefebvre, F Landon Wilson, LW Wendel Clark
and a 1st-round pick (D Jeff Kealty)

LEAF LINE: 45 GP 1 G 7 A 8 PTS 59 PIM

The strong Leafs defence from the '93 and '94
teams had begun to thin by the lockout year, and the
price of getting Sundin meant the loss of the stay-
at-home Lefebvre. Butcher had the same strong
tendencies, but the Leafs had lost some bite and
were a 1st-round playoff casualty. So was Butcher,
who was released at age 32 and did not play again.

Butcher played a small role in Gord Stellick
becoming sole GM of the Leafs after splitting the
executive duties with John Brophy and Dick Duff.
Before the Leafs acquired John Kordic for Russ
Courtnall, a swap of Courtnall for Butcher was
discussed with Vancouver's Pat Quinn. Angry
that the Butcher-to-Toronto talks had been leaked,
Quinn told Stellick during a chance meeting
while scouting a WHL game (Mike Modano
against Trevor Linden) that he'd complained to
the league. Such loose talk created by the three-
headed management team moved Harold Ballard
to pick Stellick who joked later, "I only wish I'd
traded Courtnall for someone like Garth Butcher."

D **JACK** #42
CAPUANO

(1989–90)

BORN: July 7, 1966, Cranston, Rhode Island
DRAFTED: 1984, 5th round, 88th overall
LEAF LINE: 1 GP 0 G 0 A 0 PTS 0 PIM

Capuano confessed to having the butterflies his
first game, though it must have been catching
in a dreadful 7–1 loss to Buffalo on October 11,
his only NHL start. "I remember the first goal,
I was scored on by Mike Foligno," Capuano
said. "Obviously, I would have liked to have
played more NHL games [he was in a total
of six, counting brief stops in Vancouver and
Boston], but Toronto was a great hockey town. I
remember vividly the good times in Toronto and
Newmarket, with [goalie-turned-broadcaster]
Jimmy Ralph and all the rest of the boys. I made
some great friends."

Back in Newmarket, Capuano carried on his
productive 1988–89 season from the University
of Maine. He was eventually packaged to the Isles
with forwards Paul Gagné and Derek Laxdal for
forwards Gilles Thibaudeau and Mike Stevens.

Capuano replaced Scott Gordon as Isles' head
coach in 2011, with Gordon coming to Toronto
as Ron Wilson's assistant. Jack's younger brother
Dave was a 2nd-round pick of the Canucks.

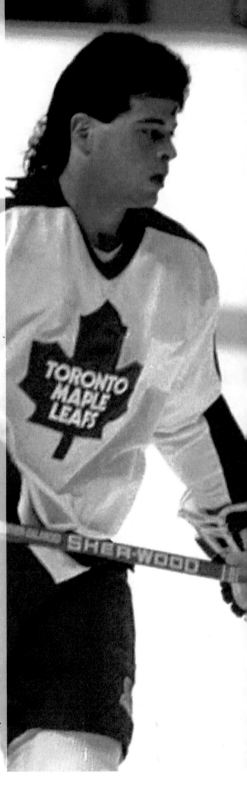

D **RANDY** #23, #28 **CARLYLE**

(1976–78)

BORN: April 19, 1956, Sudbury, Ontario
DRAFTED: 1976, 2nd round, 30th overall
LEAF LINE: 94 GP 2 G 16 A 18 PTS 82 PIM

There is great irony in Carlyle taking a job that the late Roger Neilson once had and lecturing young defencemen such as Jake Gardiner not to be so flashy with the puck. Back in the late '70s when Neilson coached the Leafs, he was hard on rookie Carlyle, who had the same puck-possession urge. "Roger was always on [Carlyle's] ass; he didn't like him at all," said former teammate Jim McKenny. "Roger would give him hell about going with the puck."

Carlyle would come to appreciate Neilson's approach, but that was after a controversial '78 trade to Pittsburgh for defenceman Dave Burrows. It's said that the last straw for Neilson was Carlyle injuring his leg in a golf cart accident in Florida during a road trip, though Borje Salming was culpable. The mishap ended a five-year team tradition of vacationing in the Sunshine State prior to the arrival of the Lightning and Panthers.

In Pittsburgh, Carlyle was part of a power play that featured five ex-Leafs: himself, Greg Hotham, Paul Gardner, Pat Boutette and Rick Kehoe. Carlyle's 1981 Norris Trophy put him in company with Bernie Parent (Vezina and Conn Smythe winner) and Doug Jarvis (Frank J. Selke winner) — players who've won individual NHL awards after being traded away by the Leafs.

RW **KELLY** #39
CHASE

(1996–97)

BORN: October 25, 1967, Porcupine Plain, Saskatchewan
ACQUIRED: March 18, 1997, from Hartford
for an 8th-round pick (RW Jaroslav Svoboda)
LEAF LINE: 2 GP 0 G 0 A 0 PTS 27 PIM

There was some question about a knee injury the veteran scrapper
Chase brought with him from Hartford, so he answered with two
fights in his first game. He had been brought in to take some of the
pressure off team policeman Tie Domi. The long-time Blue was
traded back to St. Louis the following September.

Chase and Wendel Clark both played minor hockey in rural
Saskatchewan. In the provincial amateur playoffs, Porcupine Plain
met Clark's Kelvington, and Clark showed up wearing the fad of the
day, a European bubble-type helmet. "A lot of our guys laughed at
him," Chase recalled. Clark didn't respond, then went out and scored
11 goals in a 13–2 win.

Teammates still chuckle about the time Chase asked Clark to
"keep an eye" on a girl he was dating who was moving to Toronto.
Clark helped show her around town, but he introduced her to Russ
Courtnall whom she dated awhile, leaving Chase in the cold.

After his father died, Chase became a close companion of Clark
and his brothers, Donny and Kerry, and father, Les, who managed the
Kelvington rink. Chase also worked at the Clarks' grain farm.

LW **ROB** #14, #34
CIMETTA
(1990—92)

BORN: February 15, 1970, Toronto, Ontario
ACQUIRED: November 9, 1990, from Boston for
D Steve Bancroft
LEAF LINE: 49 GP 6 G 7 A 13 PTS 33 PIM

The former Marlie junior was the 18th pick
overall in the '88 draft and seen as a perfect Bruin
prospect. He did have 19 points in his first 54
games, but defying a Bruin demotion angered
coach Mike Milbury. He was ecstatic to be moved
home to the Leafs, but his NHL adjustment
problems persisted. After a year on the farm, he
tried his luck in Germany for a few seasons.

Pictures of Cimetta in both the Marlies
and Leafs uniforms hung prominently at his
neighbourhood chippy, Black Cat Fish & Chips
on Avenue Road.

Cimetta was job training at Morgan Stanley in
the World Trade Center on 9/11 when the South
Tower's alarm sounded. Cimetta joined evacuees
on the long stair climb down, passing New
York firefighters headed the other way to their
ultimate doom. He made it out about 10 minutes
before his building collapsed.

C **BRANDON** #12 **CONVERY**

(1995–97)

BORN: February 4, 1974, Kingston, Ontario

DRAFTED: 1992, 1st round, 8th overall

LEAF LINE: 50 GP 7 G 10 A 17 PTS 24 PIM

This was a rarity for Cliff Fletcher, a top 10 pick he held on to. And there was a lot to like when Convery posted back-to-back 40-goal seasons in the OHL. But the veteran-laden Leafs had no room, even when he'd achieved 100 points during two seasons in St. John's. Convery was traded to Vancouver for Lonny Bohonos, a less-heralded player who did fill the net. He played 22 more NHL games with the Canucks and Kings before going to Europe.

One pick before Convery, the Flyers took former captain Darryl Sittler's son Ryan. Though Ryan's NHL career was cut short by injuries, he did also wear the Leaf crest briefly with St. John's in 1995–96 (Darryl had played for both NHL teams), scoring once in six games.

D DAVID COOPER #33, #42

(1996—98, 2000—01)

BORN: November 2, 1973, Ottawa, Ontario
SIGNED: September 18, 1996, as a free agent and
again on October 5, 2000
LEAF LINE: 30 GP 3 G 7 A 10 PTS 24 PIM

Cooper was a great passer, but he had some
defensive drawbacks and didn't leverage his
size often enough. Yet the Leafs were convinced
they could turn Buffalo's 11th overall pick from
the '92 draft into an NHLer. When he couldn't
last with Toronto, he bounced around other
organizations, with the Leafs giving him one
more try in 2000. That was another rollercoaster
season in which he played just twice, sometimes
coming all the way in from St. John's to sit in the
press box and then fly back.

Cooper was one of the first Canadians to play
in Russia prior to the founding of the KHL.
He appeared in 10 games for St. Petersburg in
2002—03, between stints in Germany and Italy.

C **RICH** #8, #16
COSTELLO

(1983–84, 1985–86)

BORN: June 27, 1963, Farmington,
Massachussetts

ACQUIRED: January 20, 1982, from Philadelphia
with a 2nd-round pick (F Peter Ihnačák) and
future considerations (LW Ken Strong) for C
Darryl Sittler

LEAF LINE: 12 GP 2 G 2 A 4 PTS 2 PIM

The trade saga involving disgruntled Leafs
captain Sittler had dragged on two years so
fans were naturally hoping for a good return.
But they had to wait for Ihnačák to develop,
as Costello's best numbers were in a 40-point
season on the farm in 1985–86.

The 1984 U.S. Olympic hockey team had a home
base at the Met Center, also the home of the
Minnesota North Stars, who hosted the Leafs
on November 21, 1983. With Leafs property
Costello way down on the Yanks' depth chart for
Sarajevo, Toronto turned up the heat on Costello
to turn pro that day, sign a contract and be in
the lineup that night. Costello's advisor that day
was Providence College coach and future Leaf
boss Lou Lamoriello, who helped his former
student reach an agreement with Leafs GM Gerry
McNamara. The Leafs, who lost 7–1, later took
Ed Olczyk and Al Iafrate off that same U.S. team.

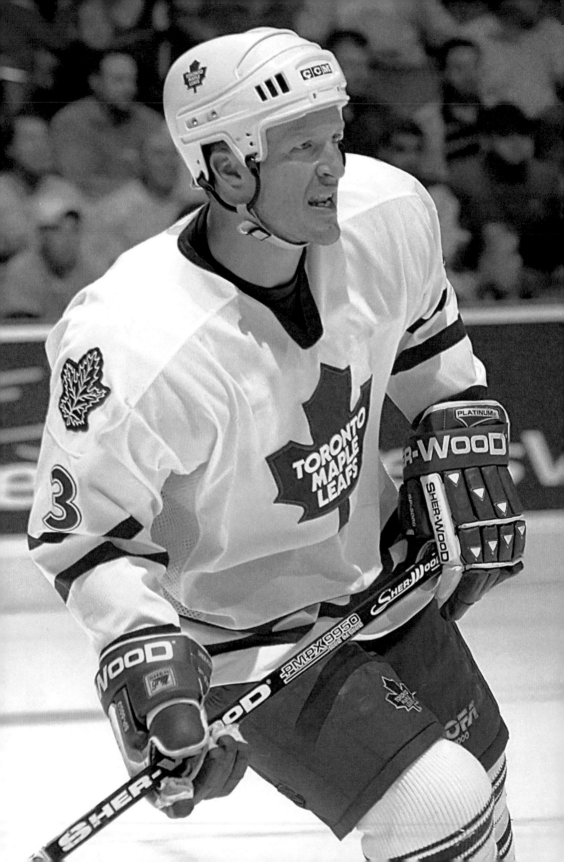

D **SYLVAIN** #3
CÔTÉ
(1997–2000)

BORN: January 19, 1966, Quebec City, Quebec
ACQUIRED: March 24, 1998, from Washington for D Jeff Brown
LEAF LINE: 94 GP 8 G 31 A 39 PTS 34 PIM

When associate GM Mike Smith and Brown were at loggerheads over
a new contract, Smith ended the dispute by acquiring Côté. Where
Brown had questioned the Leafs' ability to build a winner, the veteran
Côté became part of a team that made the '99 Eastern Conference final.

Côté was in the starting five for the opening faceoff at the Air Canada
Centre on February 20, 1999. But he didn't last the calendar year as
new GM Pat Quinn dealt him to Chicago for a draft pick that became
defenceman Karel Pilar.

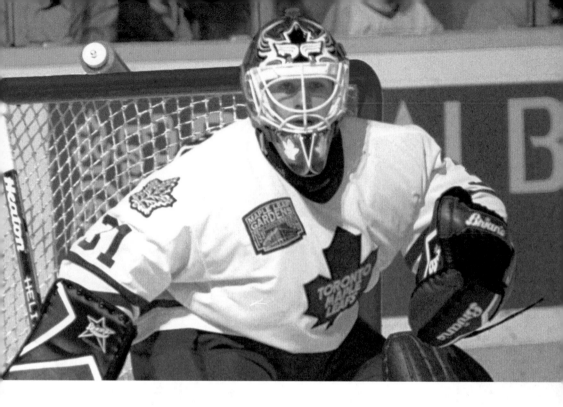

G **MARCEL** #31 **COUSINEAU**

(1996–98)

BORN: April 30, 1973, Delson, Quebec
SIGNED: November 13, 1993,
as a free agent
LEAF LINE: 15 GP 3 W 5 L 1 T 3.19 GAA

Cousineau relieved Felix Potvin during a forgettable loss to the Sabres on November 21, 1996, and a few days later beat the Canucks for his first NHL win. With Potvin and veteran back-up Don Beaupre in a funk, Cousineau ended the 1996 calendar year with a 2–0 shutout of the Isles and a short run as No. 1.

Cousineau shared the shutout in what could be the last ever 0–0 tie for the Leafs. Flown cross-continent to back up Glenn Healy in San Jose November 4, 1997 — so Potvin could travel ahead to Calgary — Cousineau was thrown in for the final frantic moments after Shark Bernie Nicholls sliced Healy's hand with his skate blade. Cousineau survived overtime for his second shared shutout as a Leaf, having helped Potvin in a win over St. Louis the year before.

RW **MIKE** #9
CRAIG
(1994–97)

BORN: June 6, 1971, St. Marys, Ontario
SIGNED: July 29, 1994, as a free agent
LEAF LINE: 172 GP 20 G 30 A 50 PTS 116 PIM

The Leafs and Minnesota North Stars (later
Dallas) tried their best to get more offence out
of the prolific junior with varying success.
Craig teased the Leafs a couple of seasons with
impressive starts at training camp, but he never
hit 10 goals, despite some good linemates. Craig
did play in Europe into his early 40s.

In a rare ruling, the NHL awarded centre Peter
Zezel and young winger Grant Marshall to
Dallas as compensation for Craig's signing.
Zezel's loss was particularly hard for the Leafs,
though it was expected he'd be sacrificed in the
arbitrator's decision. The Leafs feared losing
defenceman Kenny Jönsson, whom the Stars had
also asked for. Marshall did get his name on the
'99 Cup with Dallas.

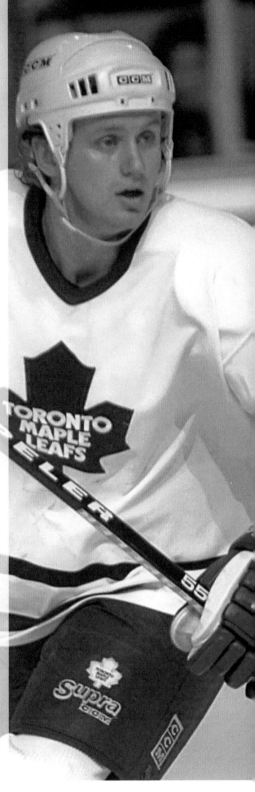

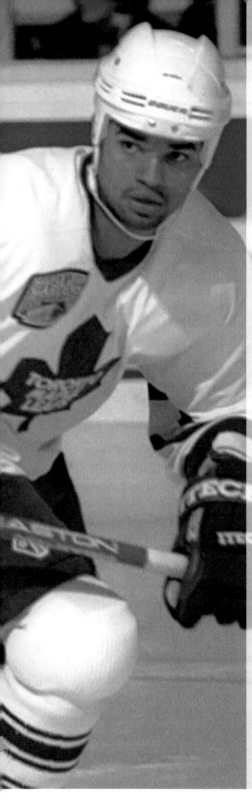

RW **JOHN** #44
CRAIGHEAD
(1996–97)

BORN: November 23, 1971, Vancouver, British
Columbia (also listed as Richmond, Virginia)
SIGNED: July 6, 1996, as a free agent
LEAF LINE: 5 GP 0 G 0 A 0 PTS 10 PIM

By the time he was called to the Leafs to replace
the injured Nick Kypreos, Craighead had fought
in six straight games in St. John's. He took on
Bob Boughner in his first NHL scrap, eventually
returning to rack up a career high 318 penalty
minutes in the AHL.

Craighead's unlikely road to the NHL was a
great story. On the last day of his Tier II career
in B.C., where he played against future stars such
as Paul Kariya, a scout from Louisville of the
ECHL threw him a lifeline. Though he was cut
after two and a half months, he played for $175
a week in the Florida Sunshine Hockey League
and slowly came back up the ranks with the good
fortune to be coached by NHLers Bill Nyrop,
Rick Dudley and Bob "Battleship" Kelly.

G **JIRI** #31
CRHA
(1979–81)

BORN: April 13, 1950, Pardubice, Czechoslovakia
SIGNED: February 4, 1980, as a free agent
LEAF LINE: 69 GP 28 W 27 L 11 T 4.07 GAA

With Eastern Bloc countries still a grey area, the
Leafs talked the much-decorated national team
goalie into defecting in the summer of '79. But it
took haggling with officials in his homeland and
injuries to Mike Palmateer, Curt Ridley and Vincent
Tremblay for Crha to get a shot. He won his first
game, 5–3 over Hartford, in relief of Ridley and
put up decent stats, despite his habit of staying deep
in his crease and wearing a crude cage mask.

Upon arrival in Toronto, Crha rented a home
in North York, which turned out to be just
eight houses from where young Leafs executive
Gord Stellick still lived with his parents.
Stellick's father, Ernie, who emigrated from
Czechoslovakia in 1948, became unofficial
interpreter for the Crha family, and sister,
Karen, babysat the Crha children. One of Jiri's
daughters, Martina, was a top-ranked Czech
junior tennis player, following in the footsteps of
her namesake, Martina Navratilova.

Already 30 when he broke in, Crha
later became a player agent, mostly handling
Czech talent. The Leafs tried to develop other
Czechoslovakian goalies, including Robert
Horyna and Martin Maglay, without success.

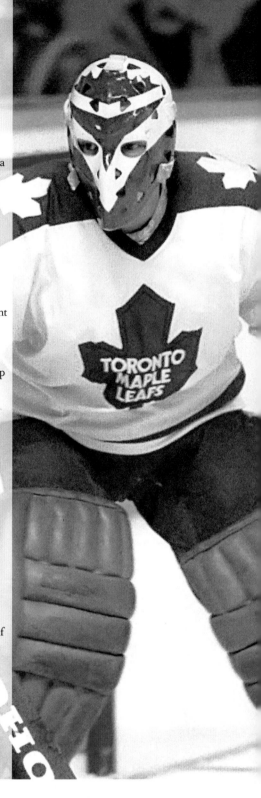

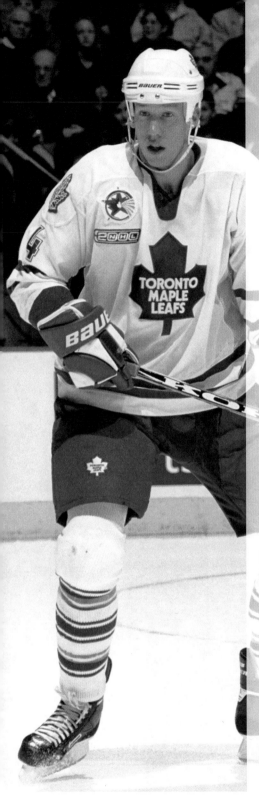

D **CORY** #4
CROSS
(1999–2001)

BORN: January 3, 1971, Lloydminster, Alberta
ACQUIRED: October 1, 1999, from Tampa Bay
with a 7th-round pick (LW Ivan Kolozvary) for
LW Fredrik Modin
LEAF LINE: 162 GP 10 G 25 A 35 PTS 168 PIM

The big man had a good reach to make up for
some mobility issues. He put in 35 playoff games,
which included an overtime goal against Ottawa
in 2001.

Cross played with the Rangers, Oilers, Penguins
and Red Wings and ended up in Germany. He
then took up coaching Canadian university
hockey with Calgary. He'd played at the
University of Alberta prior to turning pro. He
became involved in an online coaching project,
and later re-joined the Calgary Dinos as an
assistant coach.

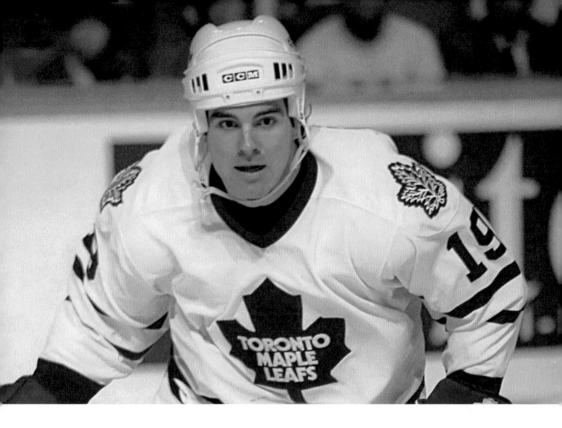

C JOHN #19 CULLEN

(1992–94)

BORN: August 2, 1964, Puslinch, Ontario

ACQUIRED: November 24, 1992, in a trade with Hartford for a 2nd-round pick (transferred to San Jose, which chose D Vlastimil Kroupa)

LEAF LINE: 100 GP 26 G 45 A 71 PTS 120 PIM

The Cullen clan was the Leafs' version of the Sutters. John was following in the steps of his father, Barry, and uncle, Brian, who both played in Toronto the '50s. His stint was marred by a herniated disc, though his five points in 15 playoff games was a better record than his two relatives had.

Cullen's formative years were in the shadow of his mother's death from cancer. Late in 1996–97 when he was with Tampa Bay, Cullen was diagnosed with non-Hodgkin lymphoma. He needed a bone marrow transplant to survive, but he made it back in the Lightning lineup during the 1998–99 season.

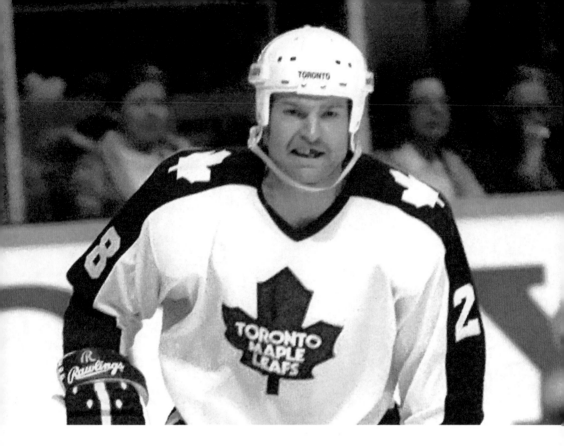

D BRIAN #28 CURRAN

(1987–91)

BORN: November 5, 1963,
Toronto, Ontario
ACQUIRED: March 8, 1988, from the
New York Islanders for a 6th-round
pick (C Pavel Gross)
LEAF LINE: 130 GP 3 G 14 A 17 PTS 512 PIM

He had a choppy skating style, but was
only a minus-2 in his Leafs stint. He
was also very up front with the media
and teammates in difficult times. This
was the one trade that the short-lived
triumvirate of Leafs GMs Stellick,
Brophy and Duff all agreed on.

The Colonel certainly stuck up for his
teammates, becoming only the third
Leaf to clear 300 penalty minutes in
one year in 1989–90. Tie Domi and
Tiger Williams are the others. Curran is
now coach and GM of the Drumheller
Dragons of the Alberta Junior Hockey
League.

D **KEVIN** #4
DAHL
(1998–99)

BORN: December 30, 1968, Regina,
Saskatchewan
ACQUIRED: October 5, 1998,
claimed from St. Louis on waivers
LEAF LINE: 3 GP 0 G 0 A 0 PTS 2 PIM

Extra blue line depth on the eve of a new season
never hurts. The Leafs scooped the unprotected
Dahl when the Blues loaned him to the IHL
Chicago Wolves, a Toronto affiliate. An ankle
injury early in the year limited his playing time.

Dahl was picked 230th overall by Montreal in
1988. But he'd compiled a long list of references,
four years at Bowling Green State University;
two with the Canadian National team; 188 NHL
games with Calgary, Toronto, Phoenix and
Columbus; as well as stops in the IHL, AHL
and ECHL, ending with three years with the
Nuremburg Ice Tigers in Germany.

c**MARTY** #15, #35
DALLMAN
(1987–89)

BORN: February 15, 1963, Niagara Falls, Ontario
SIGNED: November 15, 1986, as a free agent
LEAF LINE: 6 GP I G O A I PTS O PIM

While putting together a 50-goal season with
Newmarket in 1987–88, Dallman had a very
vocal relative urging the Leafs to call him up.
That was well-known CTV sportscaster Pat
Marsden, his father-in-law. Dallman debuted in
the NHL in a 4–3 loss in Chicago that season.
Other clubs declined to give the smallish forward
a chance and he went overseas.

Dallman became so enamoured with playing in
Austria that he took up citizenship and represented
that country at the world championships and the
Olympics in the early '90s.

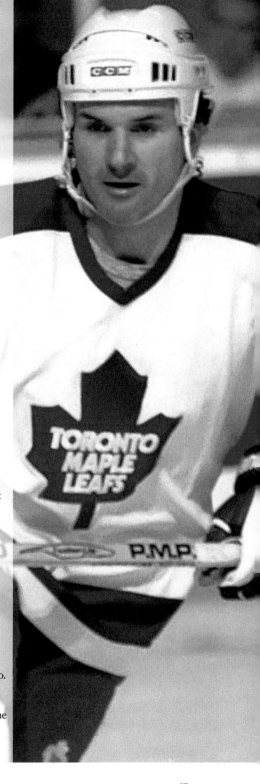

LW **LUCIEN** #27
DEBLOIS
(1990–92)

BORN: June 21, 1957, Joliette, Quebec
ACQUIRED: November 17, 1990, with D Michel
Petit and LW Aaron Broten from Quebec for
LW Scott Pearson and two 2nd-round draft
picks. One was traded to Washington (D Eric
Lavigne), while Quebec took Finnish defender
Tuomas Gronman in '92.
LEAF LINE: 92 GP 18 G 23 A 41 PTS 69 PIM

Coach Tom Watt told anyone who'd listen what
a great captain DeBlois had been for him a few
years earlier in Winnipeg. But that didn't mean
DeBlois could get the Leafs back in the playoffs
himself. So he was returned to Winnipeg in
March of '92 by incoming GM Fletcher to
reacquire winger Mark Osborne.

At times it seems DeBlois has never left Toronto.
As an eastern pro scout for Vancouver, he is
often at the ACC or Ricoh Coliseum tracking the
Leafs, Marlies and visiting teams.

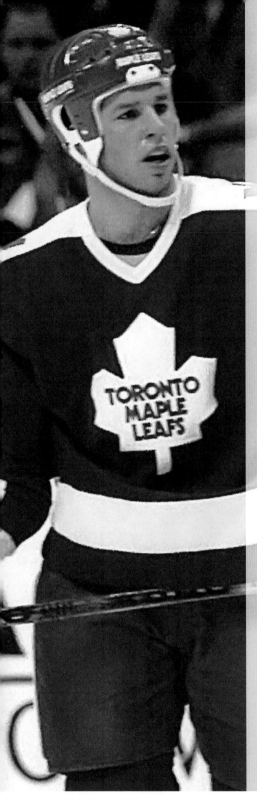

D **DALE** #3
DEGRAY
(1987–88)

BORN: September 1, 1963, Oshawa, Ontario
ACQUIRED: October 7, 1987, from Calgary for a
5th-round pick (D Scott Matusovich)
LEAF LINE: 56 GP 6 G 18 A 24 PTS 63 PIM

DeGray was upset his Toronto experience
lasted only a year after the Leafs claimed him
on waivers from a deep Calgary blue line. The
Kings nabbed him with their own claim after
Toronto left him unprotected to chase Brad
Marsh. The Leafs came to regret the move, too.
When the Kings tried to send DeGray down
later, he didn't report in hopes of forcing a deal
back to his family in the GTA, but only got as far
as the Buffalo Sabres.

DeGray coached in the AHL at Rockford, was a
scout for the Florida Panthers and is now GM of
the Owen Sound Attack of the OHL.

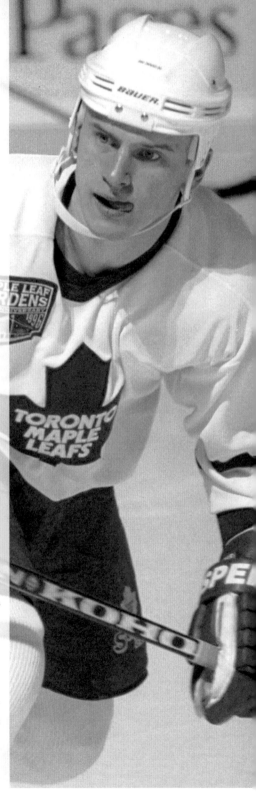

D/F **NATHAN** #43
DEMPSEY

(1996–2001)

BORN: July 14, 1974, Spruce Grove, Alberta
DRAFTED: 1992, 11th round, 245th overall
LEAF LINE: 45 GP 2 G 12 A 14 PTS 8 PIM

No one came from further back in the draft to be a Leaf than Dempsey or waited so long between chances in a remote farm location such as St. John's. But while the Leafs didn't always appreciate the utility forward's talents (verbal spats between GM Pat Quinn and player agent Art Breeze were classics), clubs such as Chicago, Boston and L.A. also gave Dempsey chances.

Dempsey was much loved in St. John's for spending eight seasons there. He won numerous community awards and was an honorary captain when the AHL recently staged its all-star game there.

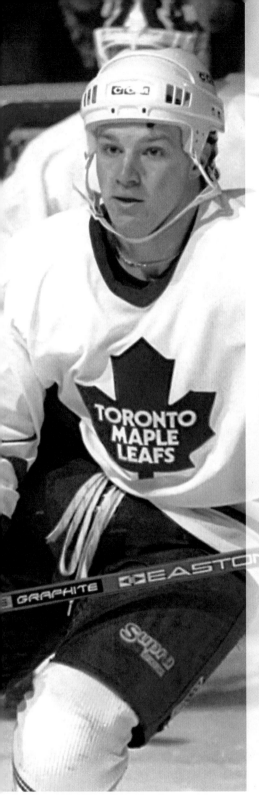

C **PAUL** #25
DIPIETRO
(1994–96)

BORN: September 8, 1970, Sault Ste. Marie,
Ontario
ACQUIRED: April 6, 1995, from Montreal for a
4th-round pick (C Kim Staal)
LEAF LINE: 32 GP 5 G 5 A 10 PTS 10 PIM

As the Leafs were on their great playoff showing
in '93, DiPietro was scoring eight in 17 games
for the Habs in their run all the way to the Cup.
Acquiring him from Montreal, which was then
in another conference, was a roster shake-up
prior to the '95 playoffs. His ice time in Montreal
had been cut back and he had a fan in former
Canadiens coach Pat Burns, who didn't hide his
glee at a steal from his old team. DiPietro played
20 games the next year. He wrapped up his NHL
career with six games in L.A. in '96, then played
another decade in Switzerland.

Not only did DiPietro play for the Leafs'
greatest rivals in Montreal, cousin Rocky
was a CFL star in Hamilton for the Toronto
Argonauts' nemesis team.

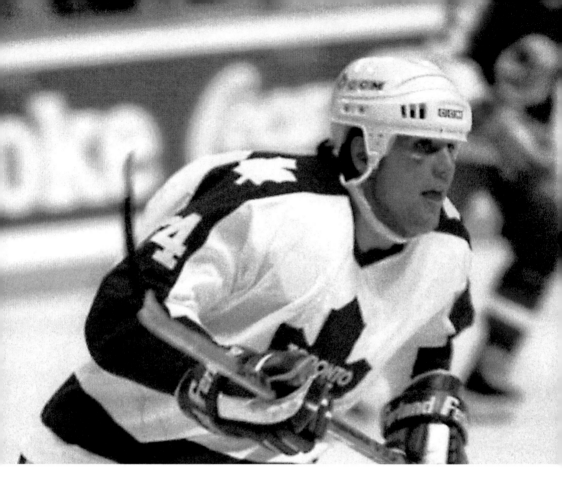

RW **ROCKY** #34
DUNDAS
(1989–90)

BORN: January 30, 1967, Regina,
Saskatchewan
SIGNED: October 4, 1989, as a free agent
LEAF LINE: 5 GP 0 G 0 A 0 PTS 14 PIM

Perhaps fated to join Toronto after
playing midget hockey for a team called
the Edmonton Maple Leafs, Dundas

actually started out as Habs' property.
Two years with their Sherbrooke
affiliate led nowhere, so he took a
chance on cracking a weaker Leafs
roster. Dundas made the opening night
call in 1989–90 and finished the year on
the farm.

Dundas became a youth pastor in
Southern Ontario, then moved into
the sports apparel business.

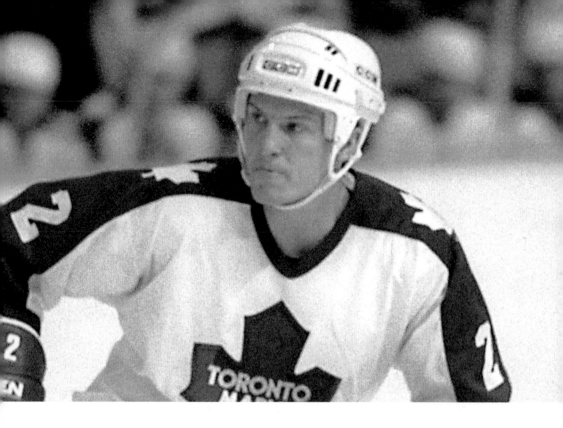

D **JEROME** #2 **DUPONT**

(1986–87)

BORN: February 21, 1962, Ottawa, Ontario

ACQUIRED: September 6, 1986, with C Ken Yaremchuk and a 4th-round draft choice (RW Joe Sacco) as compensation for Chicago signing D Gary Nylund as a free agent

LEAF LINE: 13 GP 0 G 0 A 0 PTS 23 PIM

The Leafs had a fair look at Dupont through his four seasons in their backyard with the Marlies. In his grad year he was promoted to Chicago, which had picked him 15th overall in 1980. But in the NHL points were harder to come by as he found out with the Hawks and Leafs.

After his pro career Dupont made a difference as founder of the Centre of Hockey Excellence, which combines hockey instruction and a school curriculum. As a Major Junior and Junior A coach in Ontario and Quebec, he compiled a .690 winning percentage.

D **VITEZSLAV** #23, #24
DURIS
(1980–83)

BORN: January 5, 1954, Plzen, Czechoslovakia
SIGNED: September 25, 1980, as a free agent
LEAF LINE: 89 GP 3 G 20 A 23 PTS 62 PIM

Toronto's attempt to open a channel to Czech
and Slovak talent began in earnest with former
Olympian Duris. But while Borje Salming and
Inge Hammarstrom were resounding successes
from Sweden, Duris was not much help on a bad
team. It started with an 8–3 loss to the Rangers
on opening night of the 1980–81 season. Duris,
to his credit, was a plus-13 that first year, but
after time in the minors he developed back
problems. Unable to go back home, he played a
few years in West Germany.

Duris's old-school Euro helmet that sat high on
his forehead was the object of fan ridicule — and
that of a few teammates too.

"It was an old Jofa with ear flaps and, man,
was it ugly," one Leaf recalled.

Duris was no Tim Horton, but he did make
good money as a franchisee of one of the iconic
donut stores.

D**DALLAS** #2
EAKINS
(1998–99)

BORN: February 27, 1967, Dade City, Florida
SIGNED: July 28, 1998, as a free agent
LEAF LINE: 18 GP 0 G 2 A 2 PTS 24 PIM

Long before his intense glare rattled the players he coached on the
Toronto Marlies and the Edmonton Oilers, Eakins fixed his sights on
playing in the NHL. The long journey took him through Winnipeg,
Florida, New York, Long Island, Calgary, Phoenix and St. Louis, and
this brief stop in Toronto where he impressed coach Pat Quinn as an
injury fill-in.

Eakins was influenced by four Leafs coaches: Roger Neilson, from
their Peterborough junior connection; Quinn; Ron Wilson, who was
the parent team's coach when Eakins took the Marlies job; and Randy
Carlyle, Eakins' Jets teammate in the early '90s. Eakins now coaches
the San Diego Gulls of the AHL.

_C MIKE #21, #32
EASTWOOD
(1991–95)

BORN: July 1, 1967, Ottawa, Ontario
DRAFTED: 1987, 5th round, 91st overall
LEAF LINE: 111 GP 14 G 23 A 37 PTS 85 PIM

How could a guy born in the nation's capital on Canada's 100th birthday not make Canada's team? Eastwood was regarded as an effective two-way player who added eight points in 28 playoff games. In his last year with the Leafs before the trade to Winnipeg to reacquire Tie Domi, he was the team's nominee for the Bill Masterton Memorial Trophy. He kept playing for six other NHL teams.

In a game in Calgary, Eastwood made Burns turn purple with rage, nearly missing a line change while watching Flames mascot Harvey the Hound perform near the Leafs bench.

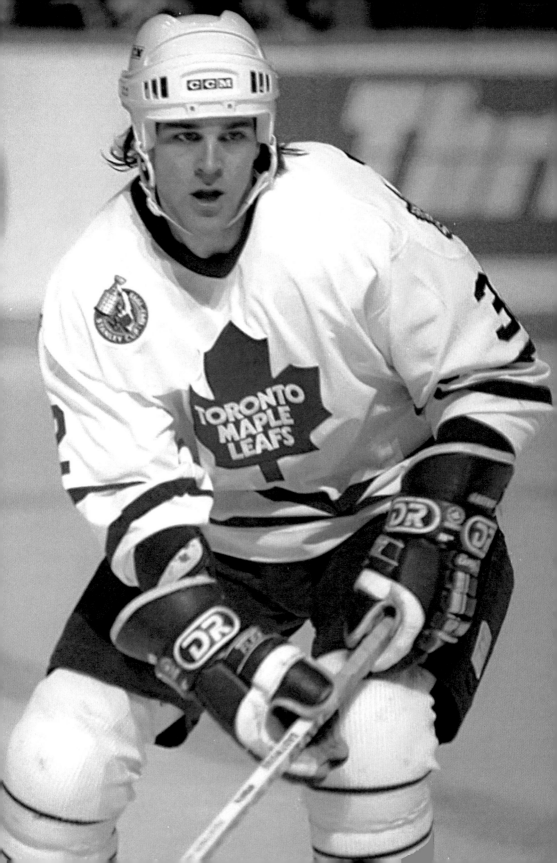

G **DON** #30
EDWARDS
(1985–86)

BORN: September 28, 1955, Hamilton, Ontario
ACQUIRED: May 29, 1985, from Calgary for a
4th-round pick (RW Tim Harris)
LEAF LINE: 38 GP 12 W 23 L 0 T 4.78 GAA

GM Gerry McNamara gave in and signed a
veteran to help his trio of youngsters, Allan
Bester, Ken Wregget and Tim Bernhardt.
Edwards played well in the season opener, a 3–1
loss in Boston, but this would soon turn out to be
the last stop in a career that began under unusual
circumstances in Buffalo. Edwards thought he
was backing up Al Smith in a game, only to see
the latter skate off the ice right after the national
anthem in a spat with the team.

Wregget regained some confidence, due in part
to Edwards's influence. At the end of the season,
Wregget was the starter in a first-round playoff
upset of Chicago and a seven-game thriller
against the Blues.

Still, the veteran wasn't spared from pranks
by younger Leafs: they loosened the tire bolts
on Edwards's Corvette in the airport parking lot
after the team returned from a road trip. Wanting
to show off his fancy car and driving skills,
Edwards roared out only to have his wheel roll
off and his car hit the pavement with a thud.

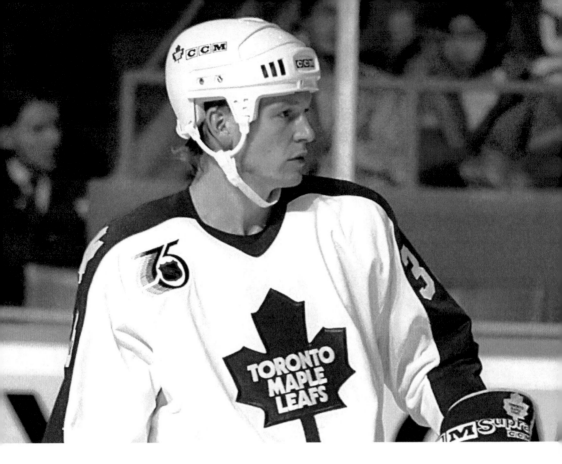

D **LEN** #36
ESAU

(1991–92)

BORN: June 3, 1968, Meadow Lake,
Saskatchewan

DRAFTED: 1988, 5th round, 86th overall

LEAF LINE: 2 GP ○ G ○ A ○ PTS ○ PIM

The captain at St. John's, Esau was
first summoned November 17 to face
Hartford when Dave Ellett suffered
a foot injury. He was also called the

day of the 10-player Doug Gilmour
trade with Calgary, when all the bodies
coming and going could not guarantee
the Leafs would have enough players
for a game at Detroit.

Five other NHL players emerged from
tiny Meadow Lake, including Dwight
King, Cup champion, and Jeremy
Yablonski, who played one fight-filled
game for the Blues and then went into
mixed martial arts.

LW **DARYL** #3
EVANS
(1986–87)

BORN: January 12, 1961,
Toronto, Ontario
SIGNED: August 21, 1986, as a free agent
LEAF LINE: 2 GP 1 G 0 A 1 PTS 0 PIM

A 61-goal season in the OHL in
1980–81 brought him to the attention
of a few teams. The Kings had him
in New Haven for a few seasons,
then flipped him to the Capitals
farm team, with Evans filling the net all
the while. With no NHL avenue yet to
open, he signed on with the Leafs via
Newmarket, finally debuting January
31 against the Wings. He popped in a
power-play goal — on a night a Leafs
loss knocked them into the Norris
Division basement.

Evans, now a radio commentator for
the Kings, is said to have developed his
strong skating skills and foot muscles by
not putting laces in his boots.

C **KELLY** #7, #40
FAIRCHILD
(1995–97)

BORN: April 9, 1973, Hibbing, Minnesota
ACQUIRED: October 3, 1994, with RW
Dixon Ward, C Guy Leveque and RW
Shayne Toporowski from Los Angeles
for D Chris Snell, LW Eric Lacroix and
a 4th-round pick (C Eric Belanger).
LEAF LINE: 23 GP 0 G 3 A 3 PTS 4 PIM

A scorer of note at University of
Wisconsin, Fairchild notched 20 goals
on just 72 shots his first season in St.

John's. But Pat Burns was reluctant to
use unknowns in Toronto, so Fairchild's
break didn't come until late the next
season under Nick Beverley. Fairchild
had a point in his debut against Detroit,
a 4–3 overtime loss, replacing an injured
Doug Gilmour. He was the last cut at
the '96 camp and played sporadically
throughout that season.

Fairchild appeared briefly with Dallas
and Colorado before ending a long minor
league career on a high, with Asia League
champions Nippon Paper Cranes.

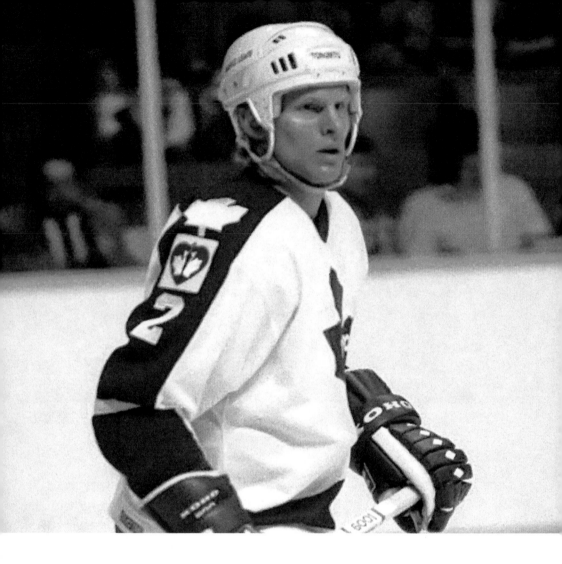

D **TED** #2, #34
FAUSS

(1986–88)

BORN: June 30, 1961, Clark Mills,
New York
SIGNED: July 21, 1986, as a free agent
LEAF LINE: 28 GP 0 G 2 A 2 PTS 15 PIM

A John Brophy pupil with Montreal's
farm team in Nova Scotia; his old coach
didn't forget him when he perceived the
Leafs needed some starch in the lineup.

Among Fauss's NHL Nova Scotia
teammates was future Habs coach
Michel Therrien.

LW PAUL #16 FENTON

(1990–91)

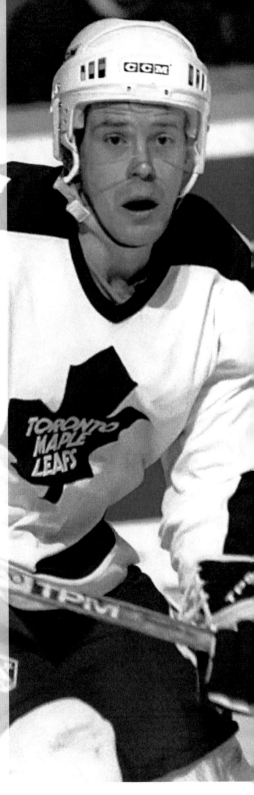

BORN: December 22, 1959,
Springfield, Massachussetts

ACQUIRED: November 10, 1990, from Winnipeg
with D Dave Ellett for C Ed Olczyk and LW
Mark Osborne

LEAF LINE: 30 GP 5 G 10 A 15 PTS 0 PIM

The Leafs specifically targeted Ellett from the
Jets, but Fenton was quite bitter at being moved
out by the Leafs just three months later. Then
Washington immediately flipped Fenton to
Calgary, making it three Canadian stops in three
years for the Boston University grad, perhaps
hastening Fenton's retirement shortly after.

The Leafs talk a lot of business these days with
Fenton, who is assistant GM of the Predators.
He remains fond of his short stint in Toronto,
where his son learned to love playing hockey.

RW **MIKE** #15, #71
FOLIGNO
(1990–94)

BORN: January 29, 1959, Sudbury, Ontario
ACQUIRED: December 17, 1990, from Buffalo
with an 8th-round pick (C Tomas Kucharcik)
for D Brian Curran and RW Lou Franceschetti
LEAF LINE: 129 GP 27 G 20 A 47 PTS 203 PIM

The popular Foligno was hampered by injuries,
but his zeal helped make fans forget about
missing the playoffs two straight years. When
the club turned the corner in '93, he played a
strong role as well. In a goal almost as big as
Nik Borschevsky's overtime tip to eliminate
Detroit, Foligno's extra-time strike at Joe Louis
Arena in Game 5 came complete with his famous
celebratory leap.

Knowing he could not retain his famous #17
with the Leafs because of Wendel Clark's
seniority, Foligno took #71. His son Nick now
wears that number in the NHL with Columbus.

RW **LOU** #15
FRANCESCHETTI
(1989–91)

BORN: March 28, 1958, Toronto, Ontario
ACQUIRED: June 29, 1989, from Washington
for a 5th-round pick (C Mark Ouimet)
LEAF LINE: 96 GP 22 G 16 A 38 PTS 157 PIM

In his last trade as GM, Gord Stellick landed a
fan favourite for a cheap price. Franceschetti
generated the "Louuuuu" chant when he hit
opponents hard at MLG. From 21 goals his first
year, Franceschetti's numbers fell in a hurry.
For Toronto's strong Italian community, it was
fitting that Franceschetti departed in a 1990 trade
and Mike Foligno came in.

When the Gardens closed on February 13, 1999,
Franceschetti led off the distinguished parade
of alumni. It started with the 1990s and he was
alphabetically first among those who'd played at
least 50 games.

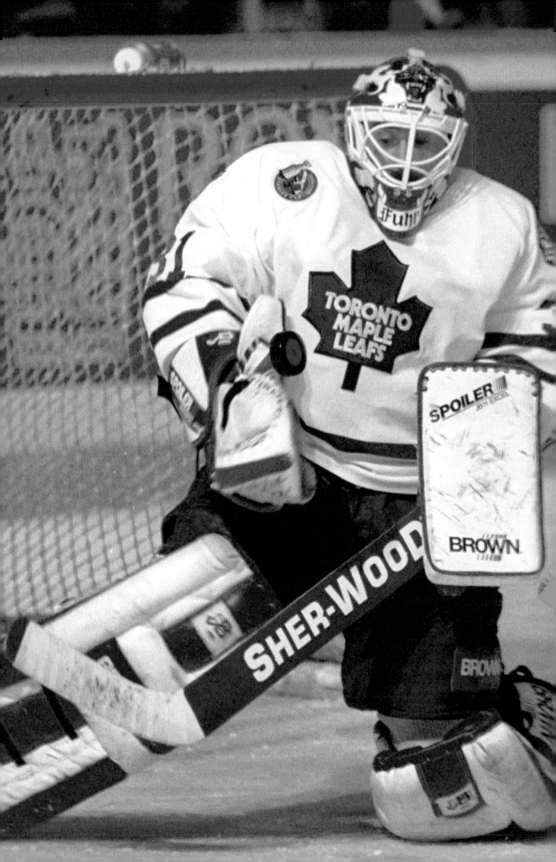

G **GRANT** #31
FUHR
(1991–93)

BORN: September 28, 1962, Spruce Grove, Alberta

ACQUIRED: September 19, 1991, from Edmonton with LW Craig Berube and F Glenn Anderson for C Vince Damphousse, C Scott Thornton, D Luke Richardson and G Peter Ing

LEAF LINE: 95 GP W 38 L 42 T 4 3.50 GAA

Toronto went without a veteran "name" goalie as No. 1 for years before the multi-Cup winner arrived. As in Edmonton, Fuhr didn't post attractive low numbers but made clutch saves in high-scoring games; however, it wasn't long into Fuhr's second year before young Felix Potvin made a push and Toronto traded Fuhr to Buffalo.

Fuhr's deal with the Leafs after arriving made him the first Leaf ever to have a seven-figure salary. But Fuhr found the early adjustment to a weak Leafs team and different surroundings to be quite difficult, and he left in the middle of a western Canadian road trip. He came back and played well.

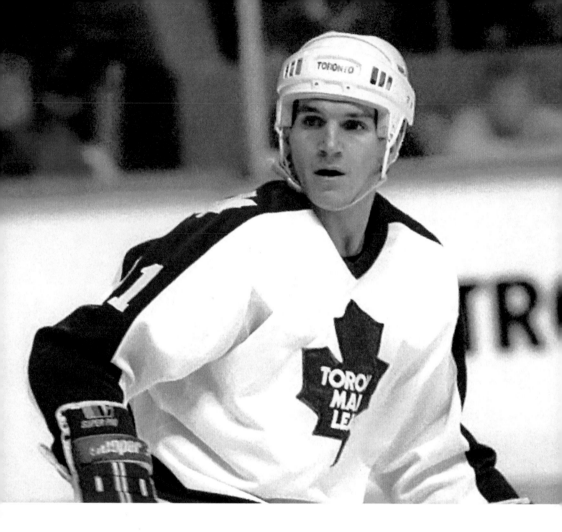

LW **PAUL** #18, #41
GAGNÉ

(1988–89)

BORN: February 6, 1962,
Iroquois Falls, Ontario
SIGNED: July 28, 1988,
as a free agent
LEAF LINE: 16 GP 3 G 2 A 5 PTS 6 PIM

Gagné flirted with 50 goals as a
Windsor junior and cleared 20 with the
Devils before they became a true trap-
style team. But there was little he could
do to aid a Leafs lineup in flux after
John Brophy's firing.

Gagné was the leading scorer on the
Newmarket Saints in 1988–89, with 33
goals and 74 points.

C **DAVE** #15
GAGNER
(1995–96)

BORN: December 11, 1964, Chatham, Ontario
ACQUIRED: January 28, 1996, from Dallas
with a 6th-round pick (D Dmitriy Yakushin)
for LW Benoît Hogue and LW Randy Wood
LEAF LINE: 28 GP 7 G 15 A 22 PTS 59 PIM

It seemed the Leafs were set for a good run in the
playoffs with Gagner having a strong finish on
his new team with Doug Gilmour, Mats Sundin,
Kirk Muller and a returning Wendel Clark.
But the Leafs were 1st-round casualties for the
second straight year, and Gagner had just two
assists in six games as well as being minus-5.

The Gagner trade with Dallas was leaked
at halftime of Super Bowl XXX. With the
Cowboys beating the Pittsburgh Steelers that
night, the deal got far more ink in Toronto than
in Texas.

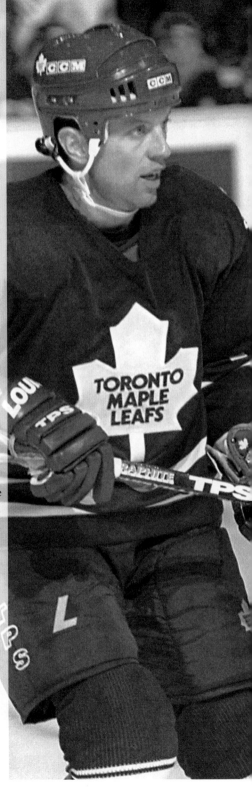

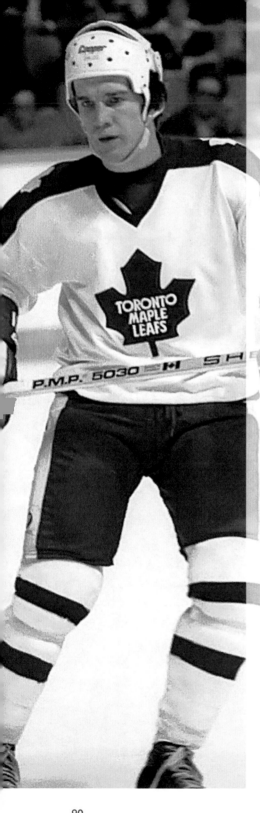

C **PAUL** #18
GARDNER

(1978–80)

BORN: March 5, 1956, Fort Erie, Ontario

ACQUIRED: March 13, 1979, from the Colorado Rockies for C Don Ashby and D Trevor Johansen

LEAF LINE: 56 GP 18 G 15 A 33 PTS 10 PIM

The Leafs were a tough roster to crack in the late '70s and Toronto turned out to be one of Gardner's least successful stops. But he did return in the late '80s to the Newmarket farm team as a coach, a passion that has taken him far afield: to Nashville as an assistant and to Germany as boss of the Hamburg Freezers.

Gardner is the son of Leaf Cup–winner Cal Gardner and younger brother of Dave Gardner, who had 266 points in two years with the junior Marlies.

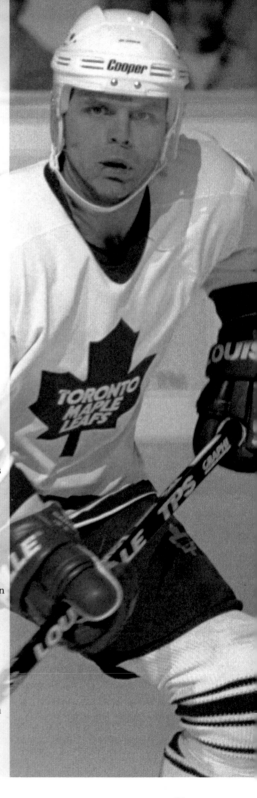

RW **MIKE** #11
GARTNER
(1993–96)

BORN: October 29, 1959, Ottawa, Ontario
ACQUIRED: March 21, 1994, from the Rangers
for RW Glenn Anderson, D Scott Malone and
a 4th-round pick (D Alexander Korobolin)
LEAF LINE: 130 GP 53 G 33 A 86 PTS 62 PIM

As the Leafs hoped, Gartner was able to keep his
record streak of 30-goal seasons going, adding
the two he needed after the trade and then 35 in
the shortened lockout year. What the Hall of
Famer never won was a Cup (New York won it
after they traded him), and Gartner fell out with
GM Cliff Fletcher, who traded him to Phoenix in
the summer of '96.

Gartner had an unexpected train trip across
Canada in February of '95 when a collision with
Edmonton's Bryan Marchment put a rib through
his lung and made it impossible to fly back from
Alberta.

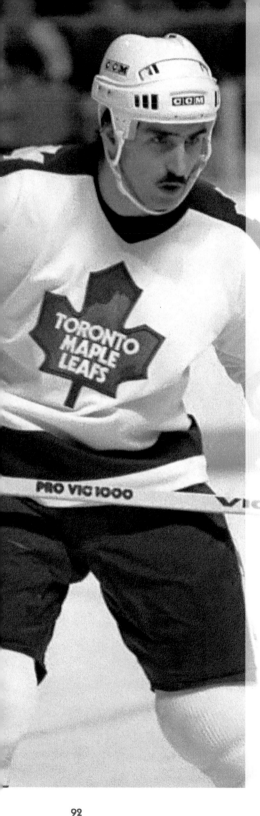

D JOHN #23
GIBSON
(1981–82)

BORN: June 2, 1959, St. Catharines, Ontario

ACQUIRED: November 11, 1981, from Los Angeles with RW Billy Harris for D Ian Turnbull

LEAF LINE: 27 GP 0 G 2 A 2 PTS 67 PIM

If the Leafs were counting on any Turnbull-like five-goal games from Gibson, they were disappointed. Gibson was there for muscle and, other than young Bob McGill, the Leafs had little of it on the back line at the time. The Leafs released Gibson a couple of years later, and he briefly resurfaced with Winnipeg.

Though the WHA had folded in 1979–80, Gibson played a bit with John Brophy's new Birmingham Bulls after the team re-formed in the Central Hockey League.

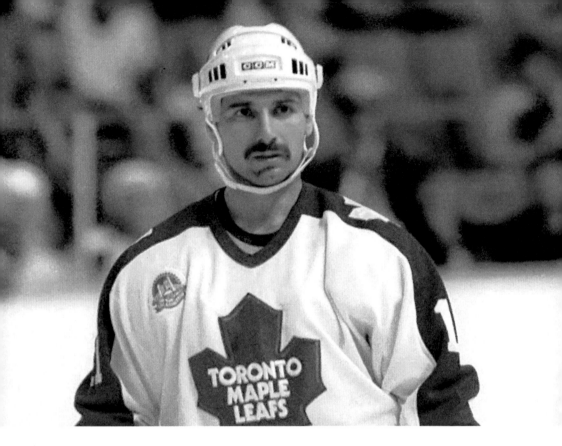

D GASTON #11 GINGRAS

(1982–85)

BORN: February 13, 1959,
Temiscaming, Quebec
ACQUIRED: December 17, 1982,
from Montreal for 2nd-round pick
(LW Benoît Brunet)
LEAF LINE: 109 GP 17 G 40 A 57 PTS 26 PIM

The same-day deals with Montreal involving Gingras and forward Dan Daoust put life into a Toronto team that had won only eight games to that point. With Gingras improving the back line and Daoust's jolt of energy, Toronto went on a burst of 8–4–4, though it eventually missed the playoffs.

Demoted by the Leafs in 1984–85, Gingras was backtracked in a deal that sent him to Montreal's farm team at Sherbrooke. That club, with Patrick Roy in goal, won the Calder Cup, and Gingras was back on the big team in '86 for the Habs's Cup win.

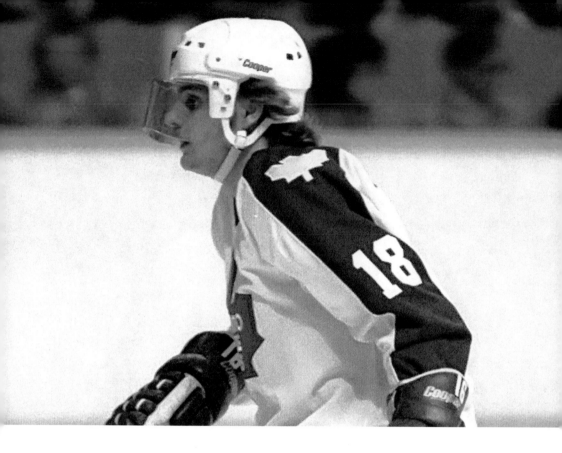

C **ERNIE** #18
GODDEN
(1981–82)

BORN: March 13, 1961, Keswick, Ontario
DRAFTED: 1981, 3rd round, 55th overall
LEAF LINE: 5 GP 1 G 1 A 2 PTS 6 PIM

Godden's OHL record of 87 goals with Windsor still stands, but the fact that 54 players were taken ahead of him in the draft indicates concerns about his size. Prankster teammates taped the name Moses on his stall for his NHL debut against the Sabres as he replaced the benched Laurie Boschman.

Godden's first NHL goal came in a 9–4 home romp over the Capitals, but any hope of following it up the next night in Boston was dashed by a snowstorm that cancelled the game. Godden played once more and was demoted. That call came just two hours before the much-anticipated team Christmas party at which Ballard gave each player two tickets anywhere American Airlines flew.

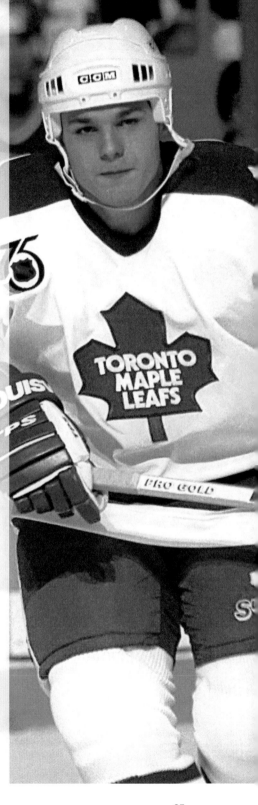

D **ALEXANDER** #93
GODYNYUK
(1990–92)

BORN: January 27, 1970, Kiev, Ukraine
DRAFTED: 1990, 6th round, 115th overall
LEAF LINE: 57 GP 3 G 9 A 12 PTS 75 PIM

Like many teams, the Leafs joined the Russian
Revolution — and got caught up in red tape.
After learning the Leafs had drafted him,
Godynyuk faked an injury with Sokil Kiev
and made his way to Toronto. Much contract
haggling with his former club team followed.
In the end, the Leafs weren't that impressed and
shipped him to Calgary in the Gilmour deal.

A few years later, Godynyuk's bold move
to leave Ukraine inspired future Leaf Alexei
Ponikarovsky to get out of the country.

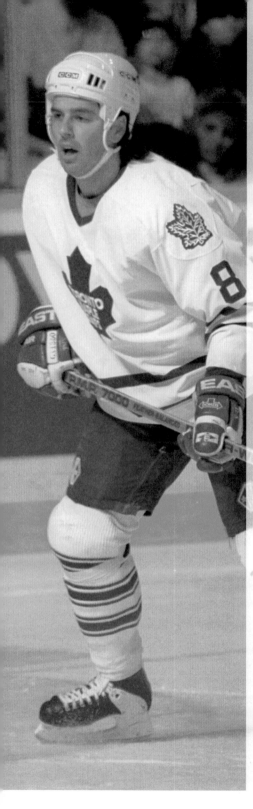

LW **CHRIS** #8
GOVEDARIS
(1993–94)

BORN: February 2, 1970, Toronto, Ontario
SIGNED: September 7, 1993, as a free agent
LEAF LINE: 12 GP 2 G 2 A 4 PTS 14 PIM

One of the last stars of the junior Marlies before they departed Toronto, the home-grown sniper had 119 goals in three OHL seasons. A 1st-round pick in Hartford, he hoped to make a better impact with the Leafs, but wasn't afforded much of a chance on a strong team. He had to be content with 12 NHL games and a 70-point year on the farm in Newfoundland.

Govedaris was picked by Hartford right after the Jets snared Teemu Selanne. You may not have heard the last of the name, as two of his four children are elite young hockey players in the GTA.

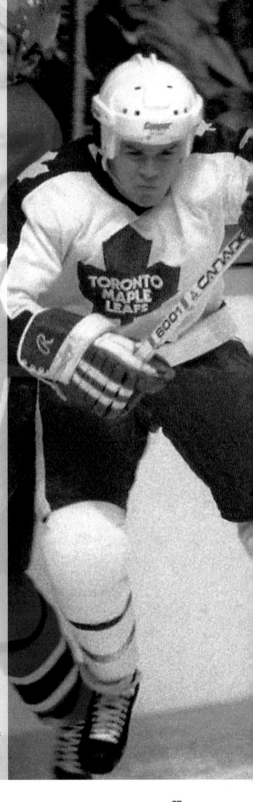

LW **PAT** #23
GRAHAM
(1983–84)

BORN: May 25, 1961, Toronto, Ontario
ACQUIRED: August 15, 1983, from Pittsburgh
with G Nick Ricci for RW Rocky Saganiuk and
G Vincent Tremblay
LEAF LINE: 41 GP 4 G 4 A 8 PTS 45 PIM

He gave the Leafs some sass for a half season,
knowing his way around MLG after a long
stint with the Marlies and a memorable season
with Niagara Falls. With the latter, he was on
a dynamic line with Steve Ludzik and Steve
Larmer. He did have 20 points in 62 games with
the Pens, but was in a more defensive role with
the Leafs.

Graham, who suffered from back pain in his
NHL career, took up chiropractic studies soon
after retiring, earned his degree and worked with
the Toronto Blue Jays.

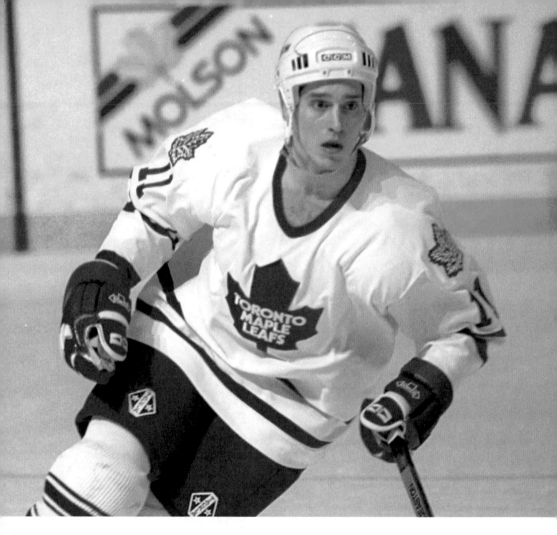

RW **MARK** #11
GREIG

(1993–94)

BORN: January 25, 1970,
High River, Alberta
ACQUIRED: January 25, 1994, from
Hartford with a 6th-round pick (traded
to the Rangers who selected C Yuri
Litvinov) for D Ted Crowley
LEAF LINE: 13 GP 2 G 2 A 4 PTS 10 PIM

The versatile Greig played on the
"GAP Line" with Glenn Anderson and
Yanic Perreault and saw time with Peter
Zezel's checking line.

Greig's older brother, Bruce, played
for the California Golden Seals and
held several power lifting records.

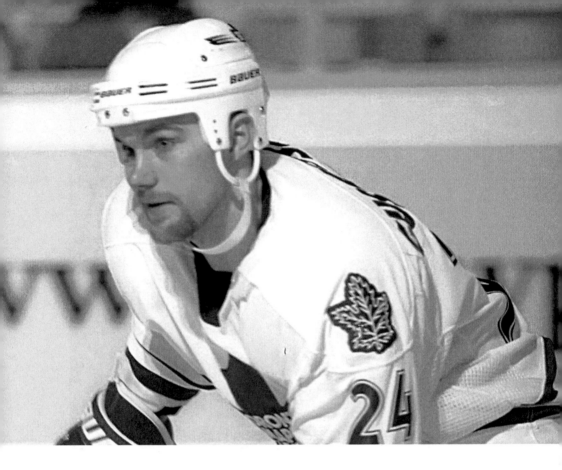

D **PER** #24
GUSTAFSSON
(1997–98)

BORN: June 6, 1970, Oskarshamn,
Sweden

ACQUIRED: June 13, 1997,
from Florida for D Mike Lankshear

LEAF LINE: 22 GP 1 G 4 A 5 PTS 10 PIM

With 29 points in a half season for
the Panthers, it was hoped Gustafsson
would be part of a strong defence
for new coach Mike Murphy. But
Gustafsson was in the doghouse rather
quickly and on the waiver wire midway
through the year. He was traded to the
Senators and played just nine more
NHL games.

Before and after his brief NHL fling,
Gustafsson was a highly respected figure
in club hockey and on the national team
in Sweden. Among his deeds was a
record goal six seconds into a game.

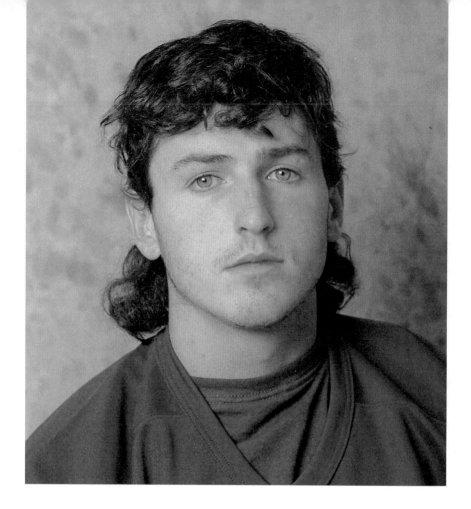

LW **SEAN** #52 **HAGGERTY**
(1995–96)

BORN: February 11, 1976, Rye, New York
DRAFTED: 1994, 2nd round, 48th overall
LEAF LINE: 1 GP 0 G 0 A 0 PTS 0 PIM

A loophole that allowed the Leafs to use a signed junior player on his team's off day permitted Haggerty to get in the lineup for a February game against the Red Wings. Haggerty was en route to a 60-goal season for Detroit's OHL team. He started his first NHL game on a line with Doug Gilmour and Kirk Muller.

At the time, GM Cliff Fletcher denied he was showcasing Haggerty for a trade. Three weeks later, Haggerty was in the huge deal to bring back Wendel Clark from the Islanders.

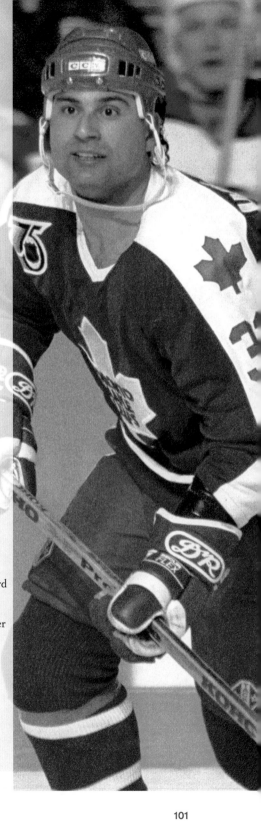

D **BOB** #33
HALKIDIS
(1991–92)

BORN: March 5, 1966, Toronto, Ontario
SIGNED: July 24, 1991, as a free agent
LEAF LINE: 46 GP 3 G 3 A 6 PTS 145 PIM

Halkidis had made his name as a tough rearguard with Buffalo and, briefly, Los Angeles. Though the Leafs didn't keep him, he sustained his career into the early 2000s in Britain, Germany and Russia.

During a road trip in L.A., Halkidis and teammates Jeff Reese and Claude Loiselle were robbed at gunpoint near a fast-food outlet.

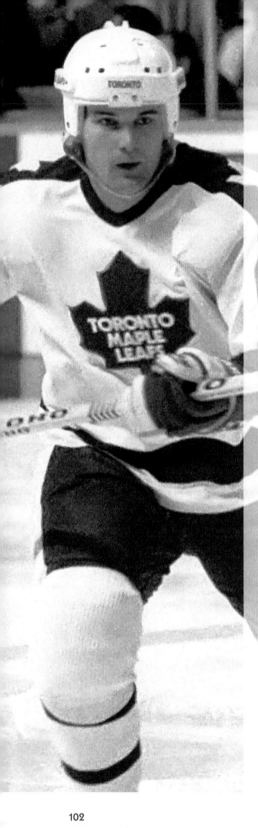

D **KEN** #29
HAMMOND
(1988–89)

BORN: August 22, 1963, Port Credit, Ontario
ACQUIRED: January 30, 1989, from IHL Denver
Rangers in exchange for loan of LW Chris McRae
LEAF LINE: 14 GP 0 G 2 A 2 P 12 PIM

A good first-pass defenceman, Hammond had
been exiled by Rangers coach Michel Bergeron in
a clash of personalities.

Hammond's great-grandfather was a stone
mason who helped build the Gardens in 1931,
while his grandfather helped install the plumbing
at 60 Carlton.

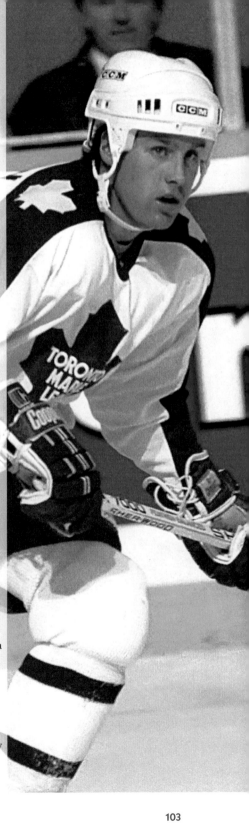

LW **DAVE** #9
HANNAN
(1989–92)

BORN: November 26, 1961, Sudbury, Ontario
ACQUIRED: October 2, 1989, on waivers from
Pittsburgh
LEAF LINE: 148 GP 19 G 34 A 53 PTS 153 PIM

One of the most diligent checkers the Leafs had
in the '90s, Hannan's spirit rarely dipped despite
downturns in team luck. The two-time Cup
winner was a good choice to be loaned to Canada
for the '92 Olympics, winning a silver medal.

After being traded to Buffalo, Hannan punched
out future Leafs captain Mats Sundin in a scrappy
game against Quebec.

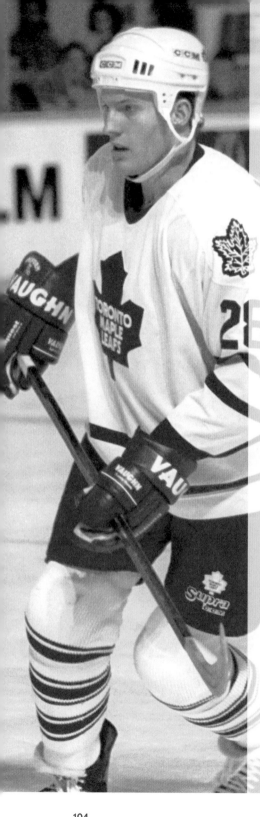

D **DAVID** #28, #38, #42
HARLOCK
(1993–96)

BORN: March 16, 1971, Toronto, Ontario
SIGNED: August 20, 1993, as a free agent
LEAF LINE: 8 GP 0 G 0 A 0 PTS 0 PIM

Harlock's time with the Leafs was split into three seasons amid numerous call-ups. His non-NHL career was interesting as well: three years as captain at Michigan and stints with the national team that included the '94 Olympics.

Harlock last played for the 2002–03 Philadelphia Phantoms, whose two top scorers were ex-Leafs Mark Greig and Peter White.

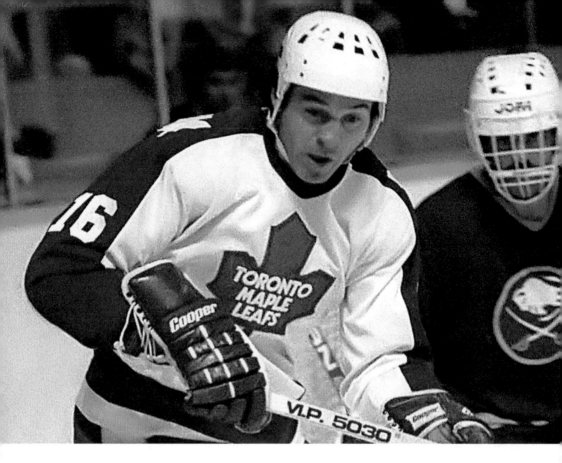

RW **BILLY** #16
HARRIS

(1981–84)

BORN: January 29, 1952, Toronto, Ontario

ACQUIRED: November 11, 1981, from Los Angeles with D John Gibson for D Ian Turnbull

LEAF LINE: 146 GP 20 G 29 A 49 PTS 44 PIM

Harris went from nine goals his first year with the junior Marlies to 13, 34 and 47. Alas, he would not get the chance to play at home until near the end of his career, making history as the first New York Islander taken in the '72 amateur draft. In that expansion, Toronto lost Brian Spencer and centre Tom Miller to the Isles, and left wing Bill MacMillan to the Atlanta Flames.

Harris now runs the Muskoka Candle Co. with its motto, "from hockey sticks to candlewicks."

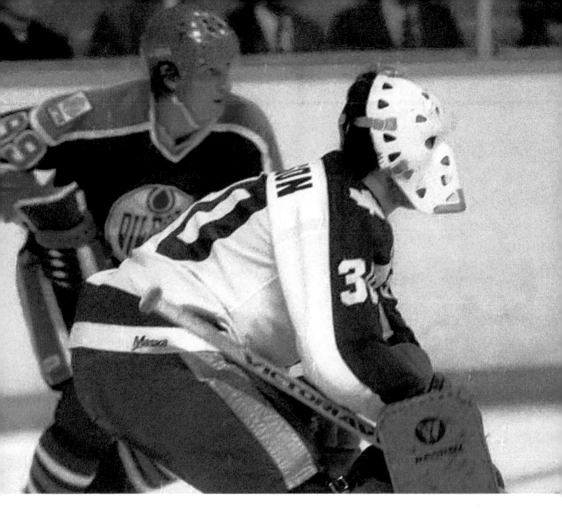

G **PAUL** **#30**
HARRISON
(1978–80)

BORN: February 11, 1955,
Timmins, Ontario

ACQUIRED: June 14, 1978, from
Minnesota for a 4th-round draft pick
(LW Terry Tait)

LEAF LINE: 55 GP 17 W 29 L 5 T 3.98 GAA

Harrison replaced Gord McRae as
Mike Palmateer's back-up, then was
challenged by youngsters Vincent
Tremblay, Czech import Jiri Crha and
veteran Curt Ridley. After a year on
the farm, he ended his NHL days in
1981–82 with Pittsburgh and Buffalo.

Harrison worked for the Ontario
Provincal Police for many years and is
now retired.

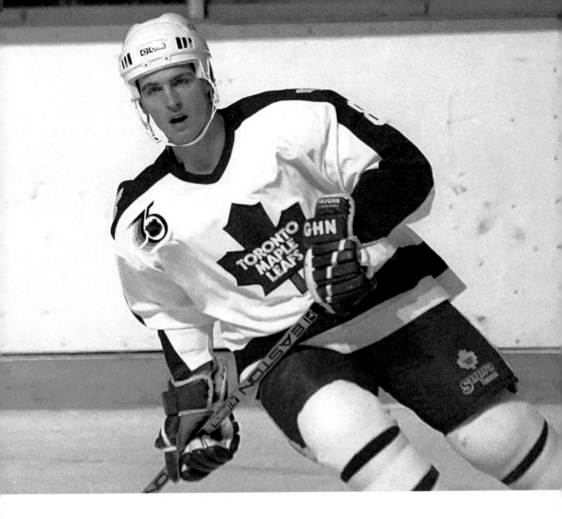

RW **TODD** #8
HAWKINS

(1991–92)

BORN: August 2, 1966,
Kingston, Ontario
ACQUIRED: January 22, 1991,
from Vancouver for D Brian Blad
LEAF LINE: 2 GP 0 G 0 A 0 PTS 0 PIM

Had Hawkins not separated his shoulder while leading St. John's in scoring he might have been given more of a chance. After another solid year on the farm with 62 points, he signed with Pittsburgh but failed to crack the big team there.

Hawkins and trademate Blad played for the same Belleville junior team.

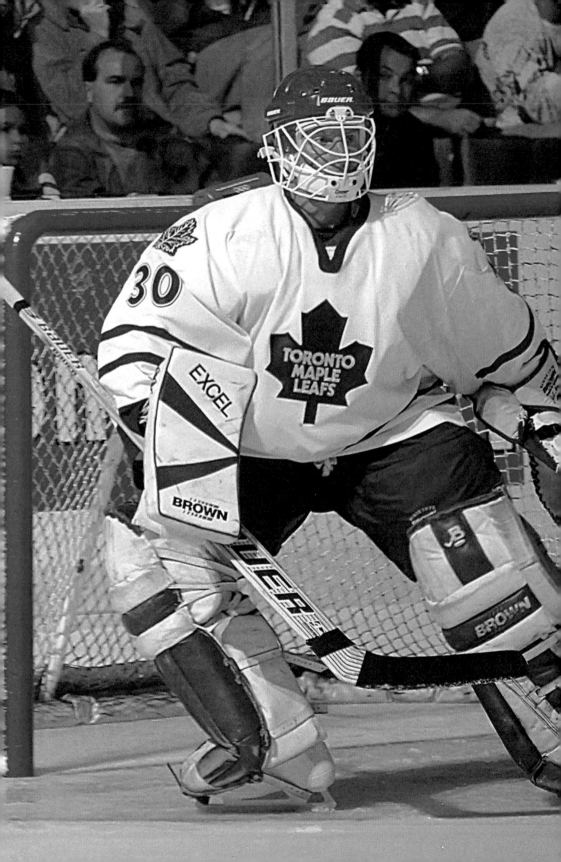

_G GLENN #30 HEALY

(1997–2001)

BORN: August 23, 1962, Pickering, Ontario
SIGNED: August 8, 1997, as a free agent
LEAF LINE: 65 GP 23 W 30 L 5 T 2.91 GAA

A Cup winner with the Rangers, Healy loved playing at the old
Gardens and was also the first to step on the ice when the ACC
first opened for practice.

A natural for TV with his edgy sense of humour, sharp mind for
history and eye for detail, he was also a spokesman for the players
during heated labour negotiations in three lockouts. Let go by *Hockey
Night in Canada* in the summer of 2016, there are predictions that
Healy might go into politics.

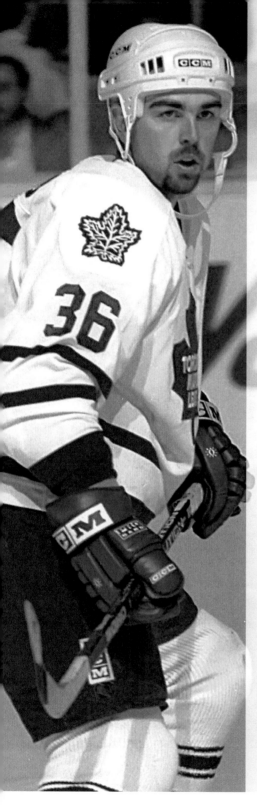

D **JAMIE** **#26, #36**
HEWARD
(1995–97)

BORN: March 30, 1971, Regina, Saskatchewan
SIGNED: May 4, 1995, as a free agent
LEAF LINE: 25 GP 1 G 4 A 5 PTS 6 PIM

With a heavy shot, Heward was a first-round pick of Pittsburgh in 1989 but didn't catch on and was looking for work after a year with the Canadian national team. He played well for the Leafs and St. John's, but his defensive side was a concern.

More than 12 years after his first Leafs stint ended, he ended up club property again. At the 2009 trade deadline, Toronto GM Brian Burke took on the salaries of four Tampa Bay players to help their cap relief, one of them Heward's. But he had post-concussion problems and wasn't going to play again.

LW **PAT** #15, #16
HICKEY
(1979–82)

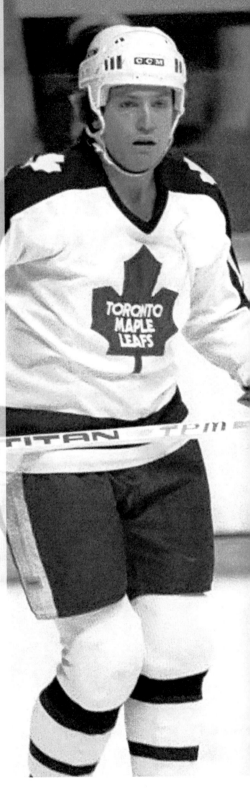

BORN: May 15, 1953, Brantford, Ontario
ACQUIRED: December 29, 1979, with RW Wilf
Paiement for RW Lanny McDonald and D Joel
Quenneville
LEAF LINE: 118 GP 38 G 49 A 87 PTS 65 PIM

Hickey had seen it all before coming to the Leafs: a
couple of years with the loons among the WHA's
Toronto Toros, a stint with the Rangers in the Big
Apple and a year under Don Cherry with Colorado.
So returning in the midst of the war among Harold
Ballard, Punch Imlach and Darryl Sittler hardly
upset him. "I came in each day to see who would be
coach, who was actually in charge and who owned
the team," Hickey joked of the turmoil.

But he became the flashpoint for an
escalation of hostilities. Sittler tore off his
captain's C after the trade and was just as upset
that Hickey and Paiement came in with salaries
equal to his $150,000 as he had a deal under
old boss Jim Gregory to be highest paid. The
newcomers actually made more than Sittler
because they were paid in U.S. dollars. Sittler
asked for a new deal and was refused, eventually
leading to his own trade.

Hickey came in to negotiate a new contract with
Imlach wearing a tie on a hot July day to psyche
out the boss.

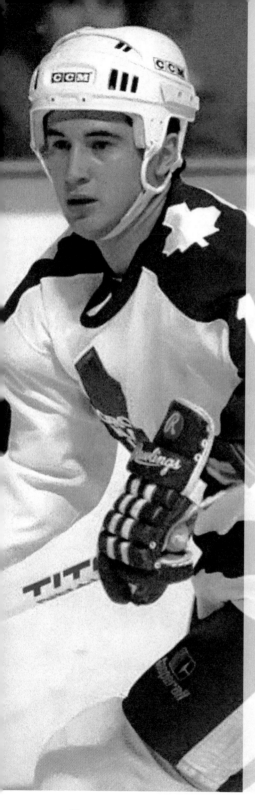

C **DAN** #16
HODGSON
(1985–86)

BORN: August 29, 1965, Fort Vermillion, Alberta
DRAFTED: 1983, 5th round, 85th overall
LEAF LINE: 40 GP 13 G 12 A 25 PTS 12 PIM

Hodgson was very productive in his half season. But there was little mention of his first game at the Gardens. It came the night of a Rick Vaive hat-trick in a disputed loss to Washington and the building half empty with the Blue Jays participating in their first playoff series against Kansas City. A two-goal game Hodgson had in Minnesota was eclipsed by the news of Vaive being stripped of his captaincy for missing a practice.

Hodgson was part of the '85 Prince Albert Raiders Memorial Cup team that included future Leafs Dave Manson, Ken Baumgartner, Curtis Hunt and coach Terry Simpson. He was also one of six future Leafs on Team Canada for the world junior tournament in 1984, joining Ken Wregget, Allan Bester, Jeff Jackson, Russ Courtnall and Gary Leeman. Hodgson notched seven points in seven games.

C **BENOÎT** #28, #32, #33
HOGUE

(1994–96)

BORN: October 28, 1966,
Repentigny, Quebec

ACQUIRED: April 6, 1995, from the
Islanders with a 3rd-round pick
(RW Ryan Pepperall) and 5th-round
pick (RW Brandon Sugden)
for G Eric Fichaud

LEAF LINE: 56 GP 15 G 28 A 43 PTS 68 PIM

The Leafs likely gave up too early on

Hogue, a proven two-way player who
would last another seven seasons with
various clubs. They dealt him to Dallas
with another like-minded forward, Randy
Wood, in hopes Dave Gagner would help
their playoff push in the spring of '96.
The Leafs crashed, while Hogue was on
the Stars' '99 Cup-winning club.

Included in Hogue's goal total with the
Leafs was an overtime winner on ex-Leaf
Daren Puppa in Tampa Bay, Toronto's
first in extra time against the Lightning.

D GREG #2, #4, #8
HOTHAM

(1979–82)

BORN: March 7, 1956, London, Ontario
DRAFTED: 1976, 5th round, 84th overall
LEAF LINE: 60 GP 4 G 11 A 15 PTS 21 PIM

He was an offensive defenceman with 60 assists one year with Saginaw of the IHL. Starting with a playoff appearance for the Dallas Black Hawks' farm team, Hotham would be in and out of the Leafs orbit for 12 years. Traded to Pittsburgh, he returned to play four seasons as a mentor in Newmarket.

His first Leafs game was part of a watered-down lineup for an exhibition against the Czech team Kladno after Harold Ballard finally dropped his opposition to visits by Eastern Bloc clubs.

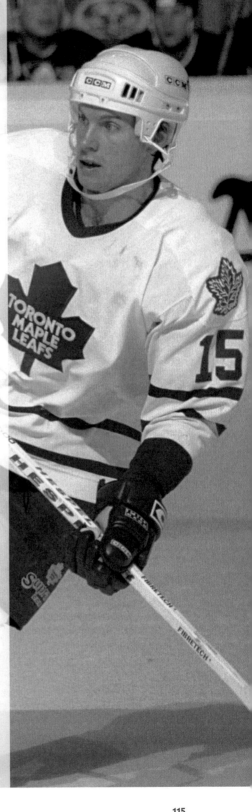

C**MIKE** #15
HUDSON
(1995–96)

BORN: February 6, 1967, Guelph, Ontario

SIGNED: August 28, 1995, as a free agent

LEAF LINE: 28 GP 2 G 0 A 2 PTS 29 PIM

He was a useful third and fourth liner when Burns had room to plug him in. Hudson was on a two-way deal after winning the Cup with the Rangers in '94.

After being claimed on waivers by the Blues, Hudson joined a number of ex-Leafs, including Grant Fuhr and Glenn Anderson, in eliminating Toronto in the first round of the '96 playoffs.

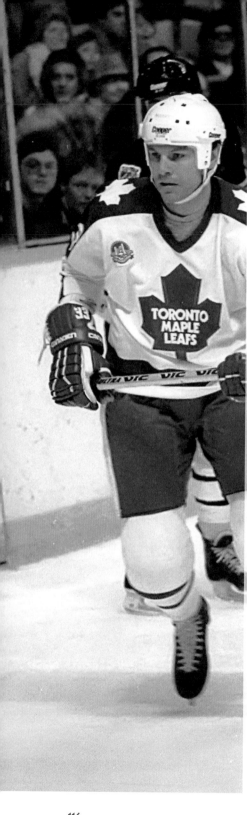

D **DAVE** #23, #33
HUTCHISON
(1978–80, 1983–84)

BORN: May 2, 1952, London, Ontario

ACQUIRED: June 14, 1978, from Los Angeles
with LW Lorne Stamler for D Brian Glennie,
RW Kurt Walker, C Scott Garland and a 2nd-
round pick (D Mark Hardy). Came back as
a free agent November 15, 1983.

LEAF LINE: 157 GP 5 G 24 A 29 PTS 400 PIM

After a shocking stick-swinging exchange
with Tiger Williams in the L.A. Forum penalty
box during the '75 playoffs, few wondered if
Hutch would be received well in Toronto. But
Dan Maloney had become a Leaf after roughing
up Glennie and there was a re-union of sorts
with him, Maloney and Sittler, all former
London Knights.

Hutchison infuriated the Atlanta Flames
in the 1979 playoff series, taunting them as the
Leafs emptied their bench with every goal in
celebration of a three-game sweep. It led to a
huge fight and the league used the incident to
ban teams from leaving their seats to take part in
such goal theatrics.

Hutchinson ran a Harley Davidson dealership
in London after he retired and became an active
member of the Leafs alumni, visiting Canadian
Forces personnel in Afghanistan.

LW **MIROSLAV** #27
IHNAČÁK
(1985–87)

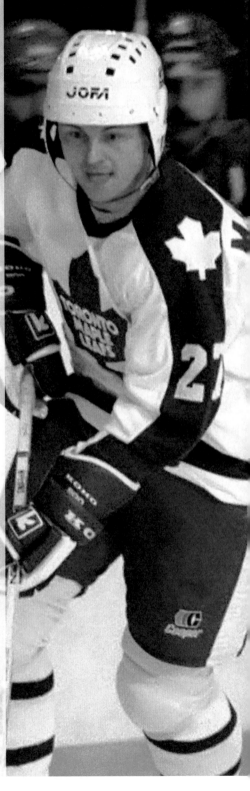

BORN: November 19, 1962,
Poprad, Czechoslovakia
DRAFTED: 1982, 9th round, 171st overall
LEAF LINE: 55 GP 8 G 9 A 17 PTS 39 PIM

Where to begin listing the mistakes in making
this move? There was faulty scouting of his play
in Europe as he turned out to be two or three
inches shorter than advertised. Then it cost the
Leafs nearly a million bucks to spring him from
behind the Iron Curtain. He was given #27 to
wear, still a sacred number in those days, and was
not at all the impact scorer that the Leafs hoped.

One of his first games did have a touch of
humour. A stranger to fighting, Ihnačák wound
up in the last bench-clearing brawl involving the
Leafs. With the Leafs comfortably ahead and the
game getting chippy, Red Wings coach Brad Park
sent his players over the boards. Detroit backup
goalie Eddie Mio thought Ihnačák would be a safe
target and grabbed the shocked newcomer.

Coach Dan Maloney, frustrated at what he
saw as lack of spirit by Ihnačák, once took his
equipment bag and threw it out the dressing room
door. Later, Ihnačák became an unrestricted
free agent and made it into one game for the Red
Wings, but all his 20- and 30-goal seasons came
much later still in Germany and Slovakia.

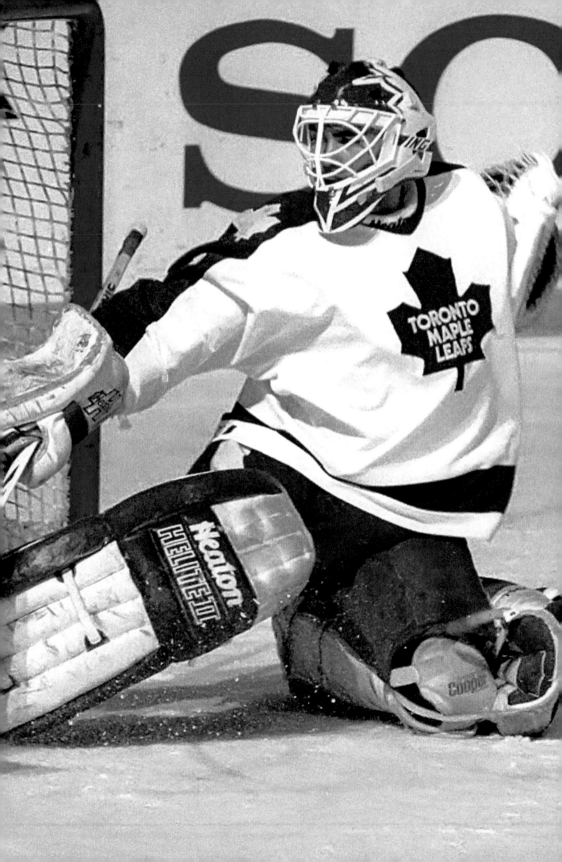

G **PETER** #1, #31
ING

(1989–91)

BORN: April 28, 1969, Toronto, Ontario
DRAFTED: 1988, 3rd round, 48th overall
LEAF LINE: 59 GP 16 W 29 L 8 T 3.91 GAA

Despite an ominous debut during which he allowed four goals on seven shots on Long Island, Ing did some quality netminding for the Leafs and set a record for rookie starts. He stopped the Kings' Wayne Gretzky on a 1991 penalty shot.

Ing's worst Leafs memory: "Walking into the Gardens, learning I was traded [to Edmonton] then having to dress in the opposing room within hours of the news."

Ing was one of the first clients of successful football agent Gil Scott as he tried to broaden into the hockey market, before it was known he'd become the top agent for NHL coaches and assistants. Ing now owns a hockey training products business and provides consulting, marketing and business advice through INGcorporated. Ing serves as president of the Leafs Alumni.

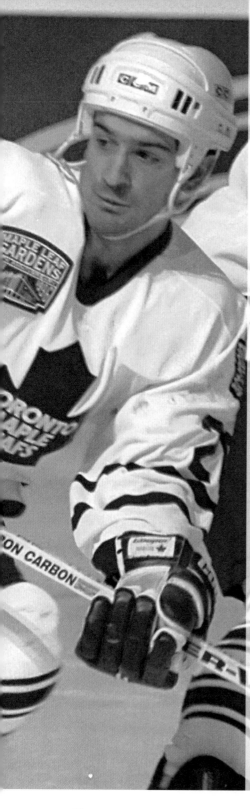

C **RALPH** #20
INTRANUOVO
(1996–97)

BORN: December 11, 1973, Toronto, Ontario
ACQUIRED: September 30, 1996, on waivers from
Edmonton
LEAF LINE: 3 GP 0 G I A I PTS 0 PIM

Used mostly on a third line with Jamie Baker
and Mike Craig, Intranuovo had a good game
against his old team in one of his three starts. But
the Oilers were miffed that Toronto had claimed
him, and when the Leafs tried to sneak him to the
farm just a few days later, Glen Sather took him
back off the wire.

Intranuovo on leaving the Leafs: "At least I
don't have to come up with all those expensive
tickets anymore."

LW JEFF #12, #25
JACKSON
(1984–87)

BORN: April 24, 1965, Chatham, Ontario
DRAFTED: 1983, 2nd round, 28th overall
LEAF LINE: 77 GP 9 G 10 A 19 PTS 90 PIM

Jackson jumped from junior to the Leafs, recording one assist in 17 games before returning to the Hamilton Steelhawks. A full year on the farm was still required before he bid for full-time employment in 1986–87 with a good season of two-way play. But restless management moved Jackson to the Rangers for Mark Osborne, losing a draft choice that became useful NHLer Rob Zamuner. Jackson's first NHL shift was against the other player of note from his hometown of Dresden, Ontario, Calgary Flame Ken Houston.

Jackson was a bookworm, studying law at the University of Western Ontario and eventually coming back to the Leafs as assistant to GM John Ferguson. The Brian Burke–era saw him depart, but Jackson remains in the game as a player agent with the Orr Hockey Group.

LW **VAL** #28
JAMES
(1986–87)

BORN: February 14, 1957, Ocala, Florida
SIGNED: October 3, 1985, as a free agent
LEAF LINE: 4 GP 0 G 0 A 0 PTS 14 PIM

James grew up on Long Island, a minor hockey
player and fan of John Brophy's Ducks, which
preceded the NHL Islanders. As a young black
man in a non-traditional NHL market, the sport
was an unusual career choice. But James had
received skates on his 13th birthday and became
good enough to play junior in Quebec and get
drafted by Detroit.

When James and Brophy were together on
the St. Catharines Saints, Brophy would tell
the muscular James to take his shirt off and
hang around the other team's dressing room
to intimidate.

James detailed his career in a book,
Black Ice (ECW Press, 2015).

C **WES #11, #12**
JARVIS
(1984–88)

BORN: May 30, 1958, Toronto, Ontario
SIGNED: October 2, 1984, as a free agent
LEAF LINE: 29 GP 1 G 1 A 2 PTS 4 PIM

Jarvis took the long way home to his birthplace, picked in the 200s of the '78 draft and making stops in Washington, Minnesota and L.A. Like his cousin Doug (a one-time Leaf pick), he excelled as a defensive player, though he could score as seen by his output as a Sudbury junior.

Jarvis and ex-Leaf Mike Gartner now work with National Training Rinks, smaller reconfigured surfaces that help with better hockey instruction.

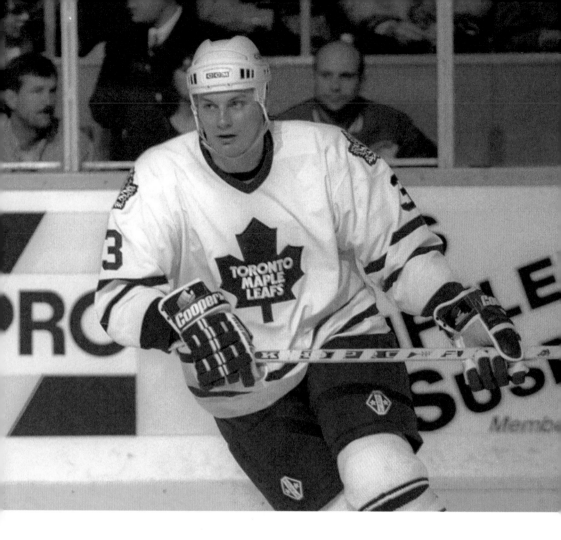

D **GRANT** #3
JENNINGS
(1994–95)

BORN: May 5, 1965, Hudson Bay,
Saskatchewan
ACQUIRED: April 7, 1995, from
Pittsburgh for D Drake Berehowsky
LEAF LINE: 10 GP 0 G 2 A 2 PTS 7 PIM

Employed as playoff insurance (four games against the Hawks), the Leafs had hoped to sign him to a long-term deal. But the 31-year-old wanted to test free agency in the summer of '95 and was able to play a bit with Buffalo.

The veteran of nearly 400 NHL games was nicknamed Old Yeller after the famous Disney dog movie.

D **TREVOR** #2, #4
JOHANSEN
(1977–79, 1981–82)

BORN: March 30, 1957, Thunder Bay, Ontario
DRAFTED: 1977, 1st round, 12th overall
LEAF LINE: 132 GP 4 G 21 A 25 PTS 134 PIM

While Marlies teammate and fellow first rounder John Anderson thrived at MLG, a stacked Leafs defence made it harder for Johansen. He did get playing time when Borje Salming was hurt in the '78 playoff run before a trade to Colorado. When the Kings put him on waivers after a half season, he was able to wrap up his career where it started.

Three Marlies juniors were taken 10th through 12th in the '77 draft: Mark Napier (Montreal), followed by Anderson and Johansen. But the Leafs let Mike Bossy get by while another Marlie, John Tonelli, went 33rd overall to the Islanders.

His father, Bill, also played for the Leafs and Marlies.

D **TERRY** #20
JOHNSON
(1986–87)

BORN: November 28, 1958, Calgary, Alberta
ACQUIRED: October 3, 1986, from Calgary
for F/D Jim Korn
LEAF LINE: 48 GP 0 G I A I PTS 104 PIM

Quebec, St. Louis and Calgary had all utilized Johnson's stay-at-home strength, and he had played 17 playoff games for the Flames in their brush with the Cup in '86.

Johnson was coached by Jacques Demers with the Nordiques farm team in Fredericton, New Brunswick, in the early '80s, later playing for Demers in St. Louis and against him in various Norris Division wars with the Leafs.

RW **GREG** #16
JOHNSTON
(1990–92)

BORN: January 14, 1965, Barrie, Ontario
ACQUIRED: June 29, 1990, from the Rangers
for RW Tie Domi and G Mark Laforest
LEAF LINE: 4 GP 0 G 1 A 1 PTS 5 PIM

Johnston was a Boston draft pick, once called up
from the Marlies to play for the black and gold at
the Gardens. At the time of this trade, Domi was
an unpolished sluggo, but he refined his game in
New York as well as engaged in vintage bouts
with Detroit's Bob Probert.

The Leaf games were the last in Johnston's NHL
career, but he played 10 more seasons in Germany
and Sweden. With Örnsköldsvik in Sweden, he
played with future Leaf Pierre Hedin.

D KENNY #19 JÖNSSON

(1994–96)

BORN: October 6, 1974,
Ängelholm, Sweden

DRAFTED: 1993, 1st round, 12th overall

LEAF LINE: 89 GP 6 G 29 A 35 PTS 38 PIM

A promising part of Toronto's future,

the young member of the Swedish national team was sacrificed in ownership's wish to get Clark back after the Mats Sundin trade. Jönsson eventually became captain of the Isles, staying nine seasons.

Jönsson's Leafs debut on January 20, 1995, in L.A. was overshadowed by Sundin's first game for Toronto.

D **ALEXANDER** #52
KARPOVTSEV
(1998–2000)

BORN: April 7, 1970, Moscow, Russia
ACQUIRED: October 14, 1998, from the Rangers
with a 4th-round pick (LW Mirko Murovic)
for D Mathieu Schneider
LEAF LINE: 125 GP 5 G 39 A 44 PTS 106 PIM

A messy contract squabble with Schneider led
to a summer-long dance between the Rangers
and Leafs to complete a trade. In the end,
associate GM Mike Smith picked up another in
his collection of Russians that he favoured since
working with the Winnipeg Jets. When Smith
moved to Chicago within the year, Karpovtsev
joined him in a trade for future all-star Bryan
McCabe. Tragically, Karpovtsev and fellow
former Leaf Igor Korolev died in the Lokomotiv
Yaroslavl plane crash on September 7, 2011.

Karpovtsev, Alexei Kovalev, Sergei Zubov and
Sergei Nemchinov made history in 1994 as the
first Russian players to get their names on the
Cup when the Rangers won the Finals.

C **MIKE** #14, #16, #20
KASZYCKI
(1979–83)

BORN: February 27, 1956, Milton, Ontario
ACQUIRED: February 16, 1980, from Washington
for D Pat Ribble
LEAF LINE: 53 GP 5 G 19 A 24 PTS 22 PIM

While many ex-Marlie junior mates were Leafs
in 1977–78, Kaszycki was on the opposition side
in the seven-game playoff saga against the Isles.
Two springs later, the Leafs fetched him from
Washington for depth up front. After spending
all of 1981–82 in New Brunswick where he
potted 118 points, he had another 22-game NHL
trial. When Toronto moved its affiliate to St.
Catharines, Kaszycki again reached 100 points.

Though Kaszycki had 119 assists in the Soo his
draft year and went 32nd overall to New York,
the Leafs liked another northern-based junior,
selecting Sudbury defenceman Randy Carlyle
30th.

C **MIKE** #34
KENNEDY
(1997–98)

BORN: April 13, 1972, Toronto, Ontario
SIGNED: July 2, 1997, as a free agent
LEAF LINE: 13 GP 0 G 1 A 1 PTS 14 PIM

The Leafs had tried to pry Kennedy away from
Dallas via trade, but went the free-agent route
with him to bolster their third line. Kennedy
had been moved throughout the Stars lineup,
including time at first line centre in place of Mike
Modano. He was a training camp cut in Toronto
as Alyn McCauley and Kevyn Adams played
well. After Kennedy broke his nose after taking a
puck in the face, he was returned to Dallas for an
8th-round pick.

Kennedy scored high on conditioning tests,
having come from an athletic family — his sister
Danielle was a competitive swimmer. Upon
retirement he opened an all-sports training
facility for kids in Oakville, Ontario.

LW **DEREK** #7
KING
(1997–2000)

BORN: February 11, 1967, Hamilton, Ontario
SIGNED: July 4, 1997, as a free agent
LEAF LINE: 161 GP 45 G 53 A 98 PTS 65 PIM

With the Leafs getting little value for their money with free-agent
scorers through the years, King gave them two 20-goal seasons.
He would also contribute years later as assistant coach and later
associate coach of the AHL Marlies under Dallas Eakins, Steve Spott
and Gord Dineen. King's last job was assistant coach of the OHL's
Owen Sound Attack.

King might have become a Leaf on draft day in 1985 had Islanders
GM Bill Torrey convinced Toronto to part with the No. 1 pick. With
time ticking down towards the Leafs making their announcement,
Torrey offered the 6th and 13th selections for top pick, which they
would've also used on Wendel Clark.

Toronto's staff considered it but stuck with Clark while the Isles
took King and Brad Dalgarno.

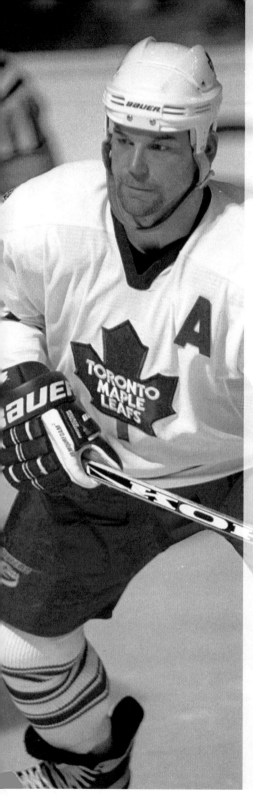

LW **KRIS** #12
KING

(1997–2000)

BORN: February 18, 1966, Bracebridge, Ontario
SIGNED: July 23, 1997, as a free agent
LEAF LINE: 188 GP 7 G 9 A 16 PTS 359 PIM

It was a good choice to make King a public service spokesman for Crimestoppers during his time in Toronto, as he rode shotgun for a number of non-combative skilled mates. His most memorable time might have been on the Three Kings line with namesake Derek and Igor Korolev, whose Russian surname translates to king. Kris King listed his worst Leaf memory as playing in the Gardens' closing in a whitewash loss to Chicago. "A great building and an awful game," he lamented.

King was put on the spot when Leafs president Ken Dryden called for the abolition of fighting in 1997. "I have to look at it as a guy who got his chance to play in the NHL because of fighting," King said diplomatically. "I got my foot in the door and it has given some others a chance to make a career for themselves." He's now a VP of NHL hockey operations.

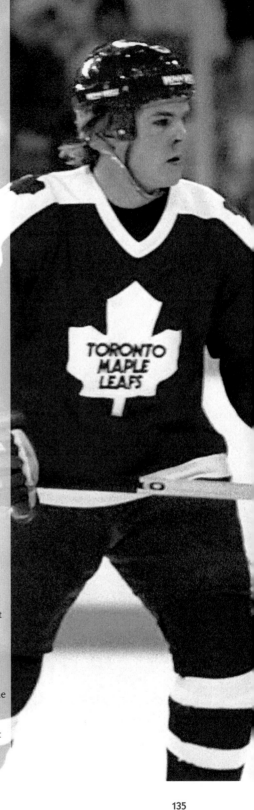

C **MARK** #20
KIRTON
(1979–81)

BORN: February 3, 1958, Regina, Saskatchewan
DRAFTED: 1977, 3rd round, 48th overall
LEAF LINE: 13 GP I G O A I PTS 2 PIM

Kirton was a good Roger Neilson junior student
in Peterborough and made the Memorial Cup
All-Star Team in '78. He opened 1979–80
with the Leafs but needed seasoning in New
Brunswick. When the Leafs required veteran
goaltending help the next year, they sacrificed
Kirton to Detroit for Jim Rutherford. Kirton's
best NHL days were there and later Vancouver,
but he returned to the fold as a Newmarket Saint
from 1987–89.

Kirton scored his first goal in his first NHL game
against ex-Leaf Wayne Thomas, then with the
Rangers. He's been a successful real estate agent
in Oakville, Ontario, for many years.

D **BILL** #26
KITCHEN
(1984–85)

BORN: October 2, 1960,
Schomberg, Ontario
SIGNED: August 16, 1984, as a free agent
LEAF LINE: 29 GP 1 G 4 A 5 PTS 27 PIM

A non-drafted player, Kitchen was still able to get on the rosters of Canada's two most famous teams. Putting in time with the Nova Scotia Voyageurs under John Brophy, he scraped his way into a competitive Canadiens lineup for a total of 12 games in three seasons. Kitchen played high-energy games for the Leafs, but his enthusiasm could not do much for a bad team.

A shot by Jim Benning deflected up and hit Kitchen in the jaw during a practice in Windsor, Ontario, ending his season. He played one more year on the farm.

Kitchen, whose brother Mike was a Leafs assistant coach, passed away suddenly in the summer of 2012.

Kitchen's work with minor hockey as a Tim Hortons franchisee in the Ottawa area led his Junior 67s team to name a community award in his memory.

C **MARK** #37
KOLESAR
(1995–97)

BORN: January 23, 1973, Neepawa, Manitoba
SIGNED: May 24, 1994, as a free agent
LEAF LINE: 28 GP 2 G 2 A 4 PTS 14 PIM

Kolesar twice flirted with 30 goals and had more
than 100 penalty minutes with the Brandon Wheat
Kings. But he had a penchant for "river hockey"
according to Pat Burns and couldn't hold a regular
place in the lineup on a healthy roster.

Kolesar's first road trip with the Leafs brought
him to Winnipeg, within driving distance of his
family's grain and cattle farm.

RW **JOHN** #27
KORDIC
(1988–91)

BORN: March 22, 1965, Edmonton, Alberta
ACQUIRED: November 7, 1988, from Montreal
with a 6th-round pick (RW Mike Doers)
for RW Russ Courtnall
LEAF LINE: 104 GP 10 G 6 A 16 PTS 446 PIM

More than 25 years later, former GM Gord
Stellick is still hearing about this one-sided
trade. "When Punch traded Lanny McDonald
to Colorado he went right out of sight," Stellick
told the *Toronto Sun*. "Unfortunately for me,
it seemed Russ was on TV every Saturday in
Montreal, with his perfect teeth and scoring four
goals a night. He was a sexy player, but when
you saw Kordic . . ."

Kordic's train wreck career of substance
abuse contributed to his early death at 27.

His wild life, from a young altar boy to his final
hours in a violent struggle with police, was
detailed in *The John Kordic Story* by Toronto
journalist Mark Zwolinski.

LW/D **JIM** #20
KORN

(1981–85)

BORN: July 28, 1957, Hopkins, Minnesota

ACQUIRED: March 8, 1982, from Detroit for a 4th-round pick (C Craig Coxe) and a 5th-round pick (D Joey Kocur)

LEAF LINE: 197 GP 26 G 43 A 69 PTS 708 PIM

Korn twice led the Leafs in penalty minutes between '82 and '84. In his second home game as a Leaf on Saint Patrick's Day in '92, he fought Quebec Nordiques tough guy Wally Weir on the ice. The bout moved into the tight confines of the Gardens penalty box as timekeeper Joe Lamantia scrambled out of the way. Among his 12 goals in 1983–84 was the club's first hat-trick against the New Jersey Devils.

Korn could have been picked up on waivers months earlier, but the Leafs ended up going the trade route. Coxe and Kocur went on to serve plenty of time in the penalty box themselves with various teams. When they'd retired, a combined 3,232 minutes was on their rap sheet; combined with Korn's penalty minutes, they tallied 5,033 in the trade.

Korn was a prime candidate to become an executive when his college coach Lou Lamoriello joined the Devils, but the latter chose not to expand his front office.

D **CHRIS** #26
KOTSOPOULOS

(1985–89)

BORN: November 27, 1958,
Scarborough, Ontario
ACQUIRED: October 7, 1985,
from Hartford for F Stew Gavin
LEAF LINE: 182 GP 11 G 37 A 48 P 221 PIM

Kotsy was effective physically and managed to
keep his plus-minus-respectable in a terrible era
of Leafs team defence. He went to Detroit as
a free agent with Borje Salming at the end of
1988–89 in a full blue line housecleaning. Now a
media analyst in the New York market, he didn't
hesitate to say where the Leafs went wrong in the
turbulent '80s:

*Dan Maloney was just getting comfortable with the
transition from player to coach [in the spring of '86].
He'd learned to handle the veterans and kids. He
asked for a minimal raise and was politely told to
get lost. Imagine that. He went to Winnipeg, and
a team with decent youth was then handed over to
John Brophy. You know the story from there."*

Kotsopoulos was a chain smoker and often
unnerved the media during interviews by
lighting up with the blowtorch players used to
curve their sticks.

C **ALEXEI** #20
KUDASHOV
(1993–94)

BORN: July 21, 1971, Elektrostal, Russia
DRAFTED: 1991, 5th round, 102nd overall
LEAF LINE: 25 GP 1 G 0 A 1 PTS 4 PIM

No doubt the young Olympian had speed (he flattened an unsuspecting Wendel Clark in an exhibition game),

but he struggled to play in traffic and that meant Pat Burns wasn't in a rush to use him. He did get in a couple of games during the Leafs' record 10-game winning streak in October.

Kudashov was still active in 2012 as captain of Dynamo Moscow's KHL champions. He no longer plays, but is now coach of Yaroslavl in the KHL.

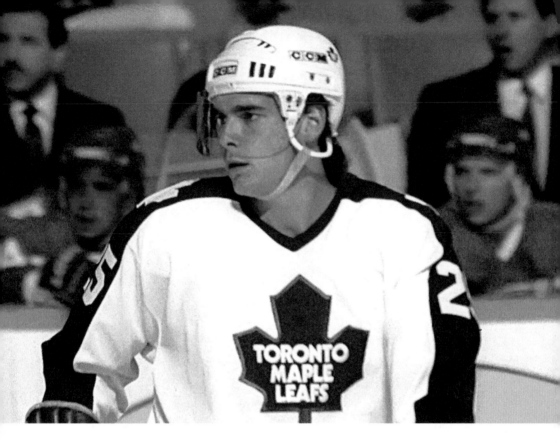

D **TOM** #25
KURVERS
(1989–91)

BORN: September 14, 1962,
Minneapolis, Minnesota
ACQUIRED: October 16, 1989, from
New Jersey for a 1st-round pick
(D Scott Niedermayer)
LEAF LINE: 89 GP 15 G 40 A 55 PTS 37 PIM

This was GM Floyd Smith's most
controversial deal — and one that
rates among the worst in team history.

Kurvers was a useful offensive player
and a member of the '86 Canadiens title
team, but as the Leafs nosedived the lost
pick turned out to be Toronto's ticket
in the Eric Lindros sweepstakes. More
rushed deals followed to avoid finishing
last, yet the Devils still picked up a
franchise player in Niedermayer.

To make things worse, Kurvers had at
first refused to report to the Leafs. After
trading him to Vancouver for forward
Brian Bradley, the Leafs lost Bradley to
Tampa Bay for nothing.

LW NICK #32
KYPREOS

(1995–97)

BORN: June 4, 1966, Toronto, Ontario

ACQUIRED: February 29, 1996, from the Rangers
with RW Wayne Presley for LW Sergio
Momesso and RW Bill Berg

LEAF LINE: 54 GP 4 G 3 A 7 PTS 92 PIM

Kypreos's days as a Leaf were marred by two
injuries: a broken ankle and a severe concussion
that ended his career. He played 442 NHL games
with more than 1,000 penalty minutes as a valued
cop but liked to boast he once was a scorer of
note — 62 goals one year for the North Bay
Centennials. Currently an analyst for Sportsnet
on TV, Kypreos was also at the centre of a crease
crashing incident in the '96 playoffs against St.
Louis when he took ex-Leaf Grant Fuhr out
of the series. Many thought St. Louis won that
series because Jon Casey replaced Fuhr.

Ryan VandenBussche, a one-time Leafs prospect
who left Kypreos's career in a pool of blood at
Madison Square Garden in the latter's final NHL
game, says both men have moved on.

"Nick and I have talked about it since and
there's no hard feelings," VandenBussche said
a few years ago. "It could easily have happened
to me."

LW **ERIC** #41
LACROIX
(1993–94)

BORN: July 15, 1971, Montreal, Quebec
DRAFTED: 1990, 7th round, 136th overall
LEAF LINE: 3 GP 0 G 0 A 0 PTS 2 PIM

Lacroix was called up from St. John's and injected in the lineup for an early season westward road trip when Burns had injury issues and sensed some players were getting too complacent. Less than a year later, he was part of a six-player deal with the Kings, primarily to bring in winger Dixon Ward.

Lacroix's father, Pierre, was GM of the Nordiques when the Mats Sundin trade was made, and Eric later joined Dad in the Colorado Avalanche front office.

G **MARK** #1
LAFOREST
(1989–90)

BORN: July 10, 1962, Welland, Ontario

ACQUIRED: September 8, 1989, from Philadelphia for a 5th-round pick (transferred to Winnipeg which took C Juha Ylönen) and a 7th rounder (LW Andrei Lomakin)

LEAF LINE: 27 GP 9 W 14 L 3.89 GAA

Trees was a combative keeper for 5-foot-11, and his early work helped him edge Allan Bester out of the picture. But a freak ankle injury kept him sidelined later in the year.

During a brawl with the Devils, Laforest came down the ice to fight opposite number Sean Burke. An unwise move as Burke had a height advantage and boxing experience, but Laforest's bravery provided a big charge for teammates in a video seen countless times.

LW **LARRY LANDON** #11

(1984–85)

BORN: May 4, 1958, Niagara Falls, Ontario
ACQUIRED: February 14, 1985, from Montreal
for D Gaston Gingras
LEAF LINE: 7 GP 0 G 0 A 0 PTS 2 PIM

Landon was a Montreal pick, helped by his
freshman year at college with the RPI Engineers.
That team included future San José Sharks coach
Kevin Constantine in net. But Landon wasn't
providing a good return, considering all that
Gingras had done for the Leafs. He did have
a 57-point year for St. Catharines when not in
the Leafs lineup.

He failed his medical at the Leafs camp in
1985 due to an arthritic hip.

For more than 20 years, Landon has been
running the Professional Hockey Players'
Association, a minor league union that has done
much to help non-NHLers.

D **RICK** #4 **LANZ**

(1986–89)

BORN: September 16, 1961, Karlovy Vary, Czechoslovakia

ACQUIRED: December 2, 1986, from Vancouver for D Jim Benning and C Dan Hodgson

LEAF LINE: 151 GP 9 G 50 A 59 PTS 115 PIM

His decent tenure with the Leafs, despite all the club's setbacks in the '80s, ended with a sporadic contribution in 1989–90 because of shoulder problems. Lanz had better numbers during a long stint in Vancouver, but there were some unfair expectations of him as Leaf.

Lanz became a Junior A coach of note in the Vancouver area, helping Scott Gomez, Kyle Turris and Milan Lucic get to the NHL. Benning's time as a player in Vancouver was short, but the Western Canadian made a name for himself in management and is now the Canucks' GM.

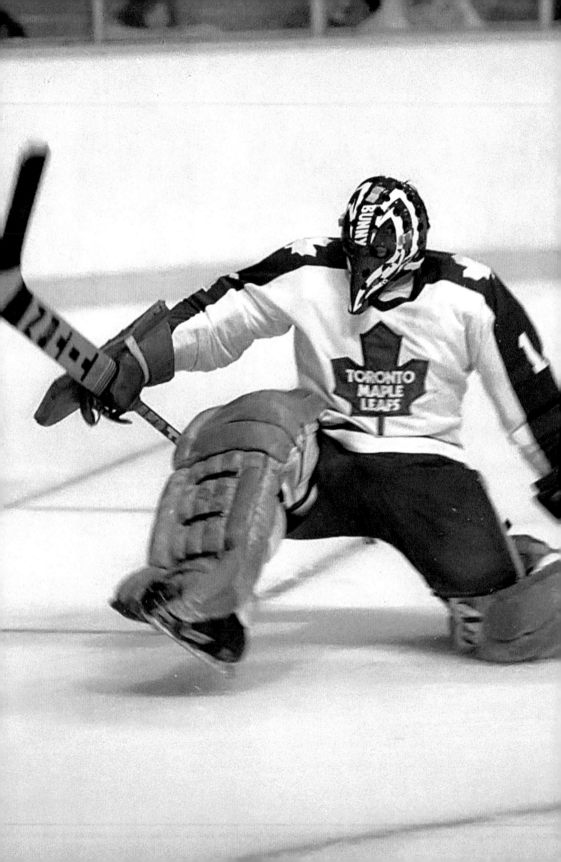

G MICHEL #1 LAROCQUE

(1980–83)

BORN: April 16, 1952, Hull, Quebec
ACQUIRED: March 10, 1981 from Montreal for D Robert Picard
and an 8th-round pick (D Steve Smith)
LEAF LINE: 74 GP 16 W 35 L 13 T 4.79 GAA

Michel "Bunny" Larocque was used to being surrounded by great
players in Montreal, but was thrown to the wolves with an inept Leafs
team trying to adjust to life without Mike Palmateer. Shortly after
arriving, Bunny was caught in net for the Buffalo Sabres' record nine
goals in one period in a 14–4 loss.

Larocque had the added discomfort of the gunk, a mysterious
skin irritation going around the league at the time, but he gutted it
out. His best game was likely a 7–1 win over the Oilers, when he
stopped Wayne Gretzky on a penalty shot.

Larocque eventually departed in a 1983 trade that brought
Rick St. Croix from the Flyers. Sadly, Larocque died of brain
cancer in 1992.

Because Larocque started the 1980–81 season with the Habs, his name
and that of the Leafs remains on the Vezina Trophy, the last Toronto
goalie so honoured to date.

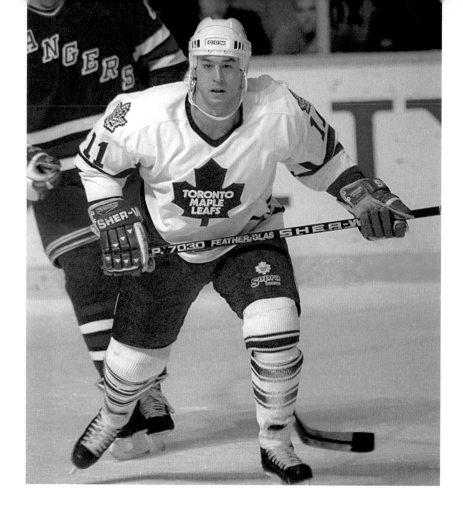

C **GUY** #11
LAROSE
(1991–94)

BORN: August 31, 1967, Hull, Quebec
ACQUIRED: December 26, 1991, from
the Rangers for LW Mike Stevens
LEAF LINE: 53 GP 10 G 7 A 17 PTS 45 PIM

While Wendel Clark was serving a
three-game suspension, the son of
Canadiens multiple–Cup winner
Claude Larose made it in the lineup.
The spitting image of his dad, though
smaller at 5-foot-9, Guy usually
energized the Leafs when on call
from St. John's.

Larose was originally an 11th-round pick
of the Sabres under GM Scotty Bowman,
who had coached Claude in Montreal.
Claude was a scout for Hartford/Carolina.

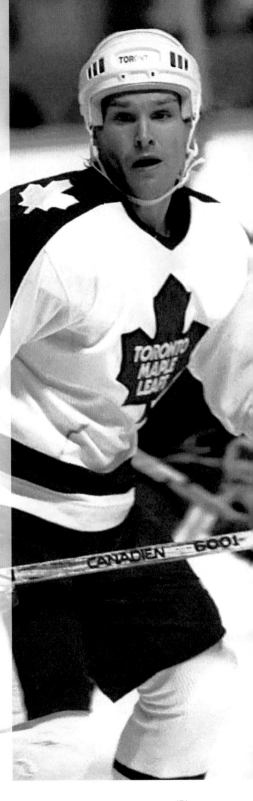

RW **CRAIG** #14, #18
LAUGHLIN
(1988–89)

BORN: September 14, 1957,
Toronto, Ontario
SIGNED: June 10, 1988, as a free agent
LEAF LINE: 66 GP 10 G 13 A 23 PTS 41 PIM

Moved a few times in his career, Laughlin
hoped to be part of a hometown resurgence
but ended up publicly critical of where the
Leafs were headed.

The Capitals, the team he knew best from
a six-year stay in D.C., beckoned him almost
from the moment the Leafs released him.
Laughlin has been a TV analyst there for
25 years.

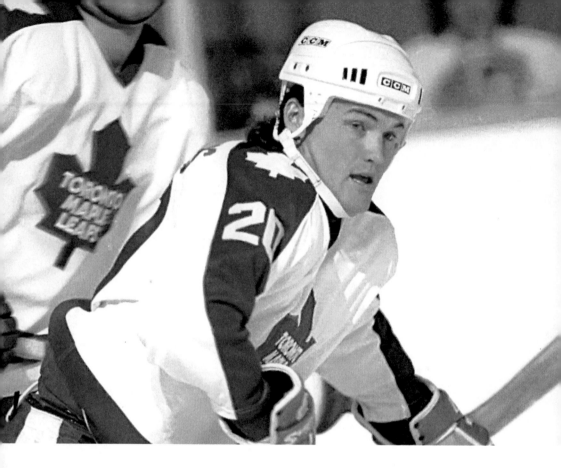

LW PAUL #20 LAWLESS

(1988–90)

BORN: July 2, 1964,
Scarborough, Ontario

ACQUIRED: February 25, 1989, from
Vancouver for C Peter DeBoer

LEAF LINE: 13 GP 0 G 1 A 1 PTS 0 PIM

This speedster from the Windsor
Spitfires played for Hartford,
Philadelphia and Vancouver before
joining the Leafs. Irate at a demotion
after six games to open the 1989–90
season, he blasted coach Doug Carpenter
and GM Floyd Smith and didn't wait for
the fallout trade before stomping out the
door. He took a hiatus and later played
10 more minor league seasons.

Lawless shares the Hartford/Carolina
record of six points in one game,
accomplished against the Leafs on
January 4, 1987. The co–record holder
is Ron Francis, another one-time Leaf.

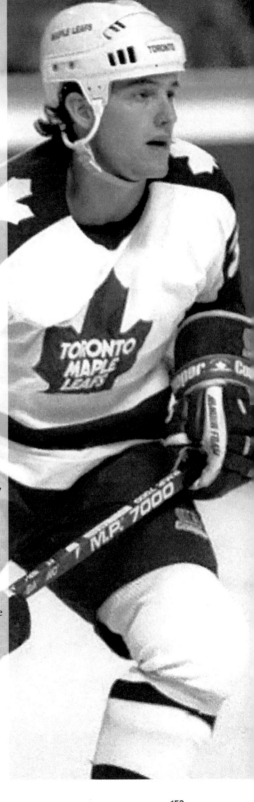

RW DEREK #15, #28, #34, #35 LAXDAL

(1984–89)

BORN: February 21, 1966, Gimli, Manitoba
DRAFTED: 1984, 8th round, 151st overall
LEAF LINE: 51 GP 9 G 6 A 15 PTS 84 PIM

Laxdal made it into three Leafs games while still
a 61-goal scorer in Brandon, but his best year
was under Brophy. "John demanded hard work,"
Laxdal said. "That's a little life lesson; you have
to work hard at everything you do, if you're
playing hockey or working in the trades. Play
for the love of the game, don't play for the pay
cheque. If you love the game and you're playing
it for the right reason, you're going to take a little
bit of Broph and implement it."

Laxdal did apply that philosophy in coaching,
first with the 2014 Memorial Cup champion
Edmonton Oil Kings, currently with the Dallas
Stars farm team in Austin.

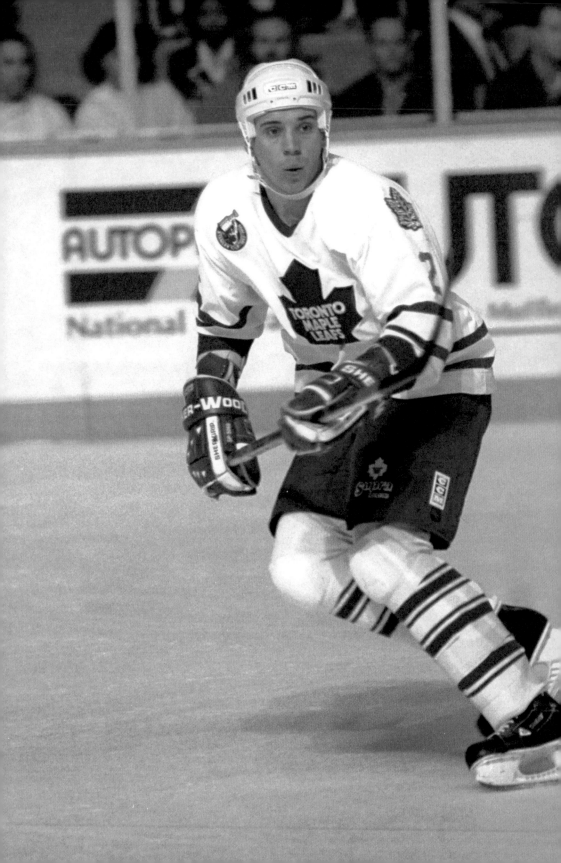

D **SYLVAIN** #2
LEFEBVRE
(1992–94)

BORN: October 14, 1967, Richmond, Quebec
ACQUIRED: August 20, 1992, from Montreal
for a 3rd round pick (D Martin Belanger)
LEAF LINE: 165 GP 4 G 21 A 25 PTS 169 PIM

Pat Burns needed some dependable players in his new job, so he
brought in one of the most reliable defencemen he'd coached in
Montreal. Huge in shutdown situations, Lefebvre played all 39 playoff
games Toronto had the next two seasons. Naturally, the Nordiques
insisted on having him as part of the Sundin-Clark trade.

Lefebvre, who helped achieve the Avalanche's first Cup in '96,
played briefly with Joe Sacco on the Leafs. Years later, Lefebvre
would launch his coaching career as Sacco's assistant in charge
of Colorado's defence. He then became head coach of Montreal's
AHL farm team in St. John's.

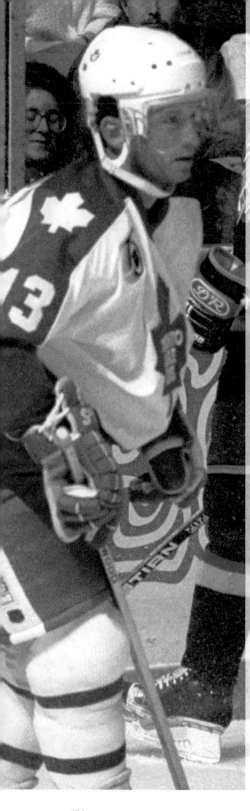

C **KEN** #13
LINSEMAN
(1991–92)

BORN: August 11, 1958, Kingston, Ontario
ACQUIRED: October 7, 1991,
sold to the Leafs by Edmonton
LEAF LINE: 2 GP 0 G 0 A 0 PTS 2 PIM

A late throw-in to the major Leafs-Oilers trade
the month before (helping the cash-strapped
Oilers), Linseman was on for two goals
against in his second and ultimately final Leafs
appearance. It was also the last NHL game
for The Rat.

Linseman was the second Leaf to wear #13 after
Ken Yaremchuk and the last before Mats Sundin
made it an honoured number.

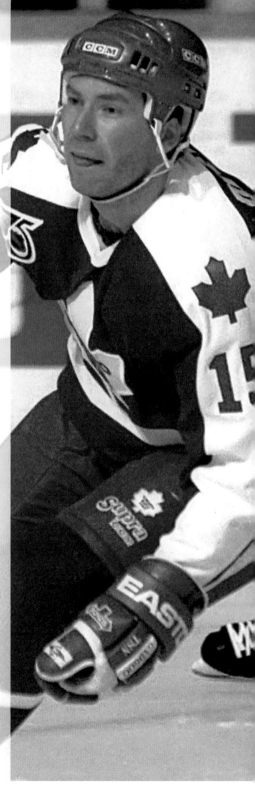

C **CLAUDE** #15
LOISELLE
(1990—92)

BORN: May 29, 1963, Ottawa, Ontario
ACQUIRED: March 5, 1991,
claimed on waivers from Quebec
LEAF LINE: 71 GP 7 G 10 A 17 PTS 104 PIM

Loiselle wound up in Toronto on trade deadline
day in a bizarre episode. The Nords briefly put
Loiselle on waivers, then tried to rescind it to
make a deal with Calgary for left wing Bryan
Deasley. NHL president John Ziegler ruled
against Quebec, so the Leafs, as the lowest seeded
team at the time, had first crack at a claim.

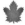

Loiselle and Deasley took new hockey paths.
Loiselle became a league executive and later
assistant GM of the Leafs, while Deasley,
who never played an NHL game, became
a player agent.

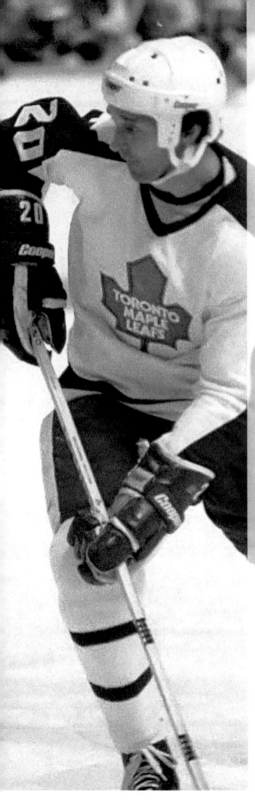

C **DON** #20
LUCE

(1981–82)

BORN: October 2, 1948, London, Ontario
ACQUIRED: August 10, 1981, from Los Angeles
for D Bob Gladney and a 6th-round pick
(LW Kevin Stevens)
LEAF LINE: 39 GP 4 G 4 A 8 PTS 32 PIM

At times it seemed Imlach was going to bring
back every one of his Buffalo Sabres to Toronto
during his second coming. Too bad it wasn't a
vintage Gilbert Perreault, though Luce gave his
usual honest effort in the half season he played.

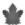

While Luce was a rookie with the Rangers
in the early '70s, he became close with Leafs
great Tim Horton, who'd been traded there for
Jacques Plante, Denis Dupéré and Guy Trottier.
As Horton's donut empire was in its formative
stages, he and Luce would go to various stores
and taste samples.

Luce and ex-Leafs Jim Benning and Gerry
Meehan were also the key Sabre hockey office
people involved in the successful defection of
Alexander Mogilny from the Soviet Union. They
also brought plenty of talent to the small market
franchise via the draft, but their reward was to all
be dismissed around the 2004 lockout when Sabres
ownership decided to cut costs and scout by video.

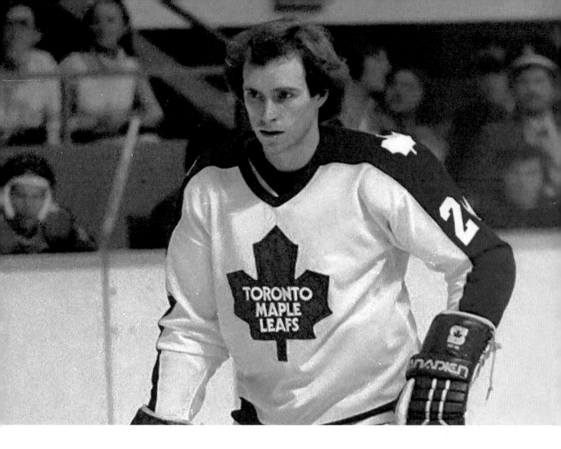

D **DARRYL** #24
MAGGS
(1979–80)

BORN: April 6, 1949,
Saskatoon, Saskatchewan
SIGNED: December 16, 1979,
as a free agent
LEAF LINE: 5 GP 0 G 0 A 0 PTS 0 PIM

The Leafs lost many players to the
WHA but, in this case, got a Blackhawks
refugee back. Maggs was rusty from not
having played in the 10 previous months,
having last appeared with the Cincinnati
Stingers of the rival league. The Leafs
won only one game Maggs played in, his
last pro hockey stop.

Maggs's first Leafs game in
Bloomington, Minnesota, saw a bench-
clearing brawl, starting with heavy
stick work between Darryl Sittler and
the North Stars' Paul Shmyr, escalating
when Brad Maxwell accepted Tiger
Williams's invite to come off the bench
for a fight.

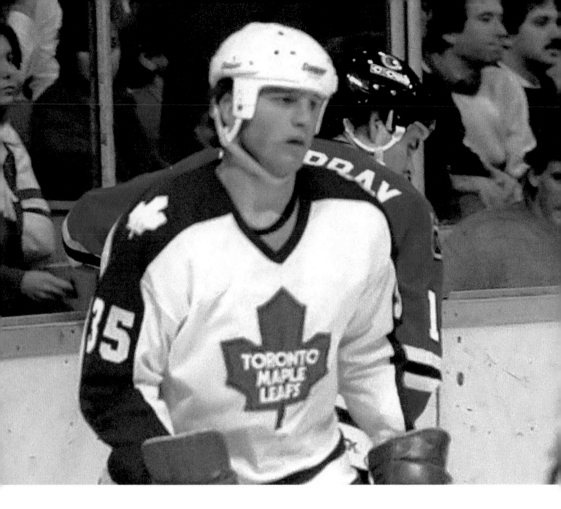

LW **MARC** #35
MAGNAN
(1982–83)

BORN: February 17, 1962,
Beaumont, Alberta
DRAFTED: 1981, 10th round,
195th overall
LEAF LINE: 4 GP 0 G 1 A 1 PTS 5 PIM

Magnan's 406 penalty minutes with

Lethbridge in 1981–82 helped him get a look with the Leafs, and soon into his first game he was into a bout with Quebec Nordiques tough guy Dave Pichette.

Magnan's penalty total at Lethbridge was comparable to the 732 combined total of his Hurricane teammates Ron, Rich and Brent Sutter. Rich played briefly in Toronto in '95.

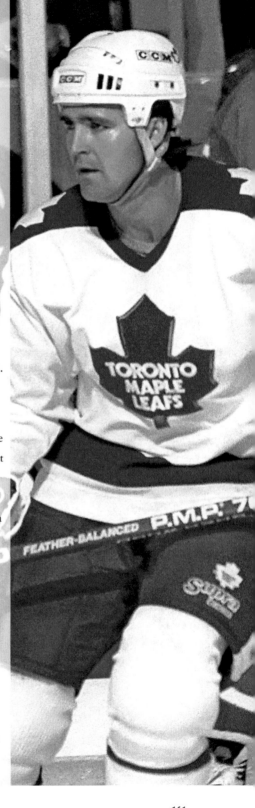

RW **KEVIN** #18, #28
MAGUIRE

(1986–87, 1990–92)

BORN: January 5, 1963, Toronto, Ontario
SIGNED: October 10, 1984, as a free agent. After
being claimed by Buffalo on waivers in 1987, he
was re-acquired June 16, 1990, in a trade with
Philadelphia with an 8th-round pick (D Dmitri
Mironov) for a 3rd-round pick (LW Al Kinisky).
LEAF LINE: 88 GP 10 G 5 A 15 PTS 258 PIM

With little minor hockey league training (one
appearance with the Oshawa Generals), Maguire
joined the Leafs. He had enforcer credentials, yet
managed 14 points in 63 games in 1990–91. He
was claimed and lost on waivers (just before the
Leafs took the team picture), traded for and then
bought out. He also embarked on an interesting
post-playing journey as an NHL referee, front
man for a GTA expansion team and running the
massive Leafs alumni operation.

As a ref, part of Maguire's value was knowing
right away if two players really wanted to fight
or were just bluffing. But in one of his earliest
games, he assessed a roughing call and then
forgot the player's number. "Luckily for me, the
guy went right to the box," Maguire laughed.

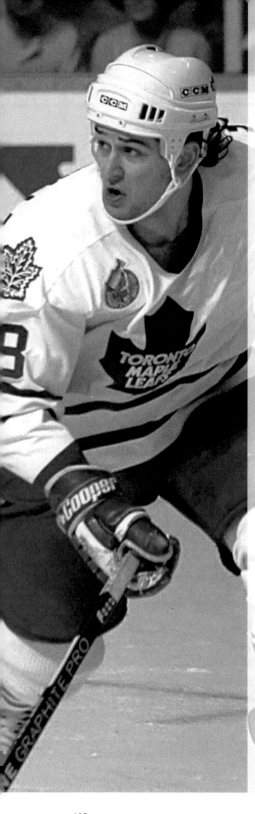

C **KENT** #18
MANDERVILLE

(1991–95)

BORN: April 12, 1971, Edmonton, Alberta
ACQUIRED: January 2, 1992, from Calgary with
G Rick Wamsley, D Jamie Macoun, D Ric
Nattress and C Doug Gilmour for G Jeff Reese,
D Alexander Godynyuk, D Michel Petit, RW
Gary Leeman and LW Craig Berube
LEAF LINE: 136 GP 8 G 15 A 23 PTS 102 PIM

An X-factor in the multi-layered Gilmour trade,
the 6-foot-3 checker was a pleasant surprise
from the Canadian Olympic team. He elbowed
veterans such as Mike Krushelnyski out of
playing time in the playoffs and lasted with five
more NHL teams after being traded back to his
hometown Oilers.

Manderville was almost a 1st-round Leaf at
the 1989 draft. After taking Belleville Bulls
Scott Thornton and Rob Pearson, the Leafs
were mulling over a third from the same team
— defenceman Steve Bancroft or Cornell
University's Manderville. They opted to keep
the Baby Bulls together and Calgary selected
Manderville a few picks later.

Manderville went to Ottawa to live and work
in media for the Sens as well as coach kids.

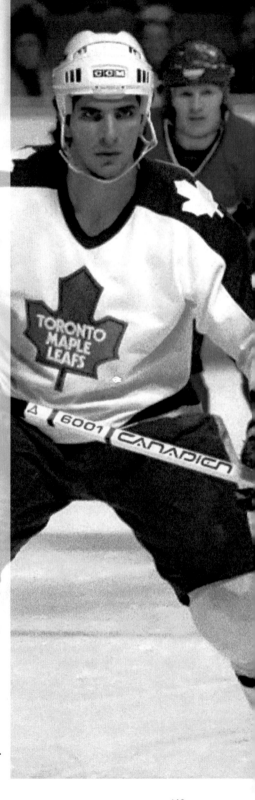

D **BOB** #3, #18
MANNO
(1981–82)

BORN: October 31, 1956, Niagara Falls
SIGNED: September 30, 1981, as a free agent
LEAF LINE: 72 GP 9 G 41 A 50 PTS 67 PIM

Only 10 Leafs defencemen have ever appeared in the NHL All-Star game, some as late fill-ins. Manno's name might not jump to mind, but he was there in '82, a legit pick based on his splendid season. Only Borje Salming had more goals and assists among Toronto blueliners that year, though as fast as Manno arrived, he was on his way to Detroit and never reached 50 points again in the NHL. He used his Italian heritage for a rewarding career playing and coaching overseas.

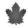

Manno met U.S. President Ronald Reagan during the '82 All-Star festivities in Washington.

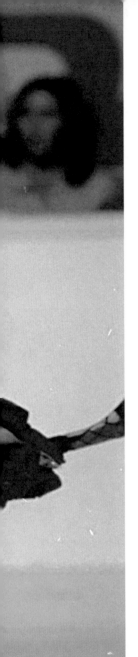

D**DANNY** #55
MARKOV

(1997–2001)

BORN: July 11, 1976, Moscow, Russia
DRAFTED: 1995, 9th round, 223rd overall
LEAF LINE: 200 GP 9 G 36 A 45 PTS 137 PIM

Immensely popular among players and fans, Markov made a huge impression on the farm and then formed a rough-hewn but effective partnership with fellow Russian Dmitri Yushkevich. Sometimes Yushkevich could not understand the Russian street slang Markov used, though Markov tried to make a point of talking to everyone he met to improve his English and overcome the isolation of being in a new country.

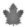

Just off the plane from Russia, Markov was put right into a road game for St. John's and was bothered by the unfamiliarity of the Philly Phantoms mascot heckling the Baby Leafs from the glass rinkside. Markov deliberately went into the pane at full speed, sending the costumed character tumbling back into the seats.

D **BRAD** #3
MARSH
(1988–91)

BORN: March 31, 1958, London, Ontario
ACQUIRED: October 3, 1988,
in the waiver draft from Philadelphia
LEAF LINE: 179 GP 2 G 28 A 30 PTS 189 PIM

The last Leaf to not wear a helmet was an
old-style NHLer in many other ways, driving a
beat-up old pickup truck he refused to part with.
He'd worn a Leafs sweater as a six-year-old, but
his days ended on a downer with long stints in
the press box.

As part of its unusual deal to "purchase" Marsh
from Toronto, the Red Wings were allowed to
return him if desired, which they did in June
of '92. That enabled the Leafs to send him to
Ottawa to complete a future considerations deal
with the expansion team, the first transaction
between the rivals. Marsh later worked for the
Sens, then owned a restaurant at Ottawa's rink
and now works for an area fitness company
called ViSalus.

LW **PAUL** #15, #28
MARSHALL
(1980–82)

BORN: September 7, 1960, Toronto, Ontario

ACQUIRED: November 18, 1980 with C Kim Davis from Pittsburgh for D Dave Burrows and C Paul Gardner

LEAF LINE: 23 GP 2 G 4 A 6 PTS 4 PIM

Marshall was a bigger forward and lasted a bit longer than Davis. He also enjoyed a 25-goal year on the farm with New Brunswick. While people have raved about the 1st round of the '79 draft, when all 21 made the NHL, Marshall was part of a 2nd round in which 20 of 21 found an NHL home, topped by Dale Hunter and Mats Naslund.

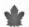

Marshall was the leading scorer on the 1977–78 Hamilton Fincups, which included five future Leafs players — Greg Terrion, Al Secord, Gaston Gingras, Doug Shedden and Rick Wamsley — and eventual assistant coach Randy Ladouceur.

D **MATT** #3, #33
MARTIN
(1993–97)

BORN: April 30, 1971,
Hamden, Connecticut
DRAFTED: 1989, 4th round, 66th overall
LEAF LINE: 76 GP 0 G 5 A 5 PTS 71 PIM

Faced with a long waiting list on
defence, the Leafs kept the rugged
Martin in the U.S. Olympic program
before giving him a shot. He soaked up
everything, including boxing lessons
from Tie Domi. Hampered by a broken
ankle in 1995–96, Martin was a semi-
regular the next season before trying his
luck with other teams via the IHL.

Though far from being a high-profile
Leaf, Martin was close friends with
Mats Sundin and was one of the few
to visit the reclusive captain in Sweden
during the off-season.

D **BRAD** #4
MAXWELL
(1985–86)

BORN: July 8, 1957, Brandon, Manitoba
ACQUIRED: August 21, 1985,
from Quebec for RW John Anderson
LEAF LINE: 52 GP 8 G 18 A 26 PTS 108 PIM

After being on the Twin Cities side of some
energetic fights involving Leafs, Maxwell found
himself in Toronto. He didn't shy away from
contact and did help the power play, but he was
limited by injuries and by a poor defensive team.
That was reflected with a minus-27, second worst
on the club that year.

The Leafs made the trade as much to get Maxwell
as to break up the complacency among first liners
Anderson, Rick Vaive and Bill Derlago. A deal
the Leafs turned down was for big defender Willie
Huber from the Rangers.

LW **GARY** #12
McADAM
(1985–86)

BORN: December 31, 1955, Smiths Falls, Ontario
SIGNED: July 31, 1985, as a free agent
LEAF LINE: 15 GP 1 G 6 A 7 PTS 0 PIM

Ten years a pro, McAdam was still an offensive threat coming off two 30-goal seasons in the minors. Struck with a puck in the eye early in the season during a game in Pittsburgh, he remained in hospital a couple of days and did not play again on advice from doctors.

The only other Leafs in franchise history born on New Year's Eve are Bob Heron (1917) and Rene Robert (1948).

RW **KEVIN** #20
McCLELLAND
(1991–92)

BORN: July 4, 1962, Oshawa, Ontario
SIGNED: September 2, 1991
LEAF LINE: 18 GP 0 G 1 A 1 P 33 PIM

With Kevin Maguire hurt and Craig Berube dealt in the Doug Gilmour trade, the Leafs brought in proven muscle with the former Oilers bodyguard. He'd been signed in the off-season to put some pop in the St. John's lineup.

Later sold to Winnipeg, where he played six games to end his NHL career, McClelland wound up returning to the Rock as assistant coach and was under consideration to run the Marlies at one stage. McClelland recently ended a six-year stint as head coach of the Wichita Wind of the ECHL.

C **DALE** #12
McCOURT
(1983–84)

BORN: January 26, 1957, Falconbridge, Ontario
SIGNED: October 22, 1983, as a free agent
LEAF LINE: 72 GP 19 G 24 A 43 PTS 10 PIM

If 1983–84 had been the No. 1 pick's first season instead of his eighth, the Leafs might have put 1977's top selection to better use. McCourt would leave the NHL after this side trip, but gave a good account with his strong special teams' work.

A nephew of George Armstrong, McCourt was the first of six former No. 1 picks drafted elsewhere to end up as a Leaf, with Rob Ramage (1979), Mats Sundin (1989), Owen Nolan (1990), Eric Lindros (1991) and Bryan Berard (1995). His brother Dan was an NHL linesman for years.

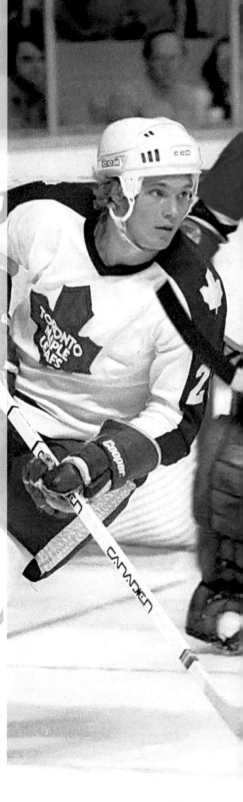

RW **BILL** #28
McCREARY JR.
(1980–81)

BORN: April 15, 1960, Springfield, Massachusetts
DRAFTED: 1979, 6th round, 114th overall
LEAF LINE: 12 GP 1 G 0 A 1 PTS 4 PIM

Talk about a one-hit wonder. McCreary played
12 Leafs games and nearly a decade in the minors,
but many will recall only January 3, 1981, when
he caught Wayne Gretzky turning the wrong way
and laid out the Great One with his shoulder.
With Gretzky on his back for a few moments,
Northlands Coliseum held its breath and the
Oilers bench seethed with calls for revenge. But
the hit, delivered by a U.S. College (Colgate
University) player of all people, was clean.

The myth persisted for years that McCreary
didn't play another NHL game because of his
audacity to hit #99. But he had 10 more starts
for the Leafs. The rest of that particular road
trip sucked. The loss in Edmonton was their fifth
straight, and coach Joe Crozier was fired shortly
after and replaced by Mike Nykoluk.

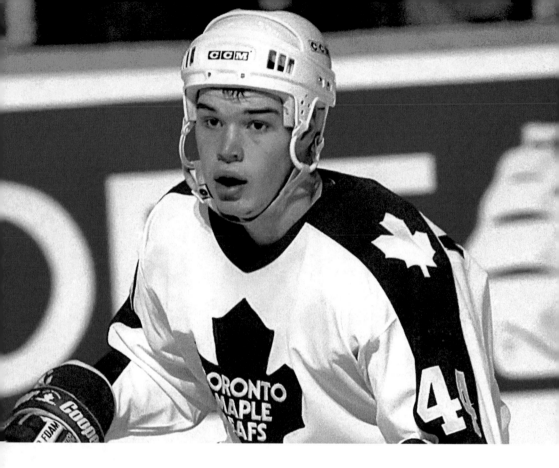

c JOHN #44 McINTYRE

(1989–91)

BORN: April 29, 1969, Ravenswood, Ontario
DRAFTED: 1987, 3rd round, 49th overall
LEAF LINE: 72 GP 5 G 15 A 20 PTS 142 PIM

McIntyre was not supposed to be brought up from the farm until midseason, but was impressive from the get-go, unfazed by stick work on the draw against veteran rival centres such as Mario Lemieux. He was the No. 3 centre for a time, using the liberal rules of obstruction to the fullest.

McIntyre fetched a good return in a trade with the Kings, 1-for-1 to get veteran forward Mike Krushelnyski, who'd play a big role in the coming years. McIntyre went on to play with Gretzky's Kings, as well as the Rangers and Canucks. He worked on the family rock gardens after he retired.

C **WALT** #11
McKECHNIE

(1978–80)

BORN: June 19, 1947, London, Ontario,
ACQUIRED: October 5, 1978, from the Minnesota
North Stars for a 3rd-round pick (D Randy
Velischek)
LEAF LINE: 133 GP 32 G 72 A 104 PTS 22 PIM

Another member of the London junior mafia
that surrounded Darryl Sittler in his later Leafs
years, McKechnie almost had a career year in
goals in 1978–79, with six of his 25 turning out
to be game winners. He played some point on
the power play too. But sweeping changes under
Punch Imlach the next season saw him moved
to Colorado for the draft pick that became
Fred Boimistruck.

A 16-year-old McKechnie was the Leafs first
ever draft pick in 1963 when the old NHL junior
sponsorship system was being phased out.

RW **SEAN** #8, #21
McKENNA
(1987–90)

BORN: March 7, 1962, Asbestos, Quebec
ACQUIRED: December 17, 1987, from Los
Angeles for LW Mike Allison
LEAF LINE: 48 GP 5 G 6 A 11 PTS 32 PIM

Before trying to restart his career with the Leafs
McKenna survived a perforated ulcer, requiring
eight days of intensive care and four blood
transfusions. He was still 15 pounds underweight
at his first Leafs camp, but he managed to fight
his way into Doug Carpenter's lineup.

While injuries limited him with the Leafs, he was
a Memorial Cup All-Star with Sherbrooke and
at one time held the AHL record of 14 playoff
goals with Buffalo's farm team in Rochester.

C **DAVE** #7
McLLWAIN
(1991–93)

BORN: January 9, 1967, Seaforth, Ontario
ACQUIRED: March 10, 1992, from the New York
Islanders with LW Ken Baumgartner for C
Claude Loiselle and RW Daniel Marois
LEAF LINE: 77 GP 15 G 6 A 21 PTS 34 PIM

Some players get their journeyman tag through
many seasons. McLlwain managed it in just one,
as part of three trades and four teams that moved
him from Winnipeg to Buffalo to the Isles to the
Leafs.

There were 13 other players and one draft pick
involved in McLlwain's four trades in 1990–91,
18 players in all when including an earlier deal in
which he went from Pittsburgh to Winnipeg.

LW BASIL McRAE #26

(1983–85)

BORN: January 5, 1961, Beaverton, Ontario
ACQUIRED: August 12, 1983, from Quebec
for D Richard Turmel
LEAF LINE: 4 GP 0 G 0 A 0 PTS 19 PIM

In early '88, the Leafs were in Minnesota to
play the Stars after Basil had been moved there
and Toronto had signed his kid brother Chris.
During a pre-game team dinner at a fancy Italian
restaurant where waiters sang arias, coach
John Brophy was gleefully anticipating a fight
between the tough-guy siblings. Heated debate
ensued with team broadcaster Joe Bowen, who
predicted they'd abstain from dropping the
gloves. The beautiful singing from the staff was
soon drowned out by a profane Brophy rant.

McRae's business interests in his former junior
team, the London Knights, expanded into his
current role as GM of the OHL powerhouse.
One of the latest stars to emerge is the Leafs'
2015 1st-round pick, forward Mitch Marner.

McRae is now director of player personnel
for the Columbus Blue Jackets. Basil's son Phil
was a 2008 pick of the St. Louis Blues. Basil had
a brief role in the *Mighty Ducks* movie with Mike
Modano.

LW **CHRIS** #29, #32
McRAE
(1987–89)

BORN: August 26, 1965,
Beaverton, Ontario
SIGNED: October 16, 1985, as a free agent
LEAF LINE: 14 GP 0 G 0 A 0 PTS 77 PIM

Though he didn't last as long as his brother Basil in the NHL, Chris's Leafs stint included a memorable training camp fight with fellow prospect Tie Domi, costing him a broken knuckle. When McRae spent time on the farm in Newmarket, it was actually his second stint there. As a Tier II Junior with the Newmarket Flyers he was a teammate of future NHL player and coach John Stevens.

Chris and Basil went on to become successful financiers, while middle brother, Phil, became a cop.

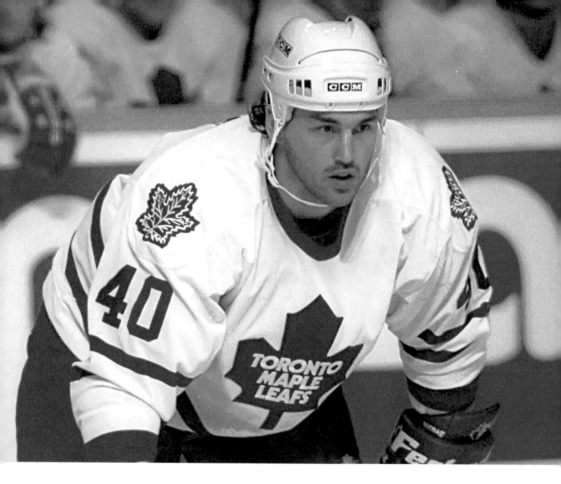

C **KEN** #36, #40
McRAE
(1992–94)

BORN: April 23, 1968,
Winchester, Ontario
ACQUIRED: July 21, 1992,
from Quebec for D Len Esau
LEAF LINE: 11 GP 1 G 1 A 2 PTS 38 PIM

A former No. 1 pick of the Nords, it was
hoped that the change of scenery would
help. He was on an industrial-strength
line with Mike Eastwood and Kent
Manderville towards the end of his time
in Toronto, but injuries and a glut of
checkers limited his overall playing time.

McRae and six other 1st-round picks
Quebec chose between 1986 and 1994
became Leafs property (Bryan Fogarty,
Mats Sundin, Todd Warriner, Wade
Belak, Owen Nolan and Eric Lindros).

D **BARRY** #26
MELROSE
(1980–83)

BORN: July 15, 1956, Kelvington, Saskatchewan
ACQUIRED: November 30, 1980, claimed on
waivers from Winnipeg
LEAF LINE: 173 GP 5 G 15 A 20 PTS 420 PIM

Years before he almost came to blows with Pat
Burns during the '93 playoffs as head coach of
the Kings, Melrose staunchly defended Leafs
teammates on the ice . . . but was a Leafs career
minus 60. He had been an avid Toronto fan as
a kid, growing up near cousin Wendel Clark.
Scout Floyd Smith knew him from coaching
the Cincinnati Stingers of the WHA; Melrose's
wife had been one of the team's Honey Bee
cheerleaders.

Demoted to St. Catharines to finish up the
1982–83 season, Melrose proved valuable as a
teacher to younger prospects, paving the way for
his coaching career in junior and pro and for a
stint on TV with ESPN.

When Melrose was claimed, the frugal
accounting departments of the Jets and Leafs
argued over who owed him a full- versus half-
day's pay. He was the first to find out that Mike
Nykoluk was the team's new coach when he got
on the same elevator at the team hotel for what
was supposed to be a "top secret" meeting with
Punch Imlach.

RW **MIKE** **#36**
MILLAR
(1990–91)

BORN: April 28, 1965, St. Catharines, Ontario
SIGNED: July 19, 1990, as a free agent
LEAF LINE: 7 GP 2 G 2 A 4 PTS 2 PIM

Teammate Doug Shedden talked up the 5-foot-10 Millar's talents prior to his call-up and then found himself demoted when coach Tom Watt gave Millar a short spin in his place.

With 136 junior goals in the OHL, Millar also scored with Washington, Hartford, Boston and Toronto during quick visits. He had 18 in 78 NHL games overall, then reached 64 in 50 games in Germany.

D **DMITRI** #15
MIRONOV
(1991–95)

BORN: December 25, 1965, Moscow, Russia
DRAFTED: 1991, 8th round, 160th overall
LEAF LINE: 175 GP 22 G 63 A 85 PTS 146 PIM

He was initially viewed negatively by Burns, but
the player, known as Tree, gradually grew on the
coach and the team. Though Mironov was not
trained in North America, he had been with the
Russian national team at a young age and had a
gold medal to his credit when he joined Toronto.

Mironov's son, Egor, attended the famous St.
Mike's College, where many golden era Leafs
had been tutored. Egor later played at Niagara
University.

LW **SERGIO** #7
MOMESSO
(1995–96)

BORN: September 4, 1965, Montreal, Quebec
ACQUIRED: July 8, 1995, from Vancouver
for C Mike Ridley
LEAF LINE: 54 GP 7 G 8 A 15 PTS 112 PIM

Another of the players the Leafs remembered
from Vancouver in the '94 conference final,
Momesso was also well known to fellow
Montrealer Pat Burns. But the restless Leafs of
that lockout year were impatient with his lack
of immediate production and traded him with
Bill Berg to the Rangers to get the muscular
Nick Kypreos.

Momesso is now a radio analyst with TSN 690
in Montreal. His nephew is Minnesota Wild
defenceman Marco Scandella.

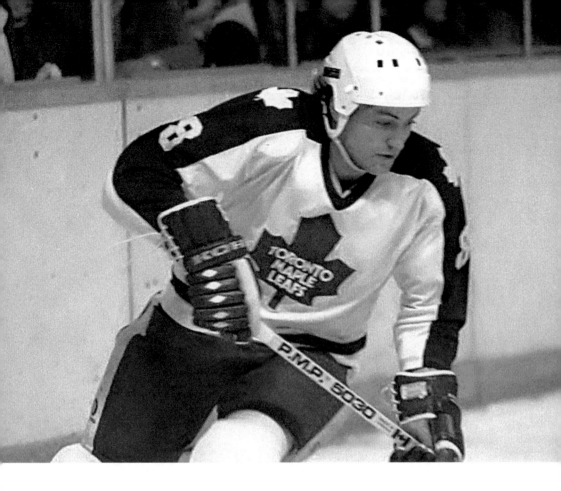

D **RICHARD** #8
MULHERN

(1979–80)

BORN: March 1, 1955,
Edmonton, Alberta

ACQUIRED: February 10, 1980, on
waivers from Los Angeles

LEAF LINE: 26 GP 0 G 10 A 10 PTS 11 PIM

With 91 points in two and a half seasons
in Atlanta, the Quebec-trained Mulhern

was still considered a hot commodity
when the Leafs picked him up from
the Kings. He enjoyed a stint as Borje
Salming's partner.

Mulhern now works in Toronto in the
packaging business. The draft pick
that Atlanta included Mulhern with
in a trade with the Kings to get Bob
Murdoch in 1979 became Leafs pro
scouting director Dave Morrison.

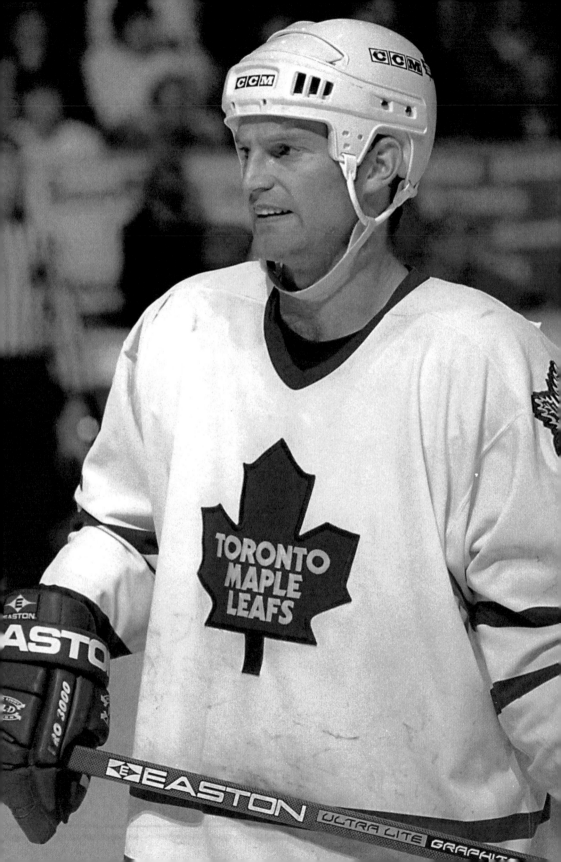

LW **KIRK** #21
MULLER

(1996–97)

BORN: February 8, 1966, Kingston, Ontario
ACQUIRED: January 23, 1996, from Ottawa with G Don Beaupre.
It was a part of a three-way trade with G Damian Rhodes going to
the Sens and LW Ken Belanger to the Isles, with Ottawa also moving
D Bryan Berard and C Martin Straka to the Islanders and New York
sending D Wade Redden to the Senators.
LEAF LINE: 102 GP 29 G 33 A 62 PTS 127 PIM

Muller should have been the consummate Leaf, the good Kingston
boy with fire in his belly. But he was more than a decade into the
NHL wars, and the Toronto team he could have helped was already a
spent force. He did carve out 20 goals for the ninth and final time of
his NHL career.

After Mario Lemieux in the '84 draft, future Leafs Muller (New
Jersey) and Ed Olczyk (Chicago) preceded No. 4 Al Iafrate to the
podium. Three other later Leafs were in the top 12: Shayne Corson
(Montreal), Sylvain Côté (Hartford) and Gary Roberts (Calgary).

D CRAIG MUNI #26, #29, #32, #33, #34

(1981–86)

BORN: July 19, 1962, Toronto, Ontario
DRAFTED: 1980, 2nd round, 25th overall
LEAF LINE: 19 GP 0 G 2 A 2 PTS 6 PIM

Muni was not pushed as fast as the other highly drafted defencemen Toronto had rushed into service in the early '80s thanks in part to a broken ankle sustained at the '81 rookie camp.

He never played more than 10 games in any season. Part of the reason was a poor relationship with St. Catharines farm coach Claire Alexander. As Muni's first three-year deal ended, Alexander suggested he sign a termination contract and prepare to leave after the 1985–86 season.

As soon as John Brophy and Alexander switched jobs, the latter promoted to be Dan Maloney's assistant with the Leafs, Muni flourished. But he was still ready to try another team; he not only found a home with Edmonton, he won a Cup there and never spent another day in the minors.

Muni said he was honoured to play for the Leafs but, like others, joked a couple of times at the coincidence of being sent down just before the Christmas party when Ballard would lavish each player with a gift of plane tickets. Muni is now in commercial development in western New York.

D **LARRY** #55
MURPHY
(1995–97)

BORN: March 8, 1961, Scarborough, Ontario
ACQUIRED: July 8, 1995, from Pittsburgh
for D Dmitri Mironov and a 2nd-round
pick (transferred to New Jersey, which
chose D Josh DeWolf)
LEAF LINE: 151 GP 19 G 81 A 100 PTS 54 PIM

Murphy was briefly among Leafs and league
leaders in points, and the expensive contract he
signed seemed money well spent. But nothing
seems to gall Leafs fans more than a big salary
combined with poor results, and Murphy's life
was hell in his final months.

He had the last laugh at the final bell of the
'97 trade deadline. After partnering a young
Kenny Jönsson, Murphy was moved to Detroit
where he immediately won a Cup ring.

Named GTHL minor player of the week in
December of 1971, a 10-year-old, 90-pound
Murphy gushed: "I like to hit like Bobby Baun, so
maybe I'll play defence for the Leafs some day."

He went on to play on one of the greatest
midget teams of all time in Canada, the Don
Mills Flyers.

D **RIC** #2
NATTRESS
(1991–92)

BORN: May 25, 1962, Hamilton, Ontario

ACQUIRED: January 2, 1992, from Calgary with
G Rick Wamsley, D Jamie Macoun, C Kent
Manderville and C Doug Gilmour for G Jeff
Reese, D Alexander Godynyuk, D Michel Petit,
RW Gary Leeman and LW Craig Berube

LEAF LINE: 36 GP 2 G 14 A 16 PTS 32 PIM

Nattress played well but was in limbo in the
summer of '92 regarding his contract status, until
an arbitrator crunched numbers and ruled that the
average salary in the NHL at the time should be
pegged at $386,000. As a 10-year veteran below
that figure, Nattress was set free. He signed with
the Flyers on almost the same day the Leafs found
his replacement by trading for Sylvain Lefebvre.

It was a move Nattress later said he regretted,
making his decision in haste while Cliff Fletcher,
who had traded for him twice, was on holiday.

Former Leafs GM Gerry McNamara's role in
the one-sided 10-player trade was the subject of
much controversy through the years. Rehired as
a Flames pro scout, McNamara was assumed to
have pushed for the deal, based on his familiarity
with the Leafs involved. McNamara later told
the *Toronto Sun* he was travelling and was not
consulted until Flames management had already
made up its mind. He claimed he would've
advised against the trade.

RW/C **ZDENĚK NEDVĚD** #10,#20, #45

(1994–97)

BORN: March 3, 1975, Lany, Czechoslovakia

DRAFTED: 1993, 5th round, 123rd overall

LEAF LINE: 31 GP 4 G 6 A 10 PTS 14 PIM

Speed gave Nedvěd a leg up at the '94 camp, but he couldn't play with the consistency Pat Burns wanted.

Nedvěd played at home for Kladno in his teens, with future Leaf Ladislav Kohn. He sought to fast track his junior career by coming to the OHL and had a 100-point season for Sudbury in 1993–94.

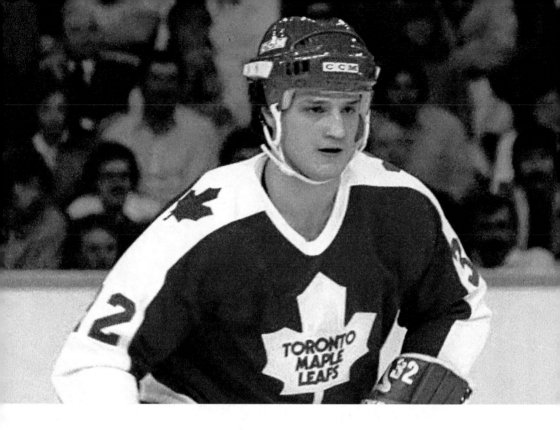

C **FRANK** #16, #32
NIGRO

(1982–84)

BORN: February 11, 1960, Richmond Hill, Ontario
DRAFTED: 1979, 5th round, 93rd overall
LEAF LINE: 68 GP 8 G 18 A 26 PTS 39 PIM

In hockey, Nigro made the most of his assets: his 5-foot-9 frame, his Italian heritage and his stint with the Leafs. He was a delightful surprise as a late pick and during 1982–83 had assists in six straight games, which tied a team rookie record matched by Dan Daoust a few games later.

Nigro was blessed with natural skill, but Leafs coaches couldn't quite tame him to play a 200-foot-game. He scored 61 goals in 121 games in the minors.

At the '92 Olympics in France, Nigro popped up on Team Italy's roster with two other ex-Leafs, Bob Manno and Bill Stewart. "This week, I'm Italian," Nigro joked. "Normally, I'm Canadian-Italian."

RW **WILF** #99
PAIEMENT
(1979–82)

BORN: October 16, 1955, Earlton, Ontario
ACQUIRED: December 29, 1979, from Colorado
with LW Pat Hickey for RW Lanny McDonald
and D Joel Quenneville
LEAF LINE: 187 GP 78 G 125 A 203 PTS 420 PIM

He was one of 16 children, the last NHLer to
wear #99 before Wayne Gretzky and scored the
league's 100,000th goal (an empty netter against
the Flyers on October 12, 1980). Only Doug
Gilmour, Darryl Sittler and Dave Andreychuk
had more points in one year than Paiement's 97
in 1980–81.

When the Leon's furniture chain celebrated
its 99th anniversary, Paiement appeared in his
#99 sweater at the end of a clever TV ad when
viewers were expecting Gretzky.

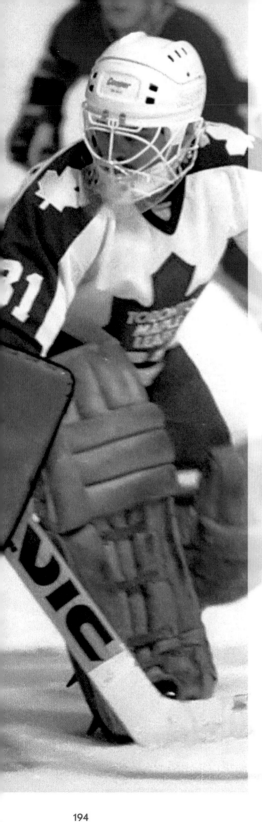

G **BOB** #31
PARENT
(1981–83)

BORN: February 19, 1958, Windsor, Ontario
DRAFTED: 1978, 4th round, 65th overall
LEAF LINE: 3 GP 0 W 2 L 0 T 5.63 GAA

During an awful stretch of two wins in 22 games, the lowly Leafs called up a few farmhands. Parent was thrown in against the Habs in a 6–1 defeat, but earned praise for his work. He stopped all nine shots by Guy Lafleur.

Parent was in goal when the Windsor Spitfires won their first OHL game, 11–10 against visiting Sudbury. Parent made 50 saves with the Spits down 7–1 at one stage of the match.

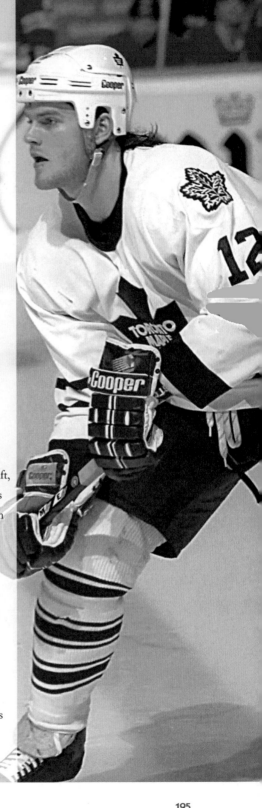

RW **ROB** #12
PEARSON
(1991–94)

BORN: August 3, 1971, Oshawa, Ontario
DRAFTED: 1989, 1st round, 12th overall
LEAF LINE: 192 GP 49 G 42 A 91 PTS 458 PIM

Ranked 27th by Central Scouting at the '89 draft, Pearson was wanted badly enough by the Leafs that they pulled the trigger at 12th, even though they had the last of three first-round picks at 21. Pearson had the longest stay of the three Belleville first rounders, backing up his OHL scoring cred with 29 points in 27 games on the farm. He had more than 50 regular-season and playoff goals for hard-to-please coaches Tom Watt and Pat Burns.

The Leafs' picking Rob went over well with his father, Gord, who owned two precious corner red season's tickets at the Gardens.

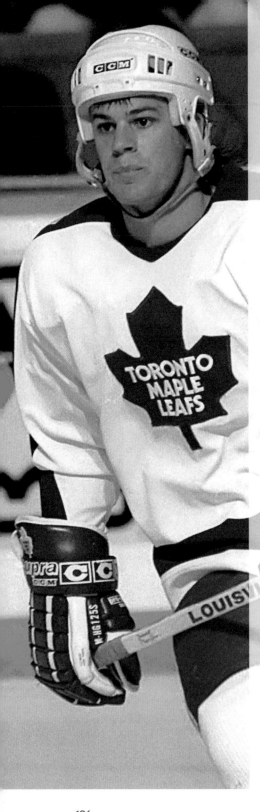

LW **SCOTT** #18, #22
PEARSON
(1988–91, 1996–97)

BORN: December 19, 1969, Cornwall, Ontario
DRAFTED: 1988, 1st round, 6th overall
LEAF LINE: 63 GP 5 G 11 A 16 PTS 114 PIM

When drafting Pearson and Tie Domi first and
second in '88, the long-range plan was to develop
a scorer and his bodyguard. It never came to be
as both were traded early in their Leafs careers,
later reacquired. Pearson lists his career highlight
as taking a Gary Leeman pass and beating Curtis
Joseph of the Blues on a breakaway for his
first playoff goal. He now lives in the Atlanta
area, working as VP for a healthcare company,
coaching his son Chase, who was a 2015 mid-
round pick of the Red Wings.

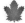

Upon shaking hands with John Brophy for
the first time, the latter said, "Let me see your
knuckles, kid!"

D **TOM** #24
PEDERSON

(1996-97)

BORN: January 14, 1970,
Bloomington, Minnesota
SIGNED: December 13, 1996,
as a free agent
LEAF LINE: 15 GP 1 G 2 A 3 PTS 9 PIM

Unhappy at the contract offers he
received from other teams at the start
of 1996–97, Pederson took a lucrative
offer from Seibu Tetsudo Tokyo of the
Japan Ice Hockey League, supplanting
ex-Leaf Tom Kurvers as that club's
designated import. He helped Seibu
to the title and immediately joined
the Leafs, who'd been interested since
Pederson played against them with San
José in the '94 conference final.

Pederson returned to the North
Star State to head up his own realty
company and coach daughter
Meaghan's girls' team.

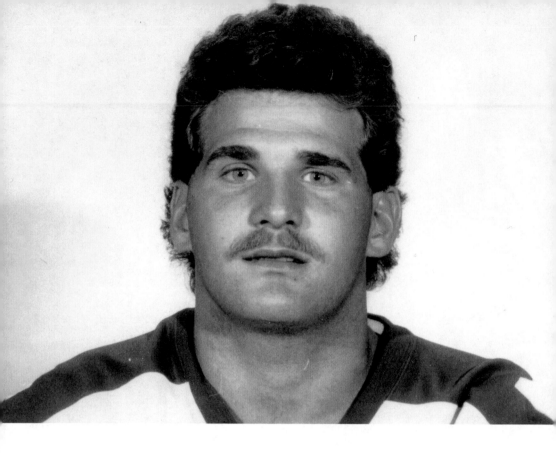

C **FRED** #8, #28, #29, #32, #34

PERLINI

(1981–84)

BORN: April 12, 1962,
Sault Ste. Marie, Ontario

DRAFTED: 1980, 8th round, 158th overall

LEAF LINE: 8 GP 2 G 3 A 5 PTS 0 PIM

There were some perks to playing for the junior Marlies in the same building as the Leafs, especially for a Toronto draft pick. On December 30, 1981, Perlini was handy to be summoned for

his first NHL game at MLG and assisted on a Terry Martin goal. A couple of months later, after a brawl-filled matinee match between the Marlies and Belleville, Perlini was asked to suit up again that night against St. Louis.

Perlini didn't play any NHL games other than with the Leafs, but he made quite a career for himself in England. While in Guildford in 1996, son Brendan was born: a future 2014 first rounder of the Arizona Coyotes.

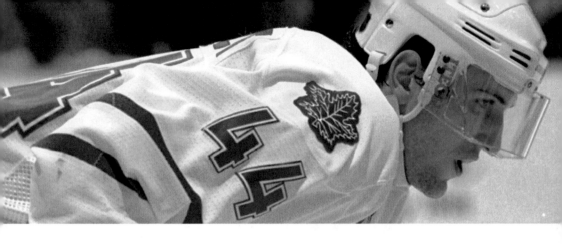

C **YANIC** #44, #94
PERREAULT

(1993–94, 1998–2001, 2006–07)

BORN: April 4, 1971, Sherbrooke, Quebec
DRAFTED: 1991, 3rd round, 47th overall.
Reacquired March 23, 1999, from Los
Angeles for RW Jason Podollan and a
3rd-round pick (G Cory Campbell).
Reacquired February 27, 2007 from
Phoenix with a 5th-round pick (C Joel
Champagne) for D Brendan Bell and a
2nd-round pick (transferred to Nashville,
which selected D Roman Josi).
LEAF LINE: 176 GP 54 G 69 A 123 PTS 90 PIM

He received the star treatment his draft
year as the Toronto media had no one to
talk to after the Leafs traded their first
and second picks. But there would be
plenty of comings and goings for him.

"It feels like Groundhog Day
again," Perreault joked the third time
the Leafs acquired him at the '07 trade
deadline. But his faceoff reputation
preceded him as he'd helped every team
he'd played for on the draw.

A third trade for Perreault might have
been unnecessary as he was quite
available on waivers two months earlier.
But it illustrated a disconnect in the Leafs
brain trust at the time. Then-GM John
Ferguson tossed in a 2nd rounder to get
Perreault, whom coach Paul Maurice
wasn't quite interested in using more than
10 minutes a game, sometimes scratching
him, as the Leafs missed the playoffs.
Nashville, meanwhile, wound up with
the 2nd-round pick and used it on Josi, a
defenceman still playing in the NHL.

Perreault joined Wendel Clark
among the rare group of Leafs to have
played three times for the Blue and
White. He also played under three
GMs — Cliff Fletcher, Pat Quinn and
Ferguson — and three coaches — Pat
Burns, Quinn and Maurice.

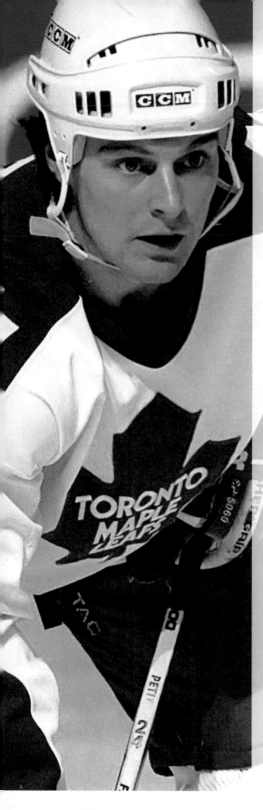

D MICHEL PETIT #22, #24

(1990–92)

BORN: February 12, 1964, St. Malo, Quebec

ACQUIRED: November 17, 1990, with LW Aaron Broten and LW Lucien DeBlois from Quebec for LW Scott Pearson and two 2nd-round picks. One was traded to Washington by Quebec with the Caps choosing D Eric Lavigne, while Quebec took Finn D Tuomas Gronman.

LEAF LINE: 88 GP 10 G 32 A 42 PTS 217 PIM

At 26, Petit was "the right age" for GM Floyd Smith as he tried to infuse a mistake-prone team with some veteran savvy. Coach Tom Watt had liked Petit from a previous union in Vancouver. But Cliff Fletcher saw the aggressive Petit as expendable when he came along as GM, and he tossed Petit into the 10-player Doug Gilmour trade with Calgary, figuring Ric Nattress could do as well or better.

As of 2015, five players have played for 10 or more teams. Two of them, Petit and Mathieu Schneider, put in time with the Leafs.

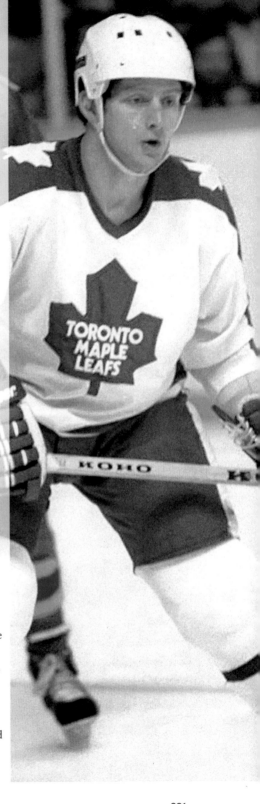

D **ROBERT** #4
PICARD
(1980–81)

BORN: May 25, 1957, Montreal, Quebec
ACQUIRED: June 11, 1980, from Washington
with F Tim Coulis and a 2nd-round pick
(D Bob McGill) for G Mike Palmateer
and a 3rd-round pick (LW Torrie Robertson)
LEAF LINE: 59 GP 6 G 19 A 25 PTS 68 PIM

The 2nd defenceman and 3rd overall pick in
1977, Picard was involved in two trades for two
goalies: Palmateer from Washington, and then
to his hometown Canadiens for Bunny Larocque
after just 59 games as a Leaf.

Picard was the lone Leaf in the 1981 All-Star
game, on a Wales Conference team that included
recently traded Leaf Randy Carlyle.

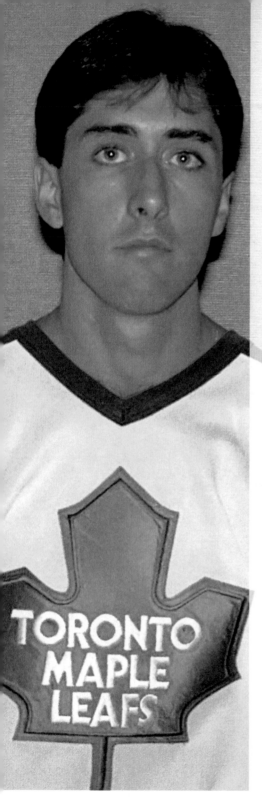

D **CAM** #11
PLANTE
(1984–85)

BORN: March 12, 1964, Brandon, Manitoba
DRAFTED: 1983, 7th round, 128th overall
LEAF LINE: 2 GP 0 G 0 A 0 PTS 0 PIM

Plante certainly had an eye-opening first game as a Leaf. The struggling club reached a record 46 losses on March 16, 1985, when he was plugged in to face the Flyers in a 6–1 defeat. Angry coach Dan Maloney had benched 50-goal scorer Rick Vaive the entire game because of a previous incident.

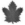

Plante had racked up 118 assists just the year before with the Brandon juniors, on a team with Ray Ferraro. Also called up for the Flyers game was Windsor junior Todd Gill, who would go on to play 639 total games for the Leafs.

LW **WALT** #8, #12
PODDUBNY
(1981–86)

BORN: February 14, 1960,
Thunder Bay, Ontario
ACQUIRED: March 8, 1982, from
Edmonton with LW Phil Drouillard for
C Laurie Boschman
LEAF LINE: 186 GP 59 G 86 A 145 PTS
178 PIM

A low-key player, Poddubny blossomed
into a 28-goal man with the Leafs and
later had 40 with the Rangers. Certainly
he was among the most productive of
Leafs who played fewer than 200 games,
though his post-career life took some
wrong turns before he died at age 49.

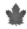

Poddubny had two hat-tricks for the
Leafs: against the Winnipeg Jets and the
Detroit Red Wings.

A huge fan of the burgeoning
World Wrestling Federation, Poddubny
and teammates took in a card one night
at the Met Center in Bloomington.
Poddubny correctly predicted what
would happen in each match as he'd
seen the same bill in Toronto a few
weeks earlier.

RW **JASON** #7, #37
PODOLLAN
(1996–99)

BORN: February 18, 1976,
Vernon, British Columbia

ACQUIRED: March 18, 1997, from
Florida for LW Kirk Muller

LEAF LINE: 14 GP 0 G 3 A 3 PTS 6 PIM

The high-profile trade was frustrating for Podollan, who didn't get much ice despite great numbers on the farm where he was among AHL offensive leaders.

Podollan and Rhett Warrener were two Panthers the Leafs sought as part of a trade package to move Gilmour in '97, before making a deal with New Jersey.

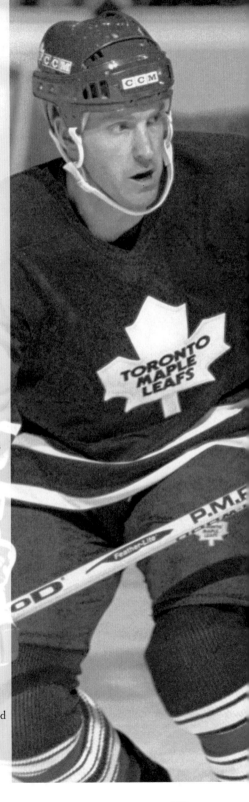

RW **WAYNE** #18
PRESLEY

(1995–96)

BORN: March 23, 1965, Dearborn, Michigan
ACQUIRED: February 29, 1996, from the Rangers
with LW Nick Kypreos for LW Bill Berg
and LW Sergio Momesso
LEAF LINE: 19 GP 2 G 2 A 4 PTS 14 PIM

Presley thought he was getting a big role with
the Rangers when he went there from Buffalo,
but he didn't click with coach Colin Campbell
and ended up just killing penalties. Past age 30,
Presley was not much help for the Leafs, who
sacked coach Pat Burns soon after this trade.

The Michigan native ended his pro career with
the powerful IHL Detroit Vipers, a team coached
by Steve Ludzik that won almost 100 games in
two years.

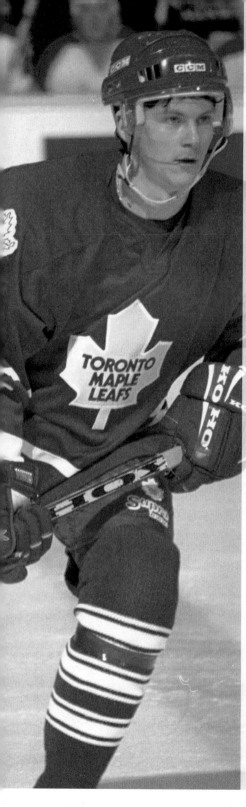

RW **MARTIN** #21
PROCHAZKA
(1997–98)

BORN: March 3, 1972, Slany, Czechoslovakia
DRAFTED: 1991, 7th round, 135th overall
LEAF LINE: 29 GP 2 G 4 A 6 PTS 8 PIM

Prochazka was a hotshot in the Czech national program and got his chance early in the 1997–98 season. But he had defensive lapses that spooked coach Mike Murphy who was already struggling with Sergei Berezin's deficiencies in that area. Murphy was reluctant to use him regularly, even after Prochazka came back from the Nagano Olympics with a gold medal.

Toronto had a bit more mileage from another native of Slany, 2006's No. 1 pick, Jiri Tlusty.

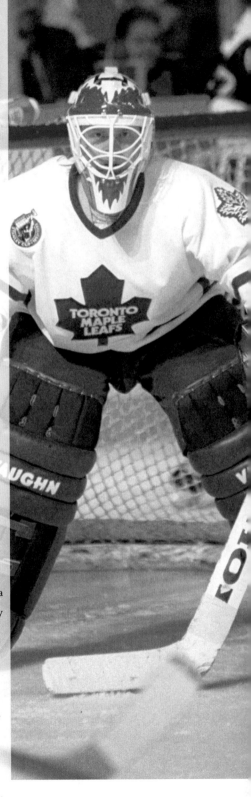

G **DAREN** #1 **PUPPA**

(1992–93)

BORN: March 23, 1963, Kirkland Lake, Ontario
ACQUIRED: February 2, 1993, from Buffalo with
LW Dave Andreychuk and a 1st-round pick
(D Kenny Jönsson) for G Grant Fuhr and
a 5th-round pick (D Kevin Popp)
LEAF LINE: 8 GP 6 W 2 L 0 T 2.25 GAA

Puppa led the NHL with 31 wins as a Sabre not
long before the deal. But hot youngster Felix
Potvin gave him very few chances to play. Puppa
went to Tampa in the expansion draft, eventually
helping the team's first run to a playoff berth.

The night the Leafs clinched their playoff spot in
'93, for what would be a memorable 21-game run,
Puppa was in goal for the 4–0 win in Calgary.
He had two shutouts in his short Leafs stint.

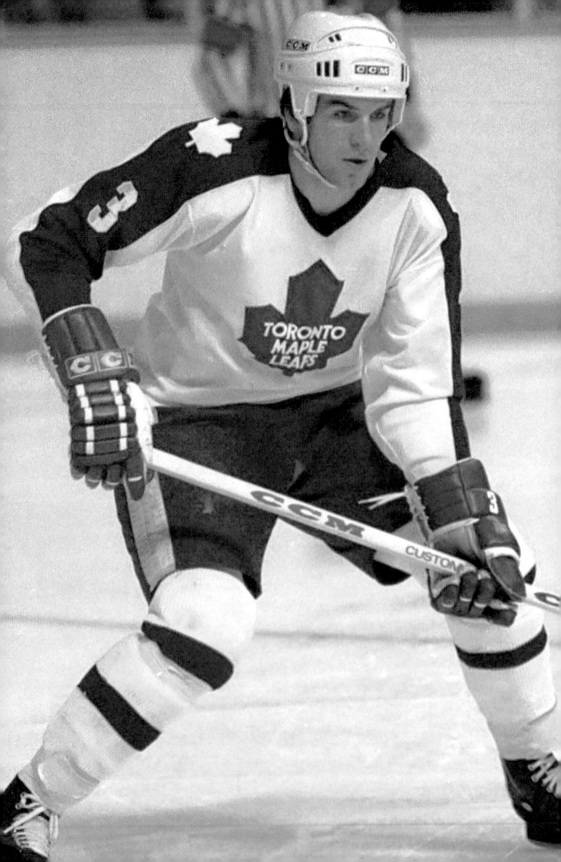

D **JOEL #3 QUENNEVILLE**

(1978–80)

BORN: September 15, 1958, Windsor, Ontario
DRAFTED: 1978, 2nd round, 21st overall
LEAF LINE: 93 GP 3 G 13 A 16 PTS 84 PIM

After starting out a virtually unknown stay-at-home defenceman, Quenneville carved out a long career as a player and coach. He had considered other career paths before playing more than 800 games and winning numerous individual awards with the Hartford Whalers.

Cliff Fletcher hired Ron Wilson as Leafs coach during his time as interim GM in the summer of 2008. It was true that Wilson was friends with Brian Burke, who was trying to get out of his managerial contract with the Anaheim Ducks, but was unable to do so until November of that year. Many think Burke's first choice as coach would've been Quenneville, who had been between jobs with Colorado and Chicago.

During the Leafs' extended playoff runs in '93 and '94, it was common to see St. John's coach Marc Crawford and assistant Quenneville join Pat Burns and his staff, Mike Kitchen and Mike Murphy, for team meetings. Burns would later win a Cup — with New Jersey — while the other four would go on to be head coaches in Toronto and the NHL. Quenneville won three Cups with Chicago, two with Kitchen as his assistant.

D **ROB** **#8** **RAMAGE**

(1989–91)

BORN: January 11, 1959, Byron, Ontario
ACQUIRED: June 16, 1989, from Calgary
for a 2nd-round pick (C Kent Manderville)
LEAF LINE: 160 GP 18 G 66 A 84 PTS 375 PIM

Ramage, fresh from a Cup with the '89 Flames, couldn't have been
thrown into a more chaotic situation: an aging Harold Ballard was at
the most unstable stage of his Gardens reign, and GM Gord Stellick
was fired soon after this trade. But Ramage was part of a high-scoring
Leafs team that managed to make the playoffs.

At the time of the Ramage deal, Ballard was taking counsel from
everyone in his circle regardless of rank, from waiters to hairdressers.
One of his minions convinced the owner that the 30-year-old Ramage
was actually 37 causing management great stress.

Ramage chose #8 with the Leafs in tribute to Barclay Plager,
who'd been a strong influence on his career in St. Louis.

G **JEFF** #1, #35
REESE

(1987–92, 1998–99)

BORN: March 24, 1966, Brantford, Ontario
DRAFTED: 1984, 4th round, 67th overall. Re-signed as a free agent January 5, 1999.
LEAF LINE: 76 GP 20 W 33 L 9 T 4.13 GAA

Reese began as the third young goalie on a team that already was trying to placate Allan Bester and Ken Wregget. Down 3–0 in a 1990 playoff series to the Blues, with Bester winless, Reese went in and helped push the series one more game. He proved himself NHL-worthy in time to be included in the 10-player deal with Calgary, where he had an excellent record of 14–4–1 behind Mike Vernon in 1992–93.

Seven years after leaving, he signed as a free agent under unusual conditions when Glenn Healy injured himself slipping on a puck during a team skills exhibition.

LW **BOBBY** #20 **REYNOLDS**

(1989–90)

BORN: July 14, 1967, Flint, Michigan
DRAFTED: 1985, 10th round, 190th overall
LEAF LINE: 7 GP 1 G 1 A 2 PTS 0 PIM

Reynolds had more than 100 goals at Michigan State in his four years there and 46 in two seasons with Newmarket.

He replaced Mark Osborne on the GEM line with Garry Leeman and Ed Olczyk and at 175 pounds was adept at drawing penalties.

Reynolds spent his first ever trip to New York City marvelling at the Manhattan skyline, then had his first two NHL points that night in a 5–5 tie against the Rangers.

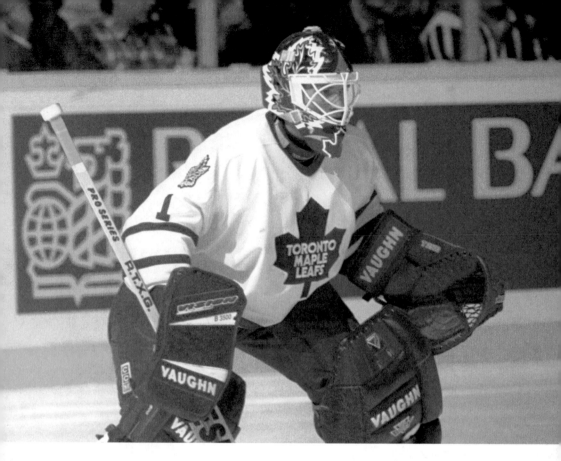

G DAMIAN #1, #31
RHODES

(1990–96)

BORN: May 28, 1969, St. Paul, Minnesota
DRAFTED: 1987, 6th round, 112th overall
LEAF LINE: 47 GP 20 W 18 L 5 T 2.79 GAA

Though he was a bundle of nerves when Pat Burns insisted he start a game during Toronto's record streak of 10 wins to start the 1993–94 season, Rhodes did his part in a 4–3 overtime decision over Florida. In another surprise start after Felix Potvin's girlfriend went into labour, Rhodes played well in a 2–1 loss. He went on to become a 22-game winner for the Senators.

In need of a goalie to expose in the '91 expansion draft — one who'd played at least 60 NHL minutes — the Leafs rushed Rhodes into a start in Detroit. He responded with a 3–1 upset win.

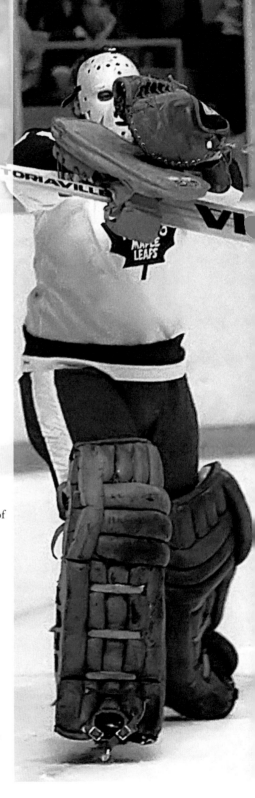

G **CURT** #1, #33, #35
RIDLEY
(1979–81)

BORN: October 24, 1951, Minnedosa, Manitoba
ACQUIRED: February 10, 1980,
purchased from Vancouver
LEAF LINE: 6 GP 1 W 2 L 0 T 5.13 GAA

Ridley and John Garrett were the only goalies of
note taken in the 1971 draft, but where Garrett
had great years in the WHA and was an early
star in Hartford, Ridley drifted through many
NHL and minor teams. Ridley was feared for
his stickwork around the net but found himself
playing sporadically behind Jiri Crha with the
Leafs. After a 6–2 road loss to Washington,
Ridley didn't play in the NHL again.

Ridley was the first NHLer ever drafted from a
Tier II team, the MJHL's Portage Terriers.

C **MIKE** #7
RIDLEY

(1994–95)

BORN: July 8, 1963, Winnipeg, Manitoba
ACQUIRED: June 28, 1994, with a 1st round pick
(G Eric Fichaud) from Washington for RW
Rob Pearson and a 1st-round pick (D Nolan
Baumgartner)
LEAF LINE: 55 GP 10 G 27 A 37 PTS 14 PIM

Lost in the furor over trading Wendel Clark
for Mats Sundin was this draft-day deal. Cliff
Fletcher needed another veteran at forward to
replace Pearson after he decided to play out his
option and a strong second centre in Ridley in
case Sundin and Doug Gilmour worked out as
linemates.

Ridley, Dave Andreychuk and Randy Wood
were the only three Leafs to play all 55 regular
season and playoffs games in the shortened
'94–95 season. Ridley was trade bait late in the
year and eventually moved in the summer for
Sergio Momesso.

RW **RENÉ** #14
ROBERT
(1970–71, 1980–82)

BORN: December 31, 1948,
Trois Rivières, Quebec
ACQUIRED: June 8, 1971, from Pittsburgh
in inter-league draft. Reacquired January 30,
1981, from Colorado for a 3rd-round pick
(D Uli Hiemer).
LEAF LINE: 74 GP 19 G 31 A 50 PTS 45 PIM

Robert's ties to the Leafs went back to the
1970–71 season. Bouncing around the minors,
he received a five-game tryout, did little, and
was claimed on waivers by Pittsburgh. Just
two years later he was lighting it up as part
of Buffalo's French Connection with Gilbert
Perreault and Rick Martin. Punch Imlach hoped
he had something left when he retrieved Robert
from the Rockies.

Robert's practice habit of aiming for the goal
post used to mystify his coaches, but he scored
almost 300 regular season and playoff goals in 13
seasons in the NHL.

He held a position with Molson Breweries in
Toronto for many years after retiring.

D **BILL** #25, #28
ROOT
(1984–87)

BORN: September 6, 1959, Toronto, Ontario
ACQUIRED: August 21, 1984, from Montreal with
a 2nd-round pick (D Darryl Shannon) for D
Dom Campedelli
LEAF LINE: 96 GP 4 G 5 A 9 PTS 89 PIM

A good deal for the Leafs with Campedelli
making it into just a couple of games for the Habs,
while Root formed a good pairing with Chris
Kotsopoulos and Shannon played 98 times himself.
Root contributed six points in 1986–87 and a goal
in the '87 playoffs against Doug Gilmour and the
Blues.

What else but a post-playing job with the Roto-
Rooter drain company?

G **JIM** #1
RUTHERFORD
(1980–81)

BORN: February 17, 1949, Beeton,
Ontario
ACQUIRED: December 4, 1980, from
Detroit for C Mark Kirton
LEAF LINE: 18 GP 4 W 10 L 2 T 5.12 GAA

Unlike Detroit GM Ken Holland, who
was drafted by the Leafs and played just
four NHL games, future team executive
Rutherford was in more than 460.
His Leafs sequence was a forgettable
year when the team went through five
goalies and a conference-worst 367
goals-against.

The final three of Ian Turnbull's record
five goals by a defenceman in 1977 came
against Rutherford, in relief of Detroit
starter Ed Giacomin.

Traded to Los Angeles for a pick
that became Barry Brigley, Rutherford
had to leave his car behind at the
Westbury Hotel. The manager called
the Leafs a few weeks later with the
regrettable news Rutherford's car had
caught fire.

LW **WARREN** #21
RYCHEL
(1994–95)

BORN: May 12, 1967, Tecumseh, Ontario
ACQUIRED: February 10, 1995, from Washington
for a 4th-round pick (G Sebastien Charpentier)
LEAF LINE: 26 GP 1 G 6 A 7 PTS 101 PIM

An over-abundance of tough guys in L.A., a
big contract and a Ken Baumgartner injury all
contributed to Rychel arriving to toughen up
the Leafs. Less than two years earlier, he helped
eliminate them in the conference final. In the
end, the Leafs committed to Tie Domi as their
muscle.

On coming north after a few years in L.A.,
Rychel said, "I'll miss the weather. I won't miss
the earthquakes, floods and the fires." But he
did return to end his career in Anaheim. Rychel's
son Kerby, a 2013 first-round pick of the Blue
Jackets, was acquired by the Leafs at the 2016
draft in Buffalo.

C **DAVID** #7
SACCO
(1993–94)

BORN: July 31, 1970, Malden, Massachussetts
DRAFTED: 1988, 10th round, 195th overall
LEAF LINE: 4 GP 1 G 1 A 2 PTS 4 PIM

The younger of the Sacco siblings, David was
a training-camp surprise after Joe was lost to
Anaheim in the expansion draft. The Leafs liked
David's deceptive speed when he finished a stint
with the U.S. Olympic team, but he was destined
to join Joe with the Ducks in a trade for Terry
Yake.

The Boston area product wore #7 with the Leafs
as a tribute to his Bruin idol, Ray Bourque.

LW **JOE** #20, #24
SACCO
(1990–93)

BORN: February 4, 1969, Medford, Massachusetts
DRAFTED: 1987, 4th round, 71st overall
LEAF LINE: 60 GP 11 G 13 A 24 PTS 16 PIM

A quick start on the farm after leaving Boston
University, and selection to the 1991 U.S. team
for the world championships kept Sacco in the
Leafs' plans. A two-goal game early in the Pat
Burns regime was promising, too. But Sacco
was soon mired in the minors and exposed to the
expansion Ducks.

As head coach in Colorado, Sacco's first-year
Avs made the playoffs with ex-Leaf Sylvain
Lefebvre his assistant, former Leaf Darcy
Tucker in a mentor role and future Leaf John-
Michael Liles on the blueline.

G **RICK** #1
ST. CROIX
(1982–85)

BORN: January 3, 1955, Kenora, Ontario
ACQUIRED: January 11, 1983, from Philadelphia
for G Michel Larocque.
LEAF LINE: 47 GP 11 W 26 L 2 T 4.61 GAA

The rise of Pelle Lindbergh in Philadelphia
was partly responsible for St. Croix coming to
the Leafs. But the '80s were a burial ground for
masked men in Toronto, with too many losses
obscuring the good work St. Croix did.

 The goalie suffered a hand injury soon after
arriving, which led teammates to nickname him
Sore Paw. One night at the Gardens he also
suffered a back injury that required him to be
stretchered off the ice . . . but no one could get
the top part of the gate to open. The idea of
trying to squeeze St. Croix, on his gurney, under
the bar was considered until the gate problem
was resolved.

St. Croix once had a Christmas tree farm in
Eastern Ontario. He is now goalie coach with the
Winnipeg Jets.

D **MATHIEU** #72 **SCHNEIDER**

(1995–98)

BORN: June 12, 1969, New York, New York

ACQUIRED: March 13, 1996, from the Islanders with LW Wendel Clark and D D.J. Smith for D Kenny Jönsson, LW Darby Hendrickson, LW Sean Haggerty and a 1st-round pick (G Roberto Luongo)

LEAF LINE: 115 GP 18 G 38 A 56 PTS 74 PIM

Schneider excited the Leafs with his play in his first full season, leading Toronto's defence with 37 points. But he ran up against associate GM Mike Smith and coach Pat Quinn in bitter contract talks the following summer, which led to a trade for Alexander Karpovtsev.

To date, Schneider is the only Leaf to have worn #72.

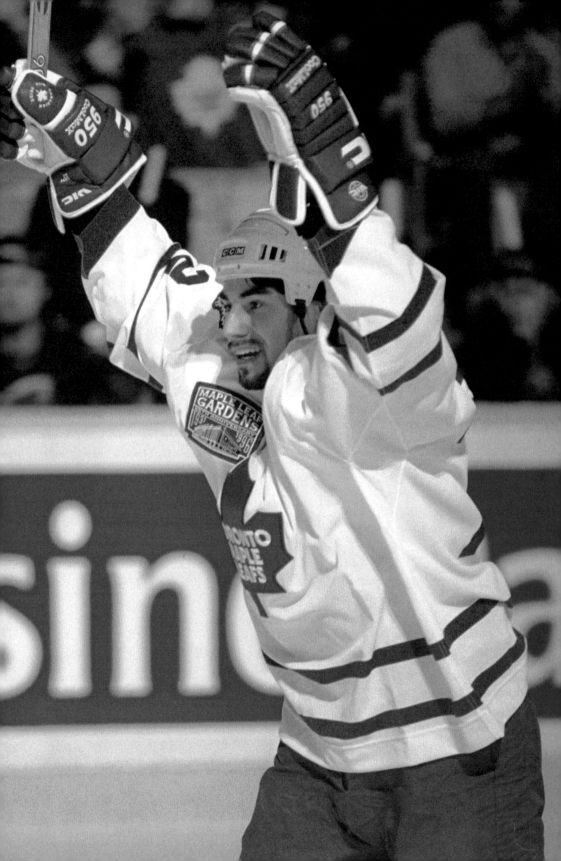

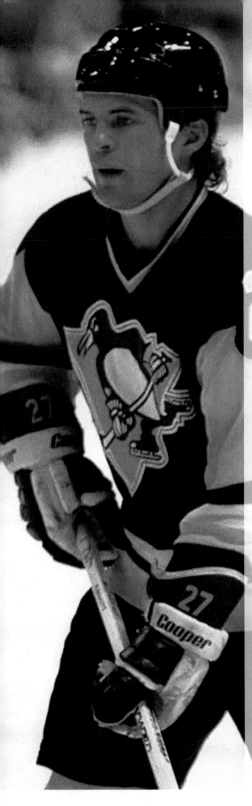

LW **ROD** #25
SCHUTT
(1985–86)

BORN: October 13, 1956, Bancroft, Ontario
SIGNED: October 3, 1985, as a free agent
LEAF LINE: 6 GP 0 G 0 A 0 PTS 0 PIM

There was a degree of pressure placed on young
Schutt, a first-round pick, by the Habs as they
launched into four straight Cups in the late '70s.
He was eventually traded to Pittsburgh for the
pick that became Mark Hunter, but his one good
year in Steeltown was followed by injuries and
a lesser role. When he came to the Leafs he was
a fill-in for a number of absentees at Christmas
of '85.

Schutt led the 1974–75 Sudbury Wolves with 135
points, one more than Ron Duguay, while future
Leaf Randy Carlyle topped the team's defence
with 79. Schutt and Carlyle were later reunited in
the early '80s with the Penguins.

LW **AL** #20
SECORD
(1987–89)

BORN: March 3, 1958, Sudbury, Ontario
ACQUIRED: September 4, 1987, from Chicago
with C Ed Olczyk for RW Rick Vaive, LW Steve
Thomas and D Bob McGill
LEAF LINE: 114 GP 20 G 37 A 57 PTS 292 PIM

Vaive's time in Toronto had been eclipsed by
Wendelmania and coach John Brophy was
insistent that Secord would help establish his
vision of the Leafs as an intimidating team.

In the '86 playoffs between the Leafs and
Hawks, in which Toronto barely squeaked in,
many corporate subscribers figured the Leafs
weren't going to make it and had sent back their
tickets. Thus the "real fans" had snatched up
the ducats in the series and made the Gardens a
nuthouse when Secord and the Hawks showed up
for Game 3, facing elimination in the Leafs upset.

The chant of "Secord sucks" rang through
the building as brooms littered the ice after the
win. Unfortunately, Secord was past his prime
by the time he arrived on Carlton Street.

Secord, who eventually realized his dream
of becoming a commercial airline pilot, was
sometimes allowed in the cockpit on Leafs
charter flights to assist with the landings.

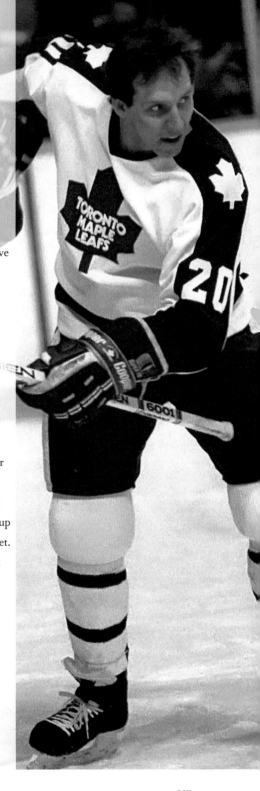

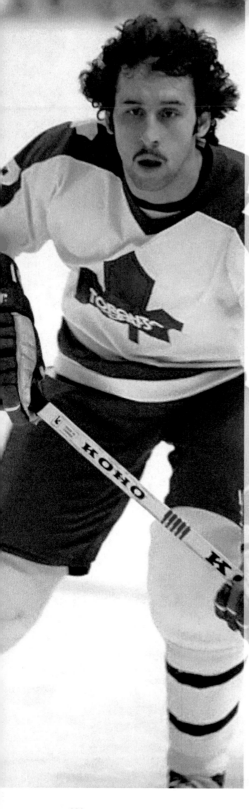

LW **RON** #18
SEDLBAUER

(1980–81)

BORN: October 22, 1954, Burlington, Ontario
ACQUIRED: February 18, 1981, purchased from
Chicago
LEAF LINE: 21 GP 10 G 4 A 14 PTS 14 PIM

In Vancouver (where he once hit 40 goals)
Sedlbauer's first NHL strike came January 26,
1975, against Toronto's Doug Favell. His 100th
NHL goal came against the Leafs, too, but he
also recalls directing one into his own net in his
final Leafs appearance. "Maybe that's why it was
my last (NHL) game," he later quipped.

On the last day of the 1980–81 season —
one in which they'd rallied mid-season under
Mike Nykoluk — the Leafs needed a win to
clinch the 16th and final playoff spot. Sedlbauer
led the way with two goals over the Nordiques in
a 4–2 road triumph.

But the Leafs' "reward" was facing top
seeded Islanders who weren't about to let
Toronto upset their Cup plans as had happened
three years earlier. The Leafs were blasted in
three straight, out-scored 20 to 4 by New York,
which was on its way to the second of four
consecutive titles.

Sedlbauer runs the family business Cougar Shoes
out of his native Burlington, Ontario.

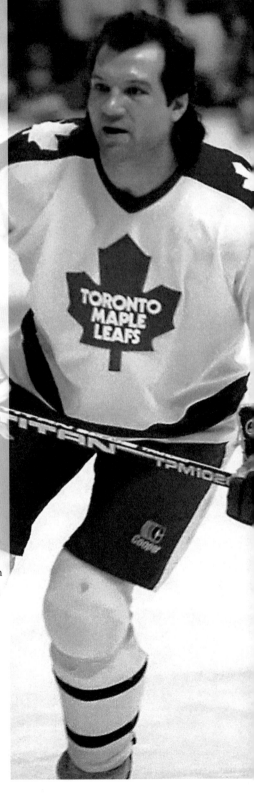

LW **DAVE** #27
SEMENKO
(1987–88)

BORN: July 12, 1957, Winnipeg, Manitoba
ACQUIRED: September 9, 1987,
from Hartford for D Bill Root
LEAF LINE: 70 GP 2 G 3 A 5 PTS 107 PIM

Semenko was getting a bit long in the tooth but
still had the respect garnered in his days as a
policeman for the young Oilers. He should have
been perfect with John Brophy, but the two often
clashed. When the coach lectured Semenko for a
late-season minor violation on a team flight, an
angry Semenko went home to early retirement.

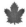

In his two years with the WHA Oilers prior
to their NHL admission, Semenko played with
former Leafs Pierre Jarry, "Cowboy" Bill Flett,
Stan Weir and Claire Alexander.

D JEFF #34
SEROWIK

(1990–91)

BORN: October 1, 1967, Manchester, New Hampshire
DRAFTED: 1985, 5th round, 85th overall
LEAF LINE: 1 GP 0 G 0 A 0 PTS 0 PIM

Serowik was with the Leafs out of camp, playing his only game as Luke Richardson's partner in a 4–1 loss in Calgary. It was a rough season in which the club won just two of its first 19 games. An offensive defenceman praised for his positioning, Serowik had a few good seasons in Newmarket and St. John's, but it wouldn't be until 1998–99 with Pittsburgh that he played any fair length of time.

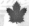

Serowik's best showing as a pro was the lockout year of 1994–95 when he had 62 points and a stellar playoff for Boston's farm club at Providence. The coach of that team was former NHL player and Toronto's one-time director of pro scouting, Steve Kasper.

Serowik now runs elite hockey camps in the northeastern U.S. and in Ontario.

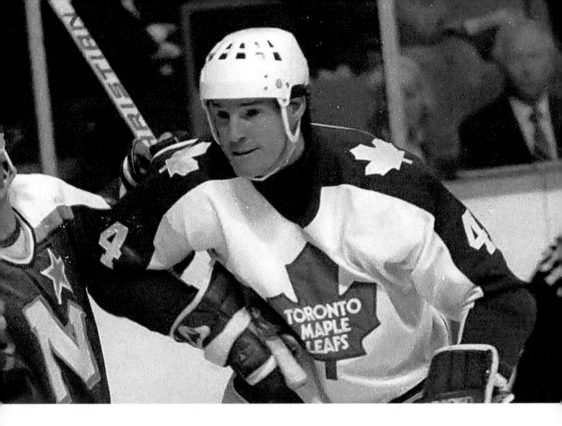

D **DAVE** #3, #4 **SHAND**

(1980–83)

BORN: August 11, 1956,
Cold Lake, Alberta
ACQUIRED: June 10, 1980, from
Washington with a 3rd-round pick,
later traded back to the Caps for a 2nd
rounder (F Kevin Lavallee)
LEAF LINE: 48 GP 0 G 5 A 5 PTS 62 PIM

With the statistic fairly new, Shand had
been a plus-47 with the Atlanta Flames,
and at 6-foot-2 and more than 200
pounds he had obvious attraction for
the Leafs. But he was quickly squeezed
out in the Leafs' rush to put young
defencemen into battle and was stuck
on the farm. When the Leafs were
still struggling in 1983–84, missing
the playoffs, Shand was playing a full
season in Washington.

Shand was on the only Atlanta team
ever to face the Leafs in a playoff series
(1979), though Cliff Fletcher's Flames
were doused by a combined 9–4 score
in a best of three.

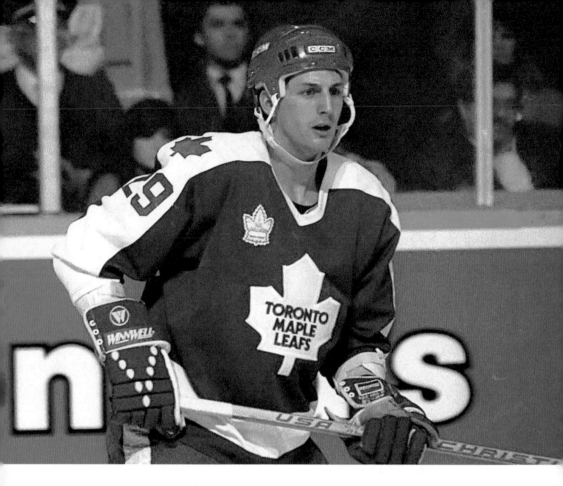

D DARRYL #4, #28, #29, #34
SHANNON

(1988–93)

BORN: June 21, 1968, Barrie, Ontario

DRAFTED: 1986, 2nd round, 36th overall

LEAF LINE: 98 GP 3 G 13 A 16 PTS 52 PIM

Shannon was a highly regarded mobile defenceman with 70 assists in his last year of junior with Windsor. He'd play nearly 600 NHL games, but his Leaf years were largely spent on a shuttle between the farm and the Gardens or sitting in the press box as the team feared losing him on waivers.

After haunting the Leafs with rival teams Winnipeg and Buffalo, Shannon ended his career with the expansion Thrashers where he wound up with another ex-Leaf defenceman, Yannick Tremblay.

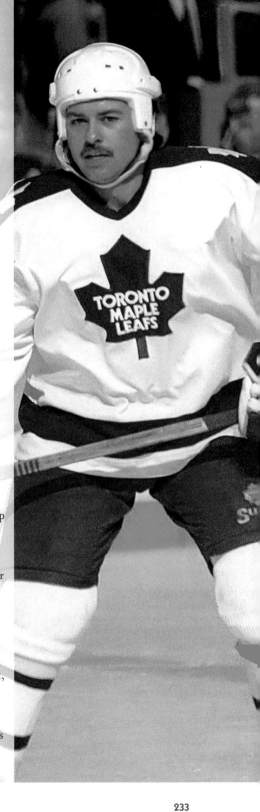

c **DOUG** #12, #37
SHEDDEN
(1988–91)

BORN: April 29, 1961, Wallaceburg, Ontario
SIGNED: August 4, 1988, as a free agent
LEAF LINE: 24 GP 8 G 10 A 18 PTS 12 PIM

Mired on the farm at first, the former 35-goal
man with Pittsburgh got a shot when the Leafs'
stumbling start in '90–91 saw Floyd Smith rip up
the roster. His brief spurt included three goals
in two games, if you include a still-uncorrected
clerical error that attributed his overtime winner
against Minnesota to Rob Ramage.

As coach of St. John's for two years, Shedden
ended with a great 46-win campaign in 2004–05,
with Matt Stajan and Kyle Wellwood thriving.
That season included what was considered the
longest pro hockey road trip at the time: 24 days
and 12 games.

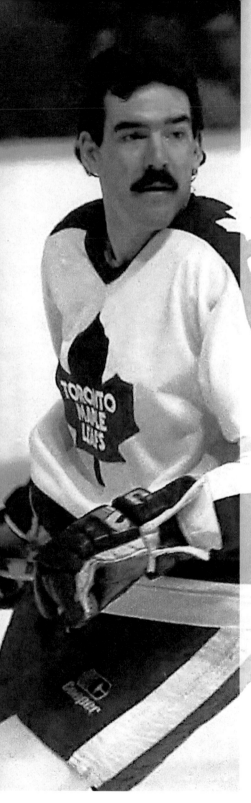

RW **BRAD** #29
SMITH
(1985–87)

BORN: April 13, 1958, Windsor, Ontario

SIGNED: July 2, 1985, as a free agent

LEAF LINE: 89 GP 10 G 24 A 34 PTS 256 PIM

"Motor City Smitty" was an instant hit — a hustling, moustachioed plugger who stepped into some nasty confrontations sans helmet. Before the Leafs lost a number of key players to Detroit in the 1990s, Smith had come the opposite direction up the 401, liking his chances in Toronto much better.

The fun-loving Smith organized a Herb Tarlek lookalike contest for the players in December of 1985. The Leafs had tied in Winnipeg and were taking two commercial flights to Los Angeles via Vancouver. Smith encouraged them to wear their most tacky suits like the character on *WKRP in Cincinnati*.

Other passengers got a kick out of an NHL team dressed so badly in polyester, led by Smith's outlandish costume. Thankfully, the temperature went from minus 25 leaving Winnipeg to plus 25 in L.A., making the lightweight suits more bearable. It was one of the best team-building moments of the difficult '80s era.

When Smith took one for the team in the '86 play-offs against the Blues, he became a mini-celebrity. The huge shiner over his eye that resulted from a punch by St. Louis defenceman Lee Norwood was featured in all the newspapers and on TV.

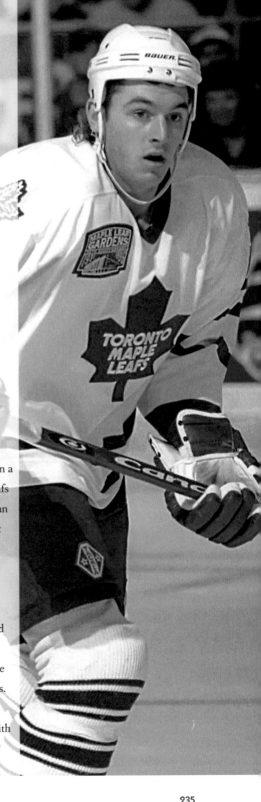

D D.J. #4, #24 SMITH

(1996)

BORN: May 13, 1977, Windsor, Ontario

ACQUIRED: March 13, 1996, from the Islanders with LW Wendel Clark and D Mathieu Schneider for D Kenny Jönsson, LW Darby Hendrickson, LW Sean Haggerty and a 1st-round pick (G Roberto Luongo)

LEAF LINE: 11 GP 0 G 1 A 1 PTS 12 PIM

It was hoped Smith would be the hidden gem in a trade mostly designed to get Clark back in Leafs colours. Smith had offensive flair and more than 600 penalty minutes but not the desired impact overall, and changes in management didn't favour an extended promotion.

D.J. stands for Denis Joseph. In 2014, he joined a long line of ex-Leafs — Bob McGill, Brad Selwood, Bill Stewart, Gus Bodnar and Charlie Conacher — as coach of the Oshawa Generals. After winning the 2015 Memorial Cup with Oshawa, Smith joined Mike Babcock's staff with the Leafs.

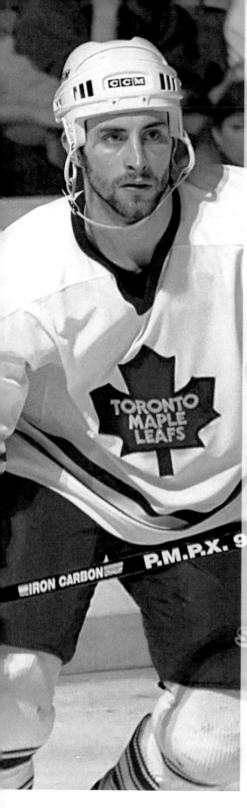

D **JASON** #25 **SMITH**

(1996–99)

BORN: November 2, 1973, Calgary, Alberta

ACQUIRED: February 25, 1997, from New Jersey with F Steve Sullivan and C Alyn McCauley for D Dave Ellett, C Doug Gilmour and a 3rd-round pick (D André Lakos)

LEAF LINE: 162 GP 5 G 29 A 34 PTS 124 PIM

He filled the void of a stay-at-home defenceman, but the coaching staff deemed him too slow a skater and, in a puzzling move, he was traded for two inconsequential draft picks (Jon Zion and Kris Vernasky).

Neither Zion nor Vernasky ever played for the Leafs, while Smith served as Oilers captain for years. Vernasky made it into 17 NHL games with Boston.

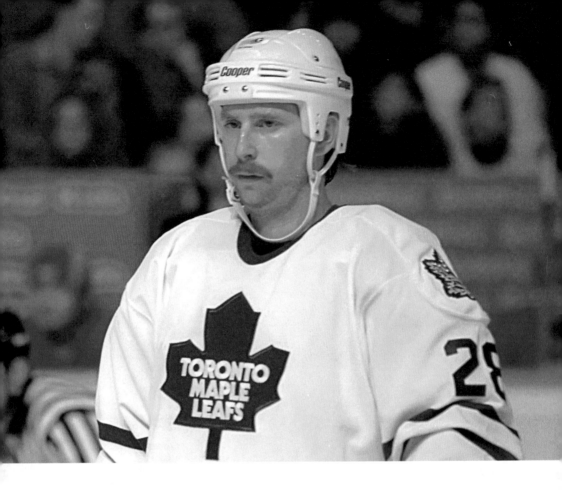

D **GREG** #25, #28
SMYTH

(1993–94, 1996–97)

BORN: April 23, 1966, Oakville, Ontario

ACQUIRED: December 7, 1993, from
Florida for cash

LEAF LINE: 13 GP 0 G 1 A 1 PTS 38 PIM

Injuries to Dave Ellett and Todd Gill
gave big Smyth an early break with
the Leafs. He had been the future

consideration in the Foligno deal with
Florida, but Toronto soon lost him on
waivers to Chicago, which had been in
pursuit at the time of the deal with the
Panthers.

Smyth's stint as a player/assistant coach
in St. John's came to a quick end in
1999 when he got in a shoving match
with unproductive forwards Jason
Bonsignore and David Nemirovsky
at a restaurant.

237

D **CHRIS** #38 **SNELL**

(1993–94)

BORN: May 12, 1971, Regina, Saskatchewan
SIGNED: August 3, 1993, as a free agent
LEAF LINE: 2 GP 0 G 0 A 0 PTS 2 PIM

Snell was the top scoring defenceman in the AHL when Todd Gill came down with back spasms before a game against the Canadiens. Snell stayed two games before the Leafs opted instead for Matt Martin, who was just returning from U.S. Olympic duty.

Traded to the Kings, Snell's short NHL window at least afforded him the chance to play with both Doug Gilmour and Wayne Gretzky.

LW **LORNE** #12 **STAMLER**

(1978–79)

BORN: August 9, 1951, Winnipeg, Manitoba
ACQUIRED: June 14, 1978, from Los Angeles with
D Dave Hutchison for D Brian Glennie, D Kurt
Walker, C Scott Garland and a 2nd-round pick
(D Mark Hardy)
LEAF LINE: 45 GP 4 G 3 A 7 PTS 2 PIM

Good wheels and defence made him valuable
to a coach such as Roger Neilson, which the
expansion Jets also realized after picking him up.

Stamler's first year of junior was an interesting
one. He was on a Marlies team that included
prodigy Dale Tallon, future Leaf Billy Harris,
coach and NHL exec Mike Murphy and NHL
bad boy Steve Durbano.

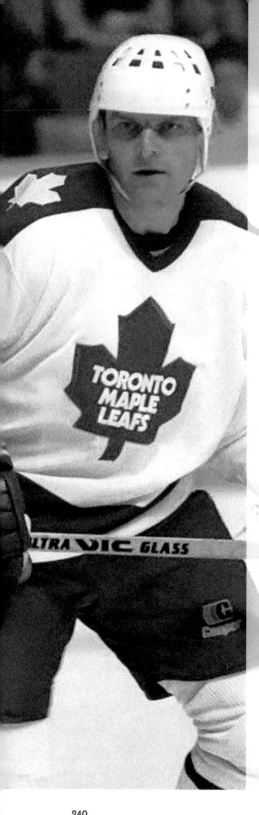

RW **MARIAN** #10
STASTNY
(1985–86)

BORN: January 8, 1953, Bratislava,
Czechoslovakia
SIGNED: August 12, 1985 as a free agent
LEAF LINE: 70 GP 23 G 30 A 53 PTS 21 PIM

Unable to keep their brother act together,
Quebec placed Marian on waivers and he came
to a Leafs team with a soft spot for Slovaks
and Czechs. For a while, Stastny played with
Miroslav Fryčer and Peter Ihnačák, but he was
held to three appearances in a 10-game playoff.

While younger siblings Peter and Anton escaped
the Iron Curtain, Marian had his family to
consider and stayed behind where he was banned
from hockey and compelled to denounce his
kin's actions. After convincing authorities he was
not a threat to flee, Marian waited for the right
moment and took his whole clan over the border
to Austria.

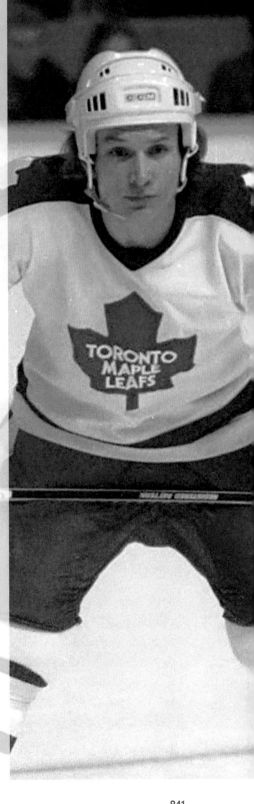

D **BOB** #15 **STEPHENSON**

(1979–80)

BORN: February 1, 1954,
Saskatoon, Saskatchewan
ACQUIRED: December 24, 1979,
from Hartford for LW Pat Boutette
LEAF LINE: 14 GP 2 G 2 A 4 PTS 4 PIM

The fiery Boutette was so popular that *SCTV* paid homage to him in a skit. Stephenson was accorded no such love and disappeared after his short stint. Prior to his Leafs assignment, Stephenson had been one of John Brophy's first recruits for the Birmingham Bulls after the Toronto Toros had ended their run at the Gardens.

Since 1998, he has been mayor of Outlook, Saskatchewan (population 2,204), home of Canada's longest pedestrian bridge.

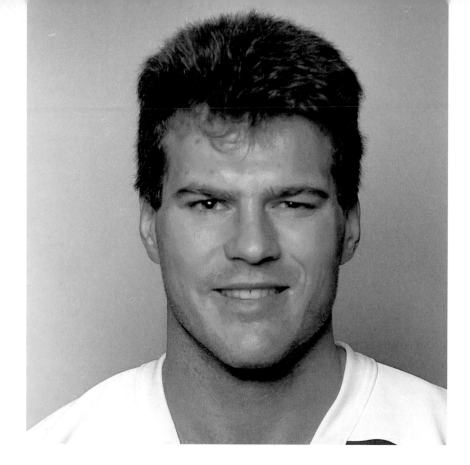

LW **MIKE** #26 **STEVENS**

(1989–90)

BORN: December 30, 1965, Kitchener,
Ontario

ACQUIRED: December 20, 1989, from
the Islanders with C Gilles Thibaudeau
for D Jack Capuano, LW Paul Gagné
and RW Derek Laxdal

LEAF LINE: 1 GP o G o A o PTS o PIM

While big brother Scott had all the

attention during his Hall of Fame
career, Mike latched on with three NHL
teams before coming to the Leafs with
the creative Thibaudeau. Both men
were called up the same night when Ed
Olczyk and Wendel Clark were hurt.

After departing the Leafs, Mike broke
out with a career best 92 points for the
Rangers' farm team in Binghamton. Its
leading scorer was Don Biggs, father of
future Leafs first-rounder Tyler.

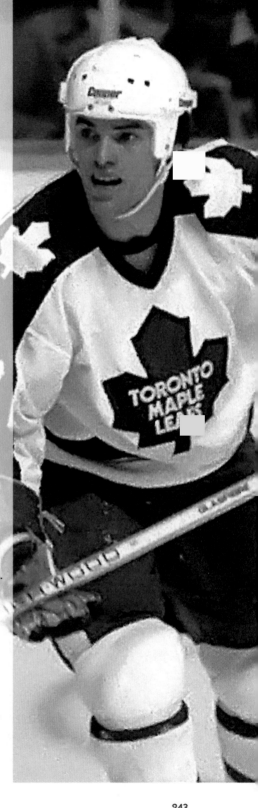

D **BILL** #17
STEWART
(1983–85)

BORN: October 6, 1957, Toronto, Ontario
SIGNED: September 10, 1983, as a free agent
LEAF LINE: 83 GP 2 G 19 A 21 PTS 148 PIM

Stewart's coaching career was preceded by 260
games on the ice, including a run with the Leafs.
He put a chance to play in Switzerland on hold
for a shot at his hometown team, but he was
often on the fringe of the starting six blueliners
and limited by injury.

After his last Leafs season in 1984–85, Stewart's
#17 went to newcomer Wendel Clark. Stewart
now coaches Dresden in the German League.

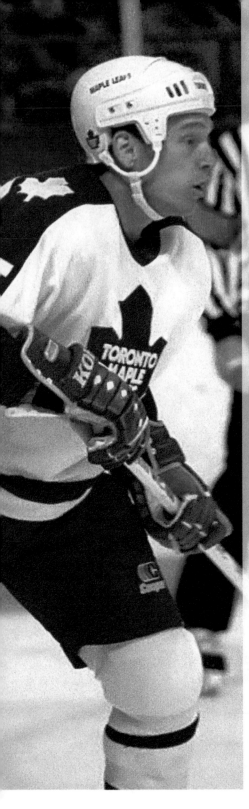

D **MIKE** #25
STOTHERS
(1987–88)

BORN: February 22, 1962, Toronto, Ontario
ACQUIRED: December 4, 1987, from Philadelphia
for a 5th-round pick (transferred to Minnesota,
which took D Pat MacLeod)
LEAF LINE: 18 GP 0 G 1 A 1 PTS 42 PIM

With the Leafs decimated by injuries on the
blueline, this turned out to be the last trade
Gerry McNamara made in his six years as GM
before getting the chop two months later.

But that summer, Flyers boss Bobby Clarke
suggested to new Leafs GM Gord Stellick that
Stothers would be much happier back in his AHL
home at Hershey, while he was looking to send
Bill Root back to the Toronto area where he'd
spent parts of three seasons as a Leaf.

More recently, Stothers has been mentioned
in several stories on the Leafs beat as he coached
Morgan Rielly — one of the best homegrown
Toronto defence prospects in years — during his
time with the Moose Jaw junior team.

Stothers played on Philly's Maine Mariners farm
team along with Dave Poulin, who (while VP of
Leafs hockey operations) had a role in choosing
Rielly in 2013. Stothers now coaches the Ontario
Reign of the AHL, farm team of the Kings.

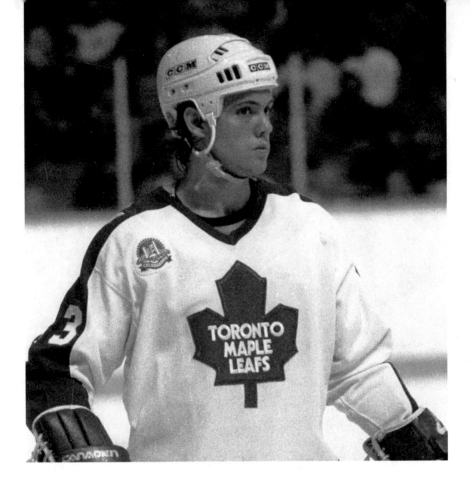

LW **KEN** #23, #32
STRONG
(1982–85)

BORN: May 9, 1963, Toronto, Ontario

ACQUIRED: January 20, 1982, from
Philadelphia with C Rich Costello
and a 2nd-round pick (F Peter Ihnačák)
for C Darryl Sittler

LEAF LINE: 15 GP 2 G 2 A 4 PTS 6 PIM

Like Mike Stothers, Strong's greater

notoriety has come in coaching, in this
case with Leafs' 2011 1st rounder Stu
Percy as part of a Toronto Marlboros
midget class that included fellow NHL
1st rounder Ryan Strome.

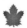

Strong played many years in Austria
for Villach after his NHL career ended,
long enough to gain citizenship and
play for the national team. Austria
won the B Pool gold medal at the 1992
World Ice Hockey Championships.

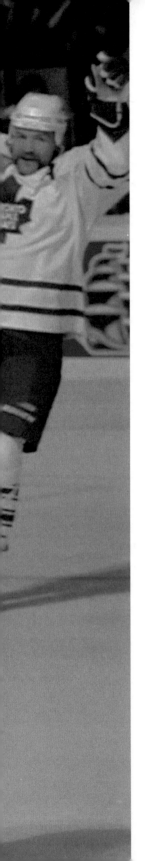

RW **STEVE** #11
SULLIVAN
(1996–2000)

BORN: July 6, 1974, Timmins, Ontario
ACQUIRED: February 25, 1997, from New Jersey with D Jason Smith
and C Alyn McCauley for D Dave Ellett, C Doug Gilmour and a 3rd
round pick (D André Lakos)
LEAF LINE: 154 GP 35 G 50 A 85 PTS 95 PIM

Sullivan has to rank among players the Leafs gave up on far too soon,
especially considering how much Gilmour had meant to the team.
Both coaches Mike Murphy and Pat Quinn couldn't get what they
wanted from him and he departed on waivers — to haunt the Leafs
with six more 20-goal seasons.

Sullivan's annual goal total with Toronto doubled every year, from
5 to 10 to 20, before dropping to nil in the seven games prior to his
release. He is now a development coach with the Arizona Coyotes.

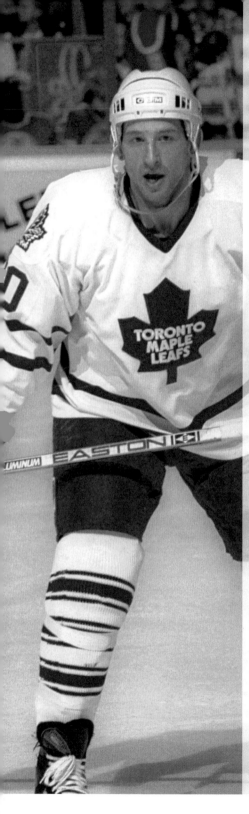

RW **RICH** #20
SUTTER

(1994–95)

BORN: December 2, 1963, Viking, Alberta
ACQUIRED: March 13, 1995,
from Tampa Bay for cash
LEAF LINE: 18 GP 0 G 3 A 3 PTS 10 PIM

The likelihood of at least one of the six Sutters
ending up with the Leafs was good given how
many trades the Leafs made and how the brothers
spread themselves around the league in their
remarkable careers. Rich was probably the
toughest on the Leafs, as a player and later a coach
in St. Louis, during the Norris Division days.

Rich played the last of his nearly thousand
regular season and playoff games with the Leafs,
during Toronto's defeat by Chicago in the first
round of the '95 playoffs.

C **GILLES** #7
THIBAUDEAU
(1989–91)

BORN: March 4, 1963, Montreal, Quebec
ACQUIRED: December 20, 1989, from
the Islanders with LW Mike Stevens for
D Jack Capuano, LW Paul Gagné and
RW Derek Laxdal
LEAF LINE: 41 GP 9 G 18 A 27 PTS 17 PIM

Thibaudeau helped form the Leafs version of
the French Connection with Vince Damphousse
and Daniel Marois. That hyper-competitive trio
would often bet one another on who'd score the
winning goal. Naturally, a couple of their best
games were against the Habs.

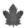

Now working in Montreal for Bell Canada
and playing alumni games with the Habs,
Thibaudeau lamented a knee injury just before
the 1990 playoffs that could have cemented some
regular ice time in T.O.

C **SCOTT** #24
THORNTON
(1990–91)

BORN: January 9, 1971, London, Ontario
DRAFTED: 1989, 1st round, 3rd overall
LEAF LINE: 33 GP 1 G 3 A 4 PTS 30 PIM

He was the first phase of the not-so-great
Belleville Bulls experiment, in which the Leafs
used three first rounders on junior mates
Thornton, Rob Pearson and Steve Bancroft.
New GM Cliff Fletcher kept Pearson and
traded Thornton, but more than a decade later
Thornton was still in the NHL, scoring 26 goals
for San José.

The first cousin of Joe Thornton, he now lives
in the Blue Mountain region north of Toronto,
running a gym and a spa.

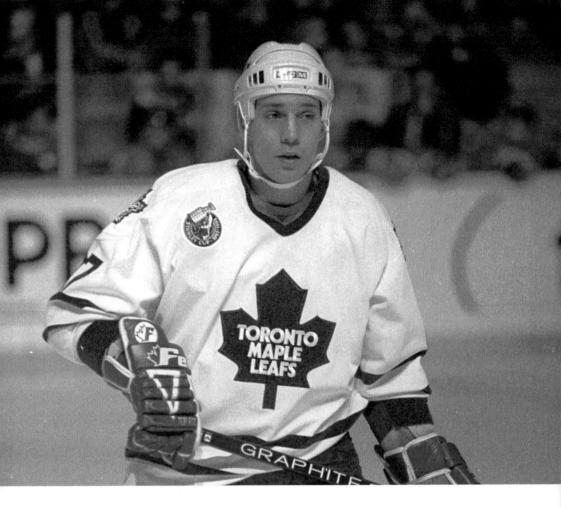

c DAVE #14, #37
TOMLINSON
(1991–93)

BORN: May 8, 1969, North Vancouver, British Columbia
ACQUIRED: 1985, NHL supplemental draft
LEAF LINE: 6 GP 0 G 0 A 0 PTS 4 PIM

Tomlinson was the leading scorer for St. John's when called up for precautionary purposes when Doug Gilmour suffered a mild concussion and Peter Zezel damaged a wrist. Tomlinson stayed a few extra games, but grew frustrated in the press box.

Tomlinson entered the media as a colour commentator with the Canucks after a long minor league and European career.

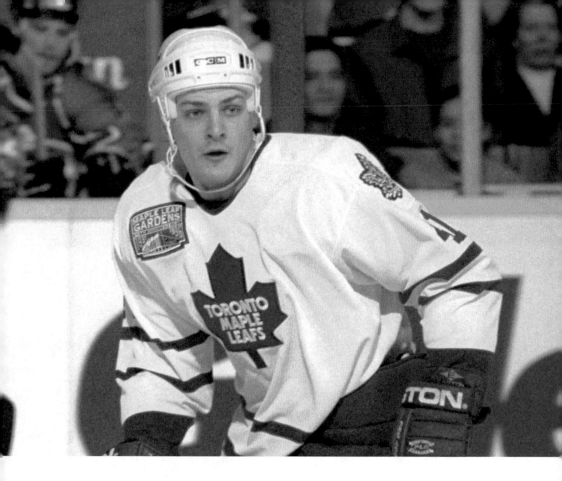

RW **SHAYNE** #41
TOPOROWSKI

(1996–97)

BORN: August 6, 1975, Paddockwood, Saskatchewan

ACQUIRED: October 3, 1994, with RW Dixon Ward, C Kelly Fairchild and C Guy Leveque from Los Angeles for D Chris Snell, LW Eric Lacroix and a 4th-round pick (C Éric Bélanger)

LEAF LINE: 3 GP 0 G 0 A 0 PTS 7 PIM

Around the time Mike Craig was handed a two-game suspension by league judge Brian Burke, Nick Kypreos was hurt and the Leafs had demoted players in the midst of a Western road trip, Toporowski came cross-country for his first NHL game in Calgary.

Toporowski was the Kings' No. 1 pick in the '93 draft, but chosen in the 2nd round as the Gretzky trade had cost the Kings several 1st rounders.

G VINCENT #1, #29, #30
TREMBLAY
(1979–83)

BORN: October 21, 1959, Quebec City, Quebec
DRAFTED: 1979, 4th round, 72nd overall
LEAF LINE: 54 GP 12 W 22 L 8 T 4.69 GAA

Tremblay might have been as successful in the minors as fellow QMJHLer Felix Potvin, but moved up to the NHL less than a year after his all-star season with the Quebec Remparts. With the Leafs weak in so many areas, the toll on goalies was predictable.

Tremblay was traded to Pittsburgh as part of a deal that brought in veteran goalie Nick Ricci. He remained on the farm and soon retired.

As a Penguin, Tremblay was caught up in the controversy of whether Pittsburgh "tanked" to finish last in 1983–84 so they could select Mario Lemieux first overall. It was noted that Tremblay was called up from Baltimore of the AHL late in the year and was over-matched with a 6.00 goals-against average in the four games, his last NHL action.

D YANNICK #38 TREMBLAY

(1996–99)

BORN: November 15, 1975,
Pointe-aux-Trembles, Quebec

DRAFTED: 1995, 6th round, 145th overall

LEAF LINE: 78 GP 4 G 11 A 15 PTS 22 PIM

Pat Quinn's first training camp as coach was spiced up by the play of three unheralded defencemen: Tremblay, Danny Markov and Tomáš Kaberle. Tremblay looked promising enough in the course of the season for the Atlanta Thrashers to take him in the expansion draft.

One casualty of Tremblay's good start was defenceman Dallas Eakins, the future Marlies and Edmonton Oilers coach, who was sent to the IHL Chicago Wolves because of excessive numbers.

D **DARREN** #25, #26
VEITCH
(1988–91)

BORN: April 24, 1960, Saskatoon, Saskatchewan

ACQUIRED: June 10, 1988, from Detroit
for RW Miroslav Frýčer

LEAF LINE: 39 GP 3 G 8 A 11 PTS 16 PIM

It's hard to imagine another team having the
off-ice mishaps that plagued the Leafs in the
1980s, but Detroit in the early years of Jacques
Demers had some doozies too. When the Wings
lost the '88 conference final to Edmonton,
Veitch was one of the players Demers blamed
for being a good-time Charlie. He was dealt to
Toronto, where coach John Brophy was fed up
with Frýčer. Neither did well in his new city,
with Frýčer later cut by Demers. At least Veitch
was named an AHL all-star and later helped the
Leafs as a mentor for raw Ukrainian rookie Alex
Godynyuk.

In the first round of the 1980 draft, the Wings
picked Veitch 5th, in between future Hall of
Famers Larry Murphy and Paul Coffey. Toronto,
without a 1st pick because of the Dan Maloney
trade with Detroit, saw the Wings take Mike
Blaisdell 11th overall. All but Coffey eventually
found their way to the Leafs, as well as four
others in the top 21: Rick Lanz, Mike Bullard,
Jerome Dupont and Paul Gagné.

RW **LEIGH** #25, #28, #34
VERSTRAETE
(1982–88)

BORN: January 6, 1962, Pincher Creek, Alberta
DRAFTED: 1982, 10th round, 192nd overall
LEAF LINE: 8 GP 0 G 1 A 1 PTS 16 PIM

You'd expect someone who played for the Red
Deer Rustlers, Billings Bighorns and Calgary
Wranglers to have around a thousand penalty
minutes by the time he reached pro hockey.
Verstraete came a long way in his hockey
journey to play just a few games in the NHL, but
he gave an honest effort on the farm to be multi-
dimensional.

The night he was called up for a game against
Quebec, Verstraete took on the legendary Moose
Dupont in his first NHL fight. He was best man
for the wedding of Leafs farm club teammate
Bob McGill.

G **RICK** #30
WAMSLEY
(1991–93)

BORN: May 25, 1959, Simcoe, Ontario

ACQUIRED: January 2, 1992, from Calgary with D Jamie Macoun, D Ric Nattress, C Kent Manderville and C Doug Gilmour for G Jeff Reese, D Alexander Godynyuk, D Michel Petit, RW Gary Leeman and LW Craig Berube

LEAF LINE: 11 GP 4 W 6 L 0 T 4.29 GAA

After years of bickering about backups, Wamsley was an ideal fit with Felix Potvin. But he just couldn't stay healthy, sidelined by strained knee ligaments, a concussion and then a second knee injury. He later coached Leafs goalies before moving on to similar positions with St. Louis, Columbus and Ottawa.

In February of '92, Wamsley opposed Greg Millen of the Wings in a rare start for both men after they had left St. Louis years before. Millen, beaten by a late Glenn Anderson winner that night, would find post-career work as a broadcaster.

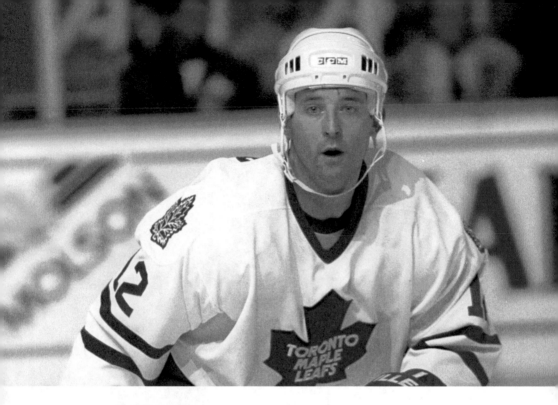

RW DIXON WARD #12

(1994–95)

BORN: September 23, 1968,
Leduc, Alberta

ACQUIRED: October 3, 1994, with RW
Shayne Toporowski, C Kelly Fairchild
and C Guy Leveque from Los Angeles
for D Chris Snell, LW Eric Lacroix and
a 4th-round pick (C Éric Bélanger)

LEAF LINE: 22 GP 0 G 3 A 3 PTS 31 PIM

Ward had been a first-year delight with
the Canucks scoring 22 goals, but that
didn't last and he wound up with the
Leafs via L.A. Game One for him was
a sweet win in Vancouver, and he had

extra ice after Mike Gartner suffered
a collapsed lung and '93 playoff–hero
Nikolai Borschevsky began getting
phased out. But Ward was also moved
aside as the Leafs toughened up for the
'95 playoffs and loaned him to the IHL
Detroit Vipers.

When the Leafs moved to the Eastern
Conference in 1998, a rejuvenated
Ward was eagerly waiting to play them
during part of his four full seasons
with Buffalo. He won a Calder Cup
with Rochester while under Buffalo's
tent and was named playoff MVP. He
now runs a hockey academy in the
Okanagan Valley.

D **JEFF** #23
WARE

(1996–98)

BORN: May 19, 1977, Toronto, Ontario
DRAFTED: 1995, 1st round, 15th overall
LEAF LINE: 15 GP 0 G 0 A 0 PTS 6 PIM

Blue chip 1st-round picks were slim for most
teams after the first 15 in the '95 draft, so it
can't really be said the Leafs wasted one on
Ware. Early in his first year, he was among
the most steady on a .500 team. But the Leafs
wanted him away from a losing environment,
back in Oshawa and playing in the world junior
tourney where Canada won gold. He was traded
to Florida a couple of years later for David
Nemirovsky, a dead-end deal for both players,
with Ware beginning to encounter the knee
problems that would soon end his career.

There was lots of confusion among Toronto
sports fans in '95 and '96 when the Blue Jays had
a young pitcher named Jeff Ware, who was also
a 1st-round pick.

D **BLAKE** #28
WESLEY

(1985–86)

BORN: July 10, 1959, Red Deer, Alberta

SIGNED: July 31, 1985, as a free agent

LEAF LINE: 27 GP 0 G 1 A 1 PTS 21 PIM

A bit player with the Nords at the end of 1984–85, the veteran Wesley figured he had something more to give. He made it into 27 games, but the Leafs had a large group ahead of him and even had rookie Wendel Clark listed as a blueliner.

Short as Blake's stay was, younger brother Glen was a Leaf for an even shorter time. Glen came near the '03 deadline and lasted just 12 games, playoffs included. Glen cost the Leafs a 2nd-round pick, as part of a larger plan to add experienced stars, such as Brian Leetch, for what was supposed to be a long playoff run.

C **PETER** #18
WHITE

(1995–96)

BORN: March 15, 1969, Montreal, Quebec

ACQUIRED: December 4, 1995, from Edmonton with a 4th-round pick (RW Jason Sessa) for C Kent Manderville

LEAF LINE: 1 GP 0 G 0 A 0 PTS 0 PIM

White might have had more time with the big team, but he had differences with St. John's coach Tom Watt about his role and parted company.

White ended up with Philadelphia where he not only got more NHL games, he met and married the daughter of Flyers legend Bobby Clarke.

D/F RON #11, #14
WILSON

(1977–80)

BORN: May 28, 1955, Windsor, Ontario
DRAFTED: 1975, 8th round, 132nd overall
LEAF LINE: 64 GP 7 G 15 A 22 PTS 6 PIM

Though many fans grew to detest Ron Wilson the coach with each
missed playoff season, he made a very positive impression playing
his first game. On March 4, 1978, he had a goal and an assist as the
Leafs beat the Canucks 4–3. It completed a link to his uncle, Johnny,
who played for the Leafs in the early '60s and also became an NHL
bench boss.

There was a longstanding debate as to whether Wilson should
have played up or back. He scored at about a 40-goal pace in two
different stints in the minors with Dallas of the CHL and New
Brunswick of the AHL.

One of many coaches who were on-ice Leafs, Wilson regretted never
seeing his father, Larry, play in the NHL. The elder Wilson had been
with Chicago in the mid-1950s, before *Hockey Night in Canada*. But
film archivist Paul Patskou did Wilson a huge favour, digging up a
16mm film of a Leafs–Hawks game in which Larry scored.

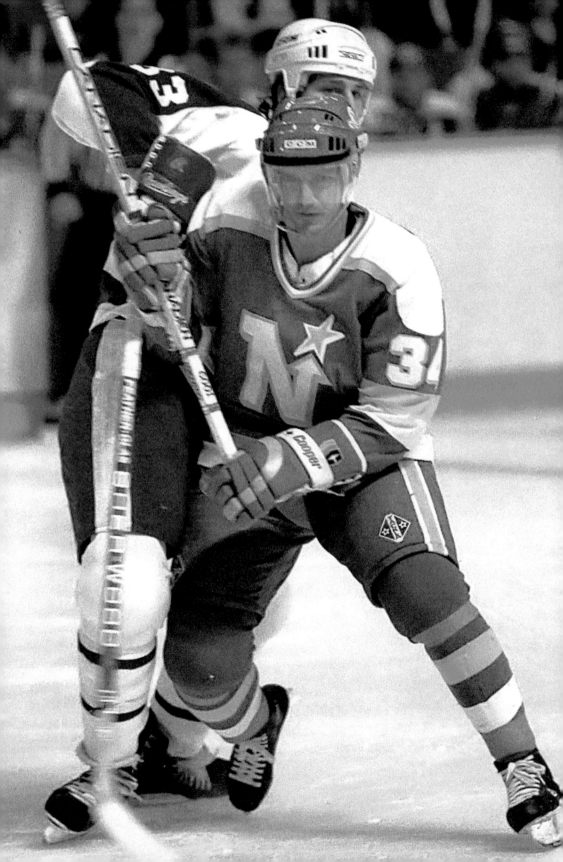

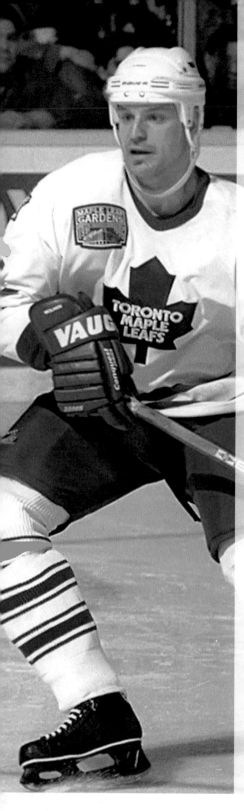

D **CRAIG** #26
WOLANIN
(1997–98)

BORN: July 27, 1967, Grosse Pointe, Michigan
ACQUIRED: January 31, 1997, from Tampa Bay
for a 3rd-round pick (D Alex Henry, transferred
to Edmonton)
LEAF LINE: 10 GP 0 G 0 A 0 PTS 6 PIM

Wolanin's short stay was nothing compared
to the years of wrangling to settle an injury
grievance with the Leafs. When Mike Smith
bought out Wolanin's $1.1 million U.S. contract
for two-thirds its price, Wolanin and the NHLPA
argued he was not given proper notice under the
CBA and was still suffering from ACL damage.
It was into the early 2000s before Wolanin
and the club finally settled for the remaining
$400,000.

Three defencemen from the 1st round in the 1985
draft — Wolanin (New Jersey), Dave Manson
(Chicago) and Calle Johansson (Buffalo) — all
played for the Leafs.

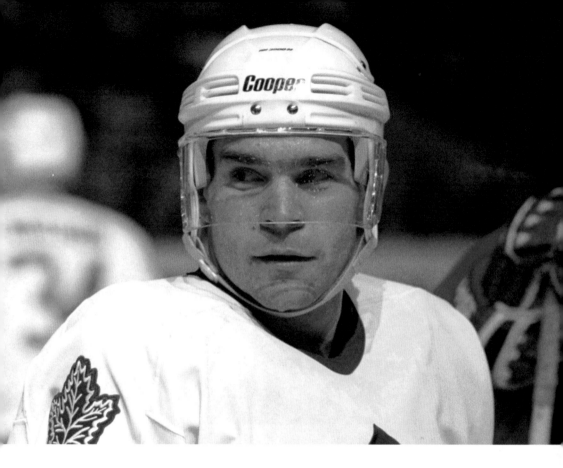

LW **RANDY** #24 **WOOD**

(1994–96)

BORN: October 12, 1963,
Princeton, New Jersey
ACQUIRED: January 18, 1995, claimed on
waivers from Buffalo
LEAF LINE: 94 GP 20 G 20 A 40 PTS 70 PIM

With teams antsy about taking on big
contracts after the first NHL lockout,
Wood was still sitting on the waiver

draft wire when Toronto's first pick
came up late in the proceedings. But
GM Cliff Fletcher had a bigger prize in
mind, soon after parlaying both Wood
and Benoît Hogue into a deal with
Dallas for Dave Gagner.

Among the small number of Yale
University grads who've had long NHL
careers are Wood, Chris Higgins and
Bob Kudelski. Wood's son Miles played
on the U.S. world junior squad.

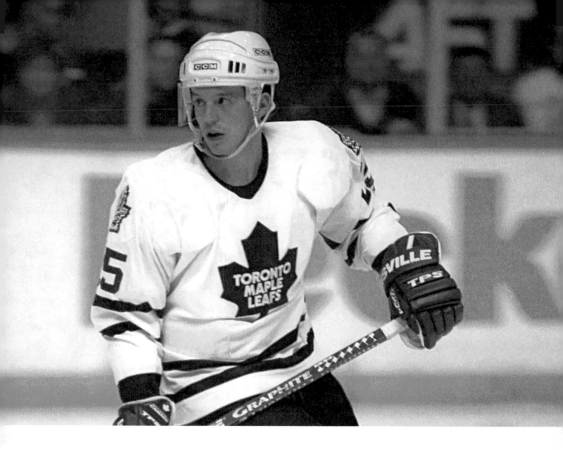

RW **TERRY** #25
YAKE
(1994–95)

BORN: October 22, 1968, New
Westminster, British Columbia
ACQUIRED: September 28, 1994,
from Anaheim for C David Sacco
LEAF LINE: 19 GP 3 G 2 A 5 PTS 2 PIM

A long series of deals between Toronto
and Anaheim began with Brian Burke
as Leafs GM and continue today with
Lou Lamoriello in that post, but Yake
was the first ever Duck to fly north
in a trade with the Leafs. Yake was
exchanged for David Sacco after big
brother Joe was taken by Anaheim in
the expansion draft. Yake had been
Anaheim's best offensive player in their
short history, but the months of lockout
changed the Leafs' approach and Yake
sat often, sometimes for a seventh
defenceman.

At one time, Yake was tried at wing
on a line with Mats Sundin and Doug
Gilmour.

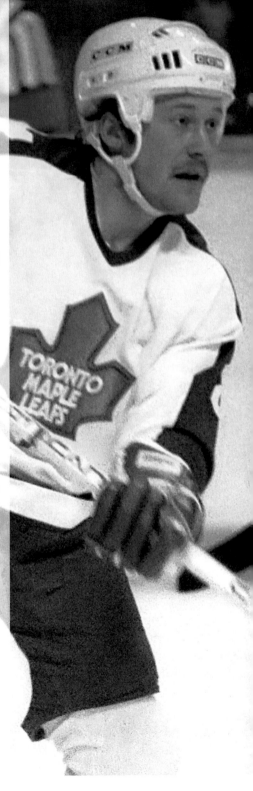

C **GARY** #8, #25, #28, #32
YAREMCHUK
(1981–85)

BORN: August 15, 1961, Edmonton, Alberta
DRAFTED: 1981, 2nd round, 24th overall
LEAF LINE: 34 GP 1 G 4 A 5 PTS 28 PIM

It was love at first sight for coach Mike Nykoluk
in the first few days of the Yaremchuk's Leafs
first camp in 1981. Nykoluk said Yaremchuk
reminded him of Bobby Clarke. But Yaremchuk
didn't really get out of the AHL. Thrilled to
make the 1981–82 opening lineup, a 6–1 win
over the Jets, he lasted 18 games that year,
though his first NHL goal would not come
for another three seasons.

Yaremchuk joined Portland Winterhawks
teammate Jim Benning as Leafs drafts, the
two having combined for 275 WHL points
in 1980–81. Just ahead of Yaremchuk at 24th
overall, Detroit selected future Leafs forward
and assistant GM Claude Loiselle.

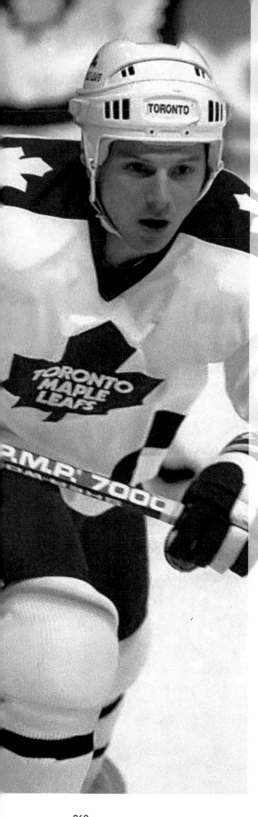

C **KEN** #15, #16, #34
YAREMCHUK
(1986–89)

BORN: January 1, 1964, Edmonton, Alberta
ACQUIRED: September 6, 1986, with D Jerome
Dupont and a 4th-round draft choice (LW Joe
Sacco) as compensation from Chicago, which
signed D Gary Nylund as a free agent
LEAF LINE: 47 GP 6 G 13 A 19 PTS 28 PIM

The Yaremchuk brothers just missed each other
in Toronto, with Ken scoring even more junior
points and getting in more Leafs games. He also
got in a spot of trouble on a Leafs road trip in
L.A., arrested for public intoxication but released
without charges.

Yaremchuk looked good with a different leaf on
his chest, getting six points in eight games for
Canada at the 1988 Olympics in Calgary.

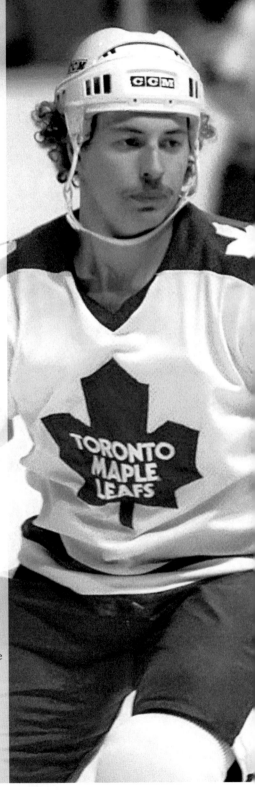

RW **RON** #32, #39
ZANUSSI
(1980–82)

BORN: August 31, 1956, Toronto, Ontario
ACQUIRED: March 10, 1981, from Minnesota
with a 3rd-round pick (C Ernie Godden)
for a 2nd rounder (F Dave Donnelly)
LEAF LINE: 55 GP 3 G 8 A 11 PTS 20 PIM

Hard-toiling Zanussi produced decent numbers
for the North Stars after an 86-point explosion
with the Fort Wayne Komets. Three goals in
12 games after the trade gave the Leafs some
encouragement, but he was blanked in 43 games
the following year. He didn't get off the farm
afterwards.

The first Leaf whose surname began with a Z,
he was represented by brief Leaf Brent Imlach,
whose father Punch was notoriously tough on
agents. But many think Punch made this deal late
on deadline day to give his son a leg up in his
new sports business career.

Zanussi retired to Minneapolis where he
worked as a baggage handler for many years for
Northwest Airlines.

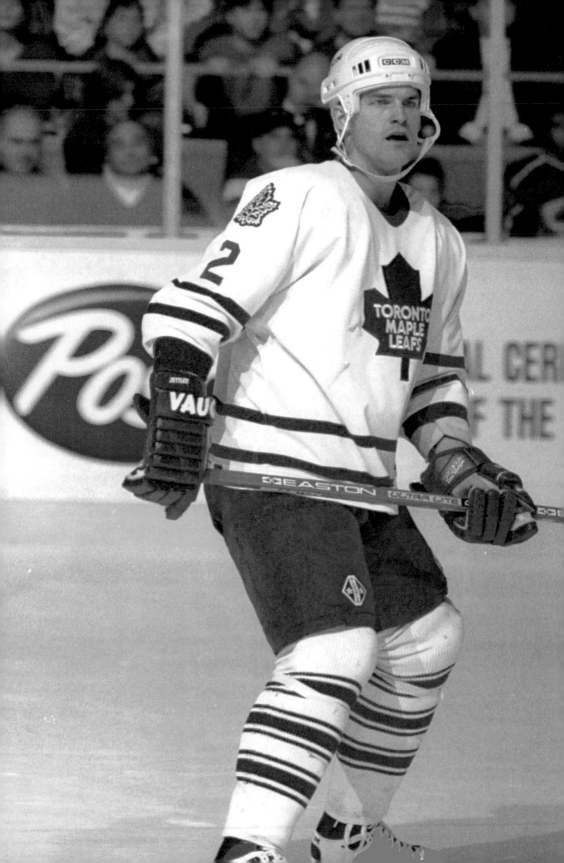

D **ROB** #2, #3 **ZETTLER**

(1995–98)

BORN: March 8, 1968, Sept-Iles, Quebec

ACQUIRED: July 8, 1995, from Philadelphia for a 5th-round pick
(G Per-Ragnar Bergkvist)

LEAF LINE: 136 GP 2 G 20 A 22 PTS 207 PIM

There was talk of the Leafs getting hometowner Bruce Driver from
Jersey as summer stock, but Zettler's arrival was deemed enough
depth to start 1995-96. Zettler had more chances to work when Kenny
Jönsson was traded and Dmitry Yushkevich fell out of favour. Zettler
had 14 points in 48 games the next year and stayed in the picture long
enough to convince Nashville to grab him in their expansion draft.

When Zettler played with the Capitals, under his future Leafs and San
José bench boss Ron Wilson, Washington was injury-riddled for a
game against Toronto. Wilson was forced to dress eight defencemen
that night, rotating Zettler and future Leaf Ken Klee as forwards, and
the Caps fought the Leafs to a 3–3 draw. Coach Wilson was actually
named one of the game stars by the Washington media.

ACKNOWLEDGEMENTS

I had this idea on the back burner for years with all of my photos on file and Lance keeping all of those stories in his head. So it was a perfect match.

Once again, Lance, thank you for your time putting it all on paper. I really don't think Lance knew how much work he'd have to do on this project.

Wendel, thanks for helping out on the book. Players in the NHL usually needed two names. You needed one. Everyone in the league knew Wendel! There are very few Toronto Maple Leafs players who have become hockey legends for their work on and off the ice. You are right there at the top of the list.

Thanks to Michael Holmes and Jack David at ECW Press for giving us another opportunity with a Leafs-themed hockey book. You are great people to work with.

Drew Rogers and Kevin Maguire at the Toronto Maple Leafs Alumni Association helped us contact players and verify information. Your support was greatly appreciated. Kevin actually made it into the book!

We appreciate the Ontario Arts Council for providing us with assistance.

— GRAIG ABEL

After Graig and I completed our first project, *Welcome to Maple Leaf Gardens*, he mentioned the hundreds of photos of lesser-known Leafs he'd accumulated in his basement and wondered what would become of them. A light bulb went off and *Cup of Coffee* began the brewing process. The words would mean little without his excellent skills behind the lens.

Thanks to former Leafs general manager Gord Stellick, whose incredible memory for faces, names and stories continues to make him one of the best commentators on radio and TV. He helped enormously with this book.

— LANCE HORNBY